HISTORIC PHOTOS OF
DENVER
IN THE 50s, 60s, AND 70s

TEXT AND CAPTIONS BY MICHAEL MADIGAN

TURNER
PUBLISHING COMPANY

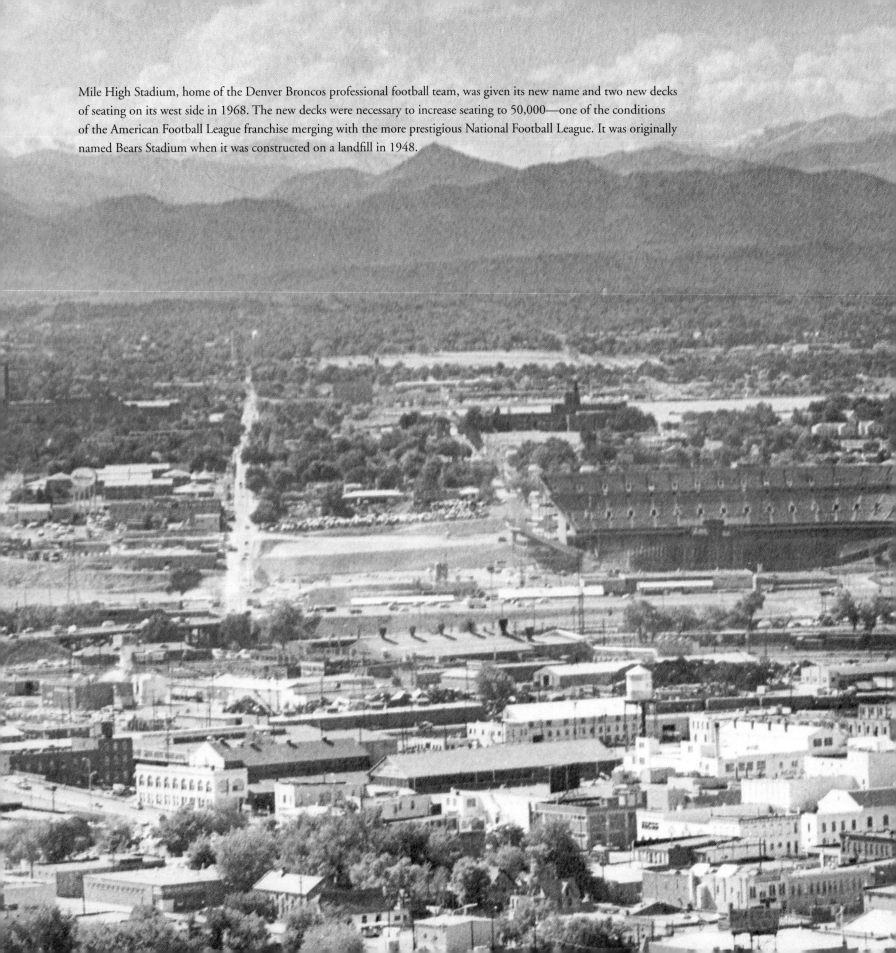

Mile High Stadium, home of the Denver Broncos professional football team, was given its new name and two new decks of seating on its west side in 1968. The new decks were necessary to increase seating to 50,000—one of the conditions of the American Football League franchise merging with the more prestigious National Football League. It was originally named Bears Stadium when it was constructed on a landfill in 1948.

HISTORIC PHOTOS OF
DENVER
IN THE 50s, 60s, AND 70s

Turner Publishing Company
200 4th Avenue North • Suite 950
Nashville, Tennessee 37219
(615) 255-2665

www.turnerpublishing.com

Historic Photos of Denver in the 50s, 60s, and 70s

Copyright © 2010 Turner Publishing Company

Library of Congress Control Number: 2010921718

ISBN: 978-1-59652-595-5

Printed in China

10 11 12 13 14 15 16 17—0 9 8 7 6 5 4 3 2 1

CONTENTS

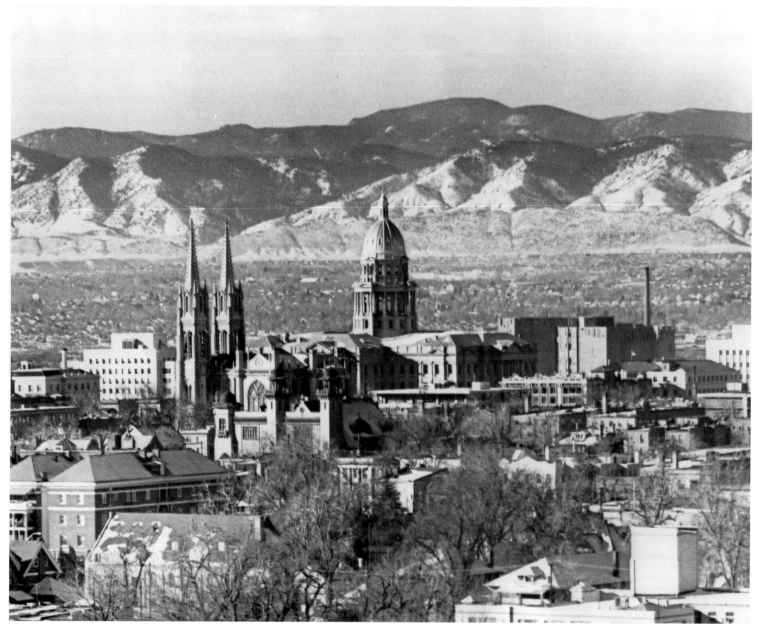

This rooftop view of the Cathedral of the Immaculate Conception's Gothic spires and the gold-plated dome of the State Capitol set against the backdrop of the Rockies was photographed June 26, 1974.

Acknowledgments

This volume, *Historic Photos of Denver in the 50s, 60s, and 70s,* is the result of the cooperation and efforts of many individuals and organizations. It is with great thanks that we acknowledge the valuable contribution of the Library of Congress and the Denver Public Library, Western History Collection, for their generous support.

There is a treasure—neither hidden nor lost—on the fifth floor of the Denver Public Library in downtown Denver. Don't everyone rush there at once. It is the Western History/Genealogy Department's Western History Photograph Collection, and without it volumes like this one and others would never be published. The collection chronicles the people, events, and places that shaped the settlement and growth of the Western frontier. Most of the images you will find in this book were selected from this vast vault. The collection also includes a significant amount of material from the Colorado Historical Society photo collection. More than 120,000 images have been digitized and are available for viewing online at the library's Web site: www.history.denverlibrary.org. In addition, more than 600,000 undigitized photographs, negatives, cartes-de-visite, tintypes, albums, and stereocards exist in the Western History Photograph Collection, most of them dating from the nineteenth century. These can also be viewed by contacting the Western History/Genealogy staff.

The person who mothers this collection as personally as the photos in her wallet and who deserves the most credit for assisting with this project is Coi Drummond-Gehrig. Myron Vallier, a Web site librarian and author of a companion to this volume, *Historic Photos of Denver* (Turner Publishing, 2007), was of great help in identifying some Denver buildings. Ann Brown deserves thanks for her research expertise.

———————

To Molly, Sean, and Sophie,
so that you may see a Denver you never knew,
as if taken by the hand of the great-grandmother you never knew

PREFACE

I wish I had been a photographer. A good one.

It is one of several professions other than the one I chose as a writing journalist that, looking back, I think, "I could have been that." Along with a seaman, an architect, a rancher. And, of course, a major-league first baseman; it's a left-handed calling. But of all these idle peeks at the rearview mirror, the one I'm closest to and may have the most informed appreciation for is photographer. I think it is because I worked alongside some of the best in the business. The best in Denver. I listened in on their pre-assignment strategy sessions about where they would stand and what light they would steal. And I witnessed the magic arts of the photo editors who later picked just the right frame from a roll—yes, even in the 1970s they were film rolls—of thirty-six. Or one hundred and thirty-six. Some photographs taken by these professionals were selected for this retrospective from the archives of the Denver Public Library.

Most of the photographs, though, were chosen from private collections donated to DPL by six shooters—Charles S. Grover, Ralph Morgan, M. D. Smith, Fred Thumhart, Steve Weil, and Roger Whitacre. I do not know them personally. But it is evident they knew this city very personally and viewed it through the wide angle of experience. Many of the photographs have never been shared publicly, and might never have been. It is my privilege to see what they saw, and to document some of their life's work.

So why the 1950s, 1960s, and 1970s? It can be argued that modern Denver was defined in those thirty years after World War II. It also has to be one of the most complex periods in the city's history. It was a time when buildings began to scrape the sky. When historic landmarks were lost and brilliant new architecture discovered. When whole neighborhoods were relocated. When Beetles added to a growing air-pollution problem, and Beatles helped citizens forget their problems for one evening. When the city and state won and then forfeited one of the world's greatest spectacles, the Winter Olympics, in a period of two years. It was a time when all these things happened—for better and for worse—because people believed they

were doing what was best for Denver. The book is naturally divided into three decades, one per chapter. Each one earned its own place in history, and in this book.

Not all of the photos are remarkable. But they are all honest. Except for touching up imperfections that have accrued with the passage of time and cropping where necessary, no other changes were made. The focus and clarity of some images is limited by the technology and the ability of the photographer, and by the environment at the instant he snapped the shutter.

I invite readers to scrutinize the photographs. To learn them. To discover the sign in the window, the future star at the bottom of the movie marquee, the street that no longer exists. There are secrets captured in each image.

That's why not everyone gets to be a photographer. A good one.

—*Michael Madigan*

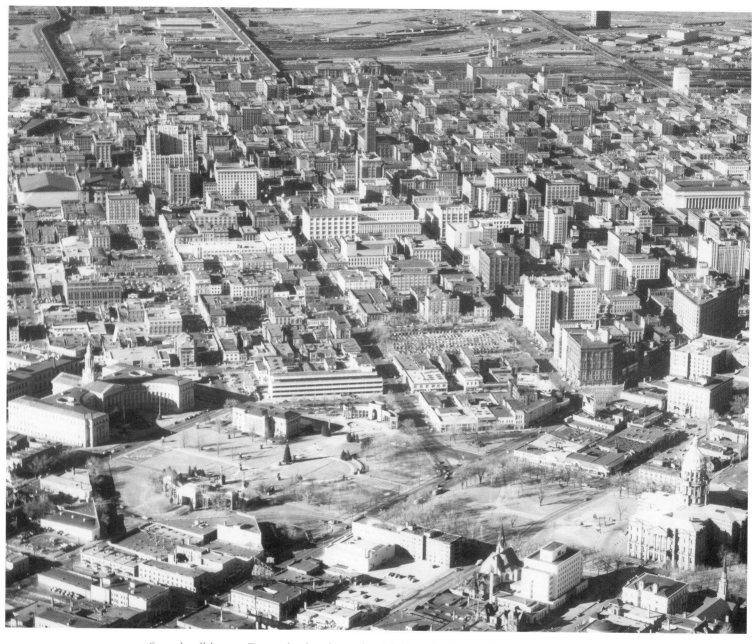

Several well-known Denver landmarks can be picked out in this aerial photographed January 5, 1952. Starting clockwise from lower left: the City and County Building, the Auditorium-Theater, the Daniels & Fisher Tower, the multi-columned Denver Post Office, and the State Capitol.

MAKING UP FOR LOST TIME

(1950–1959)

Denver and its residents emerged from World War II weary of its necessary limitations and sacrifices. The Queen City of the Plains was in desperate need of a makeover—civically, architecturally, culturally, and emotionally. It was a city in search of its identity.

It wasn't without a national image. But that image was based on the blessings of its geography on the flanks of the Rocky Mountains, pleasant though whimsical climate, and some venerable icons—the Brown Palace Hotel, the National Western Stock Show, and Elitch Gardens amusement park.

Change drove into town in fat-finned automobiles and parked in front of new clusterings of neighborhood stores—called "malls"—full of fresh goods and ideas. Federal tax-dollar funds fueled large public projects. To make room for the new growth, the Denver Urban Renewal Authority swept a huge broom—in the form of a wrecking ball—through blocks and blocks of downtown neighborhoods. Unfortunately, much history and heritage was swept away, too. Still, a building boom was begun that would last for three decades. The first "skyscrapers" changed the city skyline. Auto dealerships popped up seemingly overnight to supply the growing demand. The old-grid pattern of streets was modified with one-way streets. A toll highway was built between Denver and Boulder, and the first Interstate highway through the city—I-25, or the Valley Highway—opened.

Thousands of returning military men, whose families waited out the war at Lowry Air Force Base and Fort Logan and Rocky Mountain Arsenal, opened new businesses and created new jobs. Parks were expanded with new attractions for the swelling families. Radio and television, after a wartime glimpse of their potential, entered a period of huge expansion.

In 1959, the city awakened to learn it even had its own professional football team, the Denver Broncos of the fledgling American Football League, and it fell in love with a passion the rest of the country would come to envy.

The "Mile High City" now sounded a much more hopeful tone. Denver was on its way. It may have appeared sometimes it didn't know exactly where it was going. But it was making up for lost time.

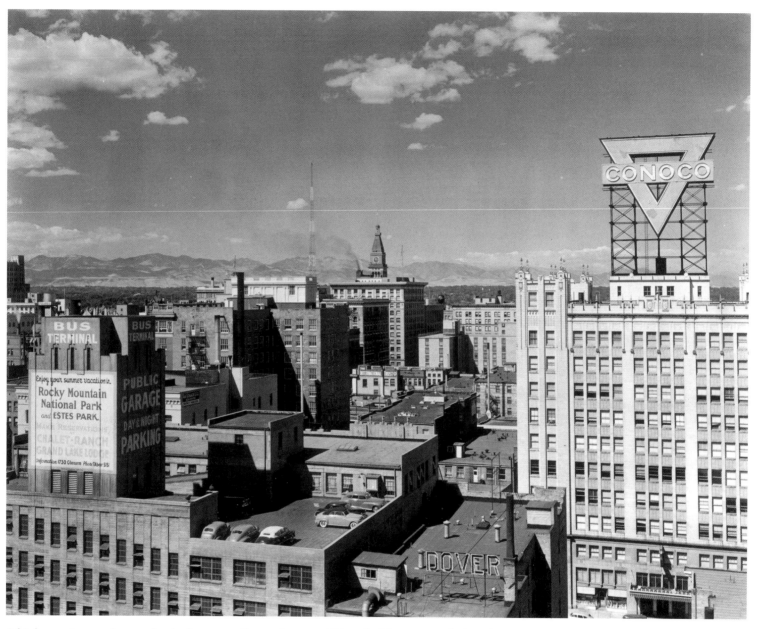

A birds-eye view northwest takes in downtown Denver between 17th and 18th streets, including the Daniels & Fisher Tower, center, one of the Mile High City's enduring landmarks. Building signs advertise the growing number of businesses and local attractions.

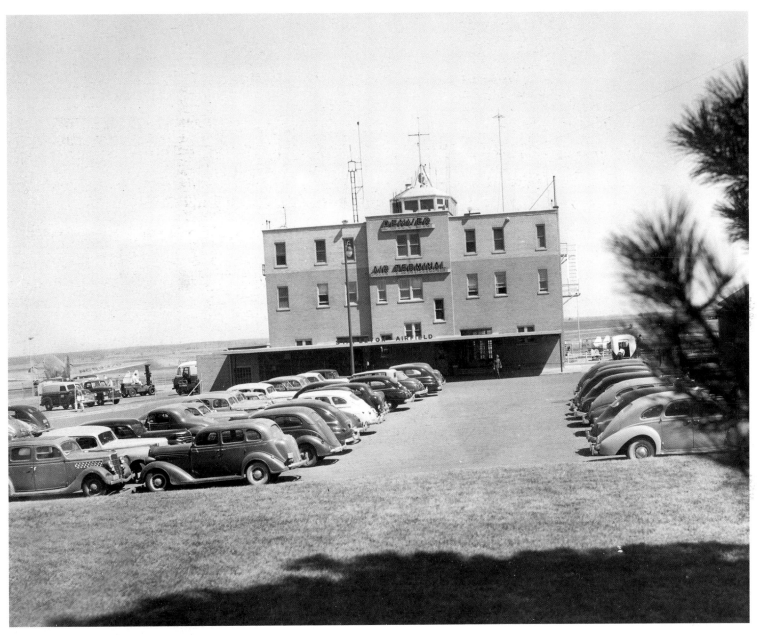

Stapleton Airfield, shown here in the early 1950s, was Denver's main airport over 66 years. It was known as Denver Municipal Airport when it opened in 1929. After an expansion in 1944, the name was changed to Stapleton Airfield in honor of Benjamin F. Stapleton, the city's mayor most of the years from 1923 to 1947. It later became Stapleton International Airport.

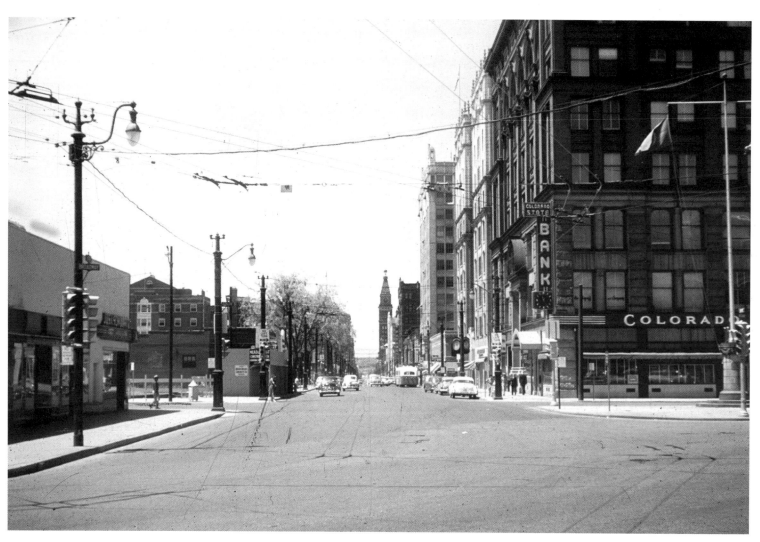

Old-style globe streetlights, traffic signals, and a grid of overhead electric trolley lines frame this view down 16th Street. The Daniels & Fisher Tower anchors the west end with the Colorado State Bank on the corner. Years later, 16th Street was closed to personal vehicle traffic and turned into a pedestrian mall that served as both an urban corridor and community gathering place.

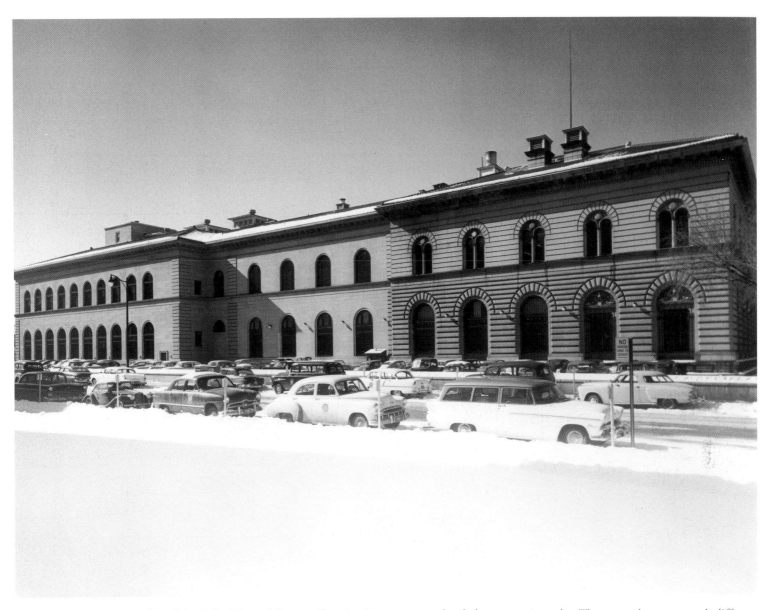

The east side of the United States Mint on Cherokee Street seems a placid place on a winter day. The atmosphere was much different on December 18, 1922, when bank robbers drove up to the West Colfax Avenue entrance, got the drop on guards, and escaped in a shoot-out with $200,000. A portion of the money, $80,000, was eventually recovered. But no one was ever charged in the heist.

By 1950, electric and diesel buses were serving the city, having replaced the streetcars of a generation past.

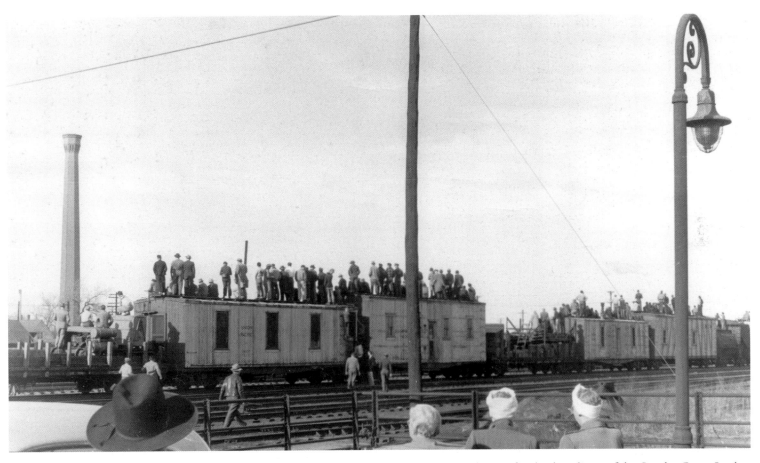

Spectators climb aboard Union Pacific rail cars to take ringside seats for the demolition of the Omaha-Grant Smelter smokestack on February 25, 1950. Eight blasts of dynamite brought most of the old ore smelter down, followed by more dyamite the next day to finish the job.

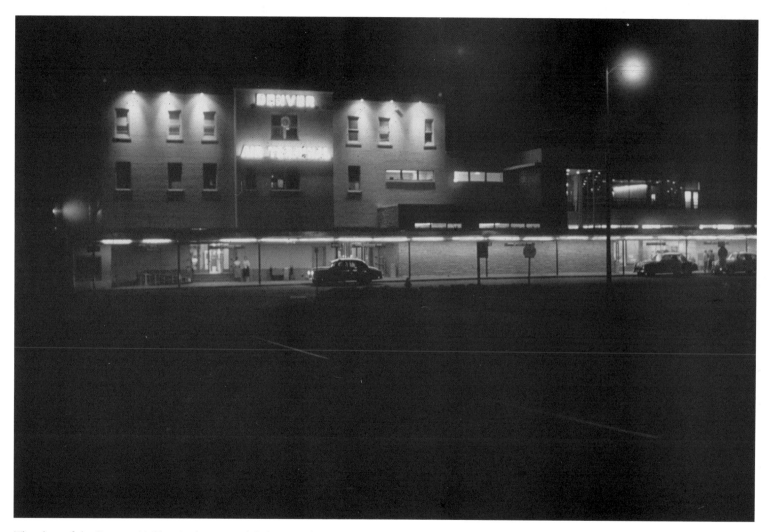

The glow of the Denver Air Terminal casts weak light at night over Stapleton Airfield.

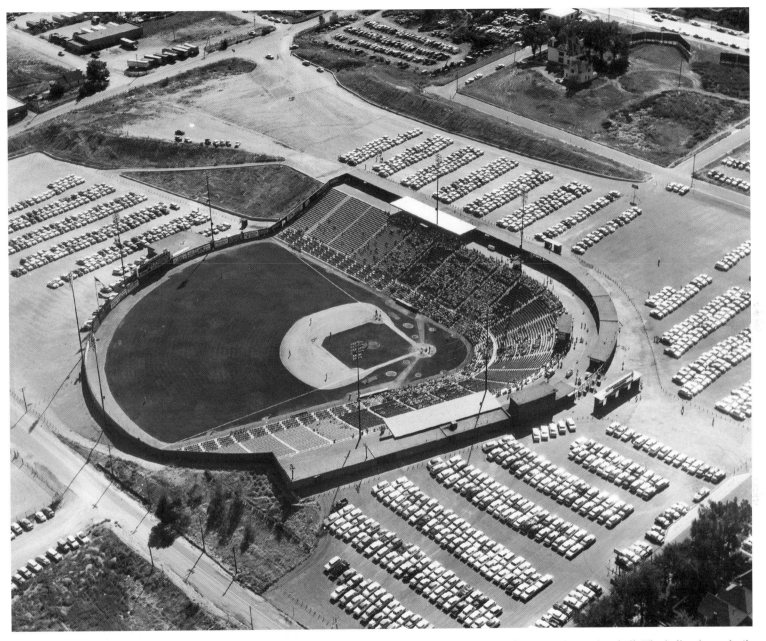

Bears Stadium in the 1950s was a single-level grandstand that seated 17,000 for minor league baseball. The ballpark was built on an old landfill. Bears owner Robert Howsam constructed the stadium as the first step toward his dream of one day bringing a Major League Baseball franchise to the city.

Harry M. Rhoads is still regarded as one of the legendary photographers in Denver history. He made his name on the staff of the *Rocky Mountain News,* for which he photographed presidents, princes, and paupers who visited the city. A bellows camera sits in one of his chemical darkrooms.

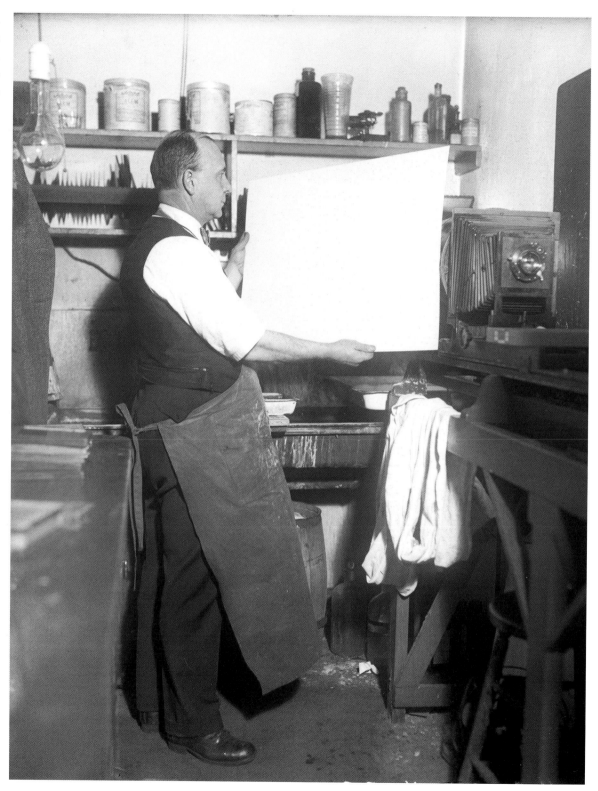

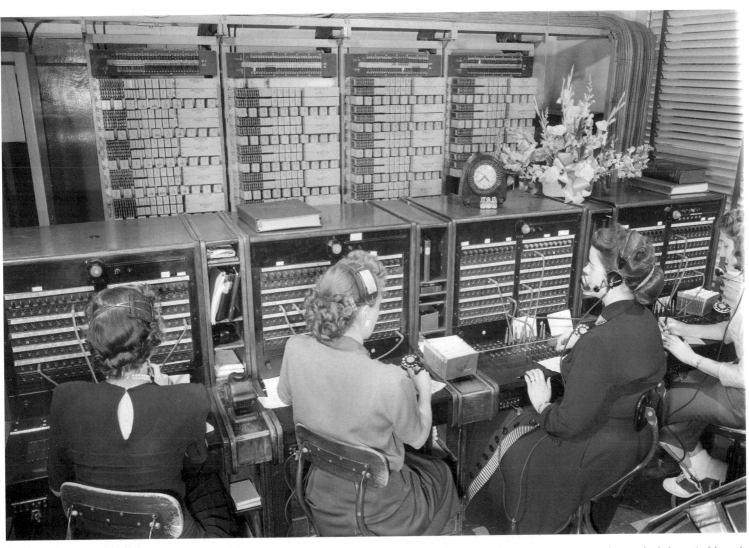

They were called "telephone secretaries" and "switchboard operators" in the 1950s, the countless women who worked the switchboards all across Denver and America. Rotary dial equipment, visible at center, was standard communications technology, and saddle shoes, worn by the operator at right, were the standard in women's fashion.

Two University of Denver students relax in front of the Mary Reed Building on campus. Built in the collegiate Gothic style in 1932, it first served as the library and later the administration building.

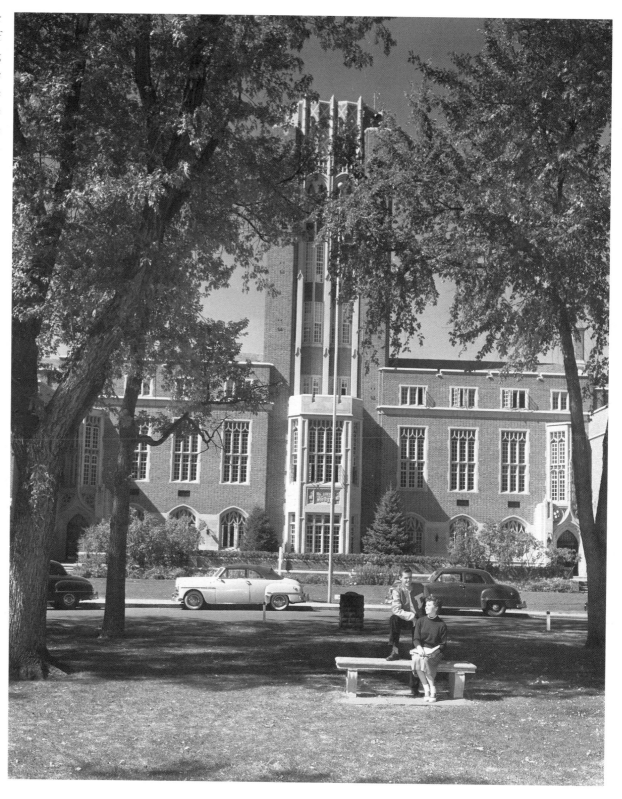

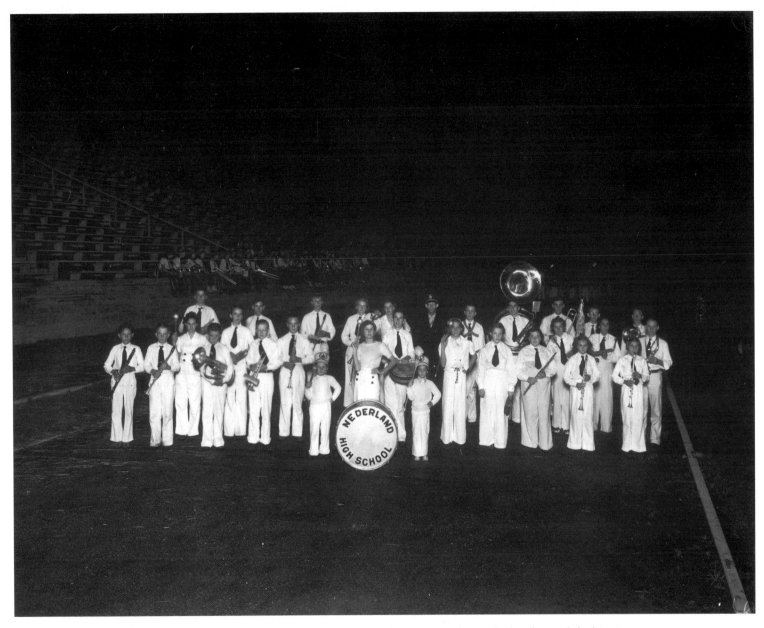

The Nederland High School Junior Band prepares for a tune on the field of a Denver stadium. The band visited the big city from the town of Nederland, nestled in the Rockies 17 miles outside Boulder.

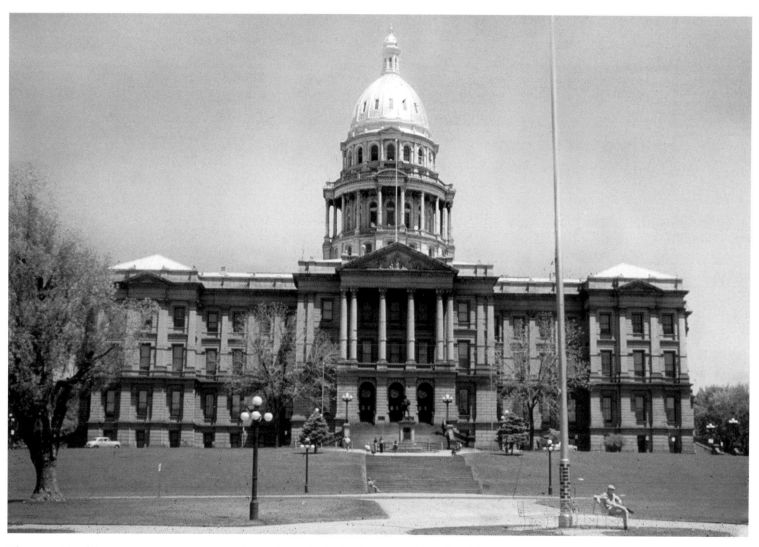

The west side of the State Capitol looms over Lincoln Street in the Capitol Hill neighborhood. The cornerstone of the building was set on the Fourth of July, 1890, when a copper-box time capsule full of mementos was placed in the northeast corner. The next day the *Rocky Mountain News* reported that 60,000 citizens filled nearby Lincoln Park for an enormous barbecue of 350 sheep and 237 "fat steers."

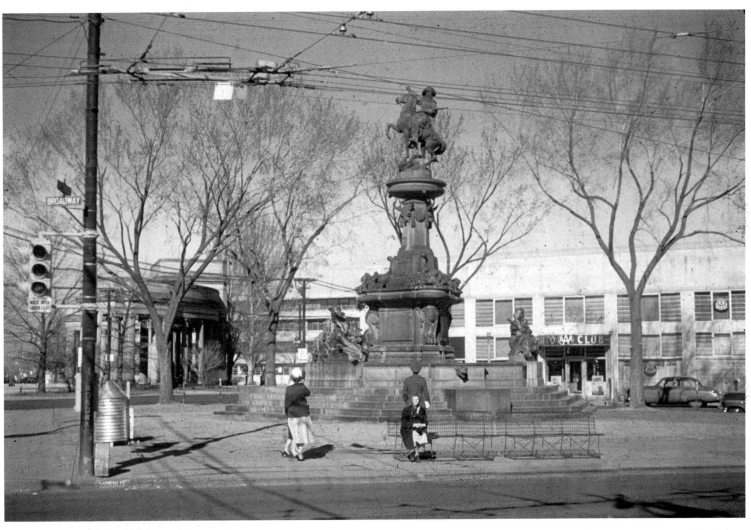

The *Pioneer Monument Fountain* is the centerpiece of the triangle intersection of Broadway, Colfax Avenue, and Cheyenne Place downtown. Civic Center, at left, sits across from the AAA automobile club in this 1950s view.

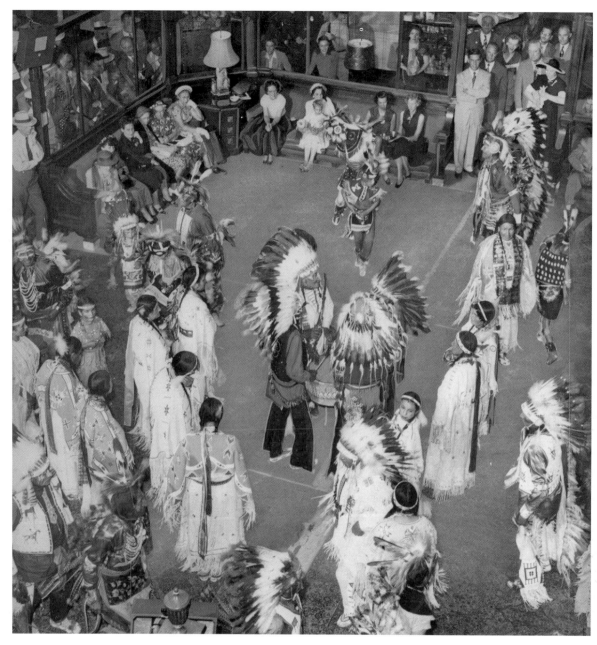

Native American Sioux in traditional tribal garb of deerskin leggings and dresses and feathered headdresses perform for spectators in the lobby of the Brown Palace Hotel in July 1950. The historic hotel has hosted events of every color and stripe since it opened in 1892.

Lights from the Manhattan Restaurant, the Golden Nugget, and the Windsor Hotel turn night into day on Larimer Street, a city landmark since Denver's early years.

Fire fighters scale truck ladders to put out a blaze at the Denver Athletic Club on February 17, 1951.

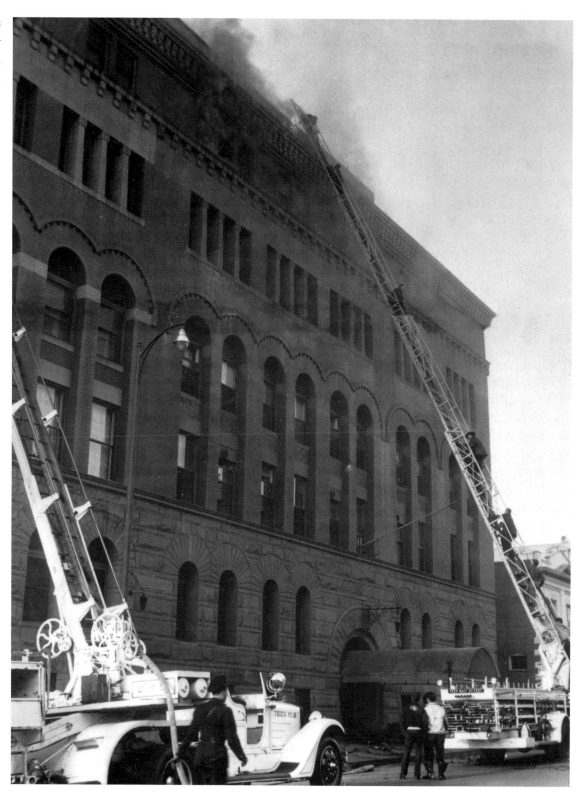

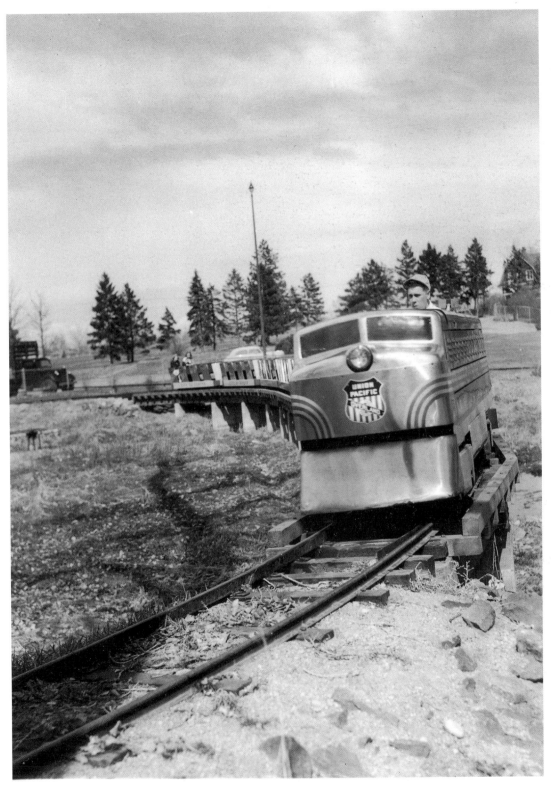

A miniature Union Pacific train was one of the attractions in City Park in 1951. Air traffic, the automobile, and federal interference would soon bring the era of railroading to its knees, but the nation's fascination with trains would continue into the twenty-first century, in Denver as elsewhere.

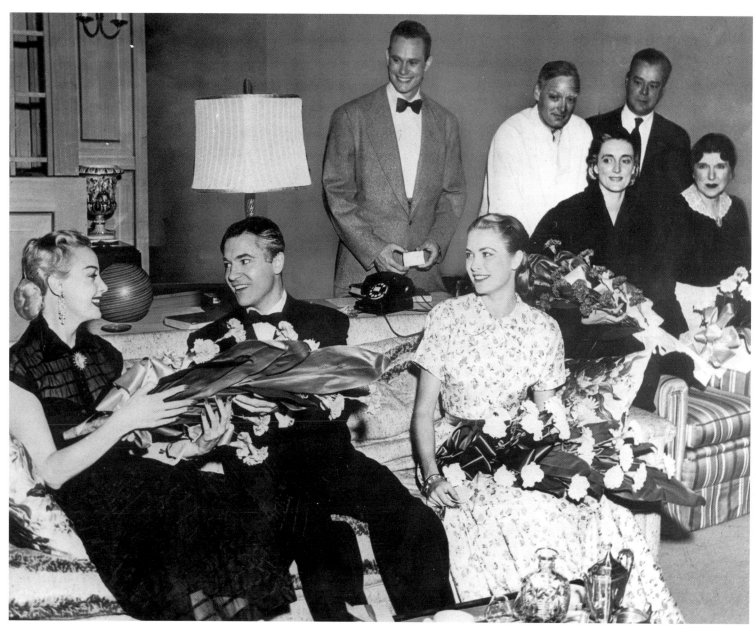

Opening night at Elitch Gardens Theatre was always a grand social event. In June 1951, actresses Lynn Salsbury and Grace Kelly, in town to perform with Whitfield Connor, are presented bouquets of flowers.

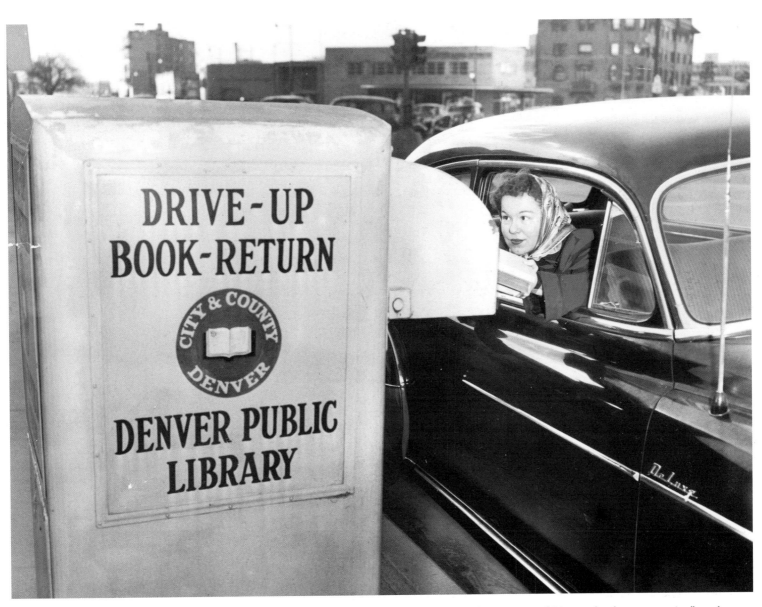

By 1952, automobiles had been crisscrossing Denver for decades. But that January a "drive-up book-return station" made news in the *Denver Post*. The newspaper identified the driver as Barbara Blamey of nearby Grant Street and pointed out, "She doesn't have to step out of the car."

This March 1952 view is from the Capitol steps across Lincoln and Broadway streets to the City and County Building. But the neighborhood uproar at the time was over the three-story-tall whiskey bottle, over the right shoulder of the building, which is just visible perched as an ad above the Zook Building. *Rocky Mountain News* editor Jack Foster successfully campaigned to have the bottle removed because he said it cheapened the view of the Rocky Mountains from his office.

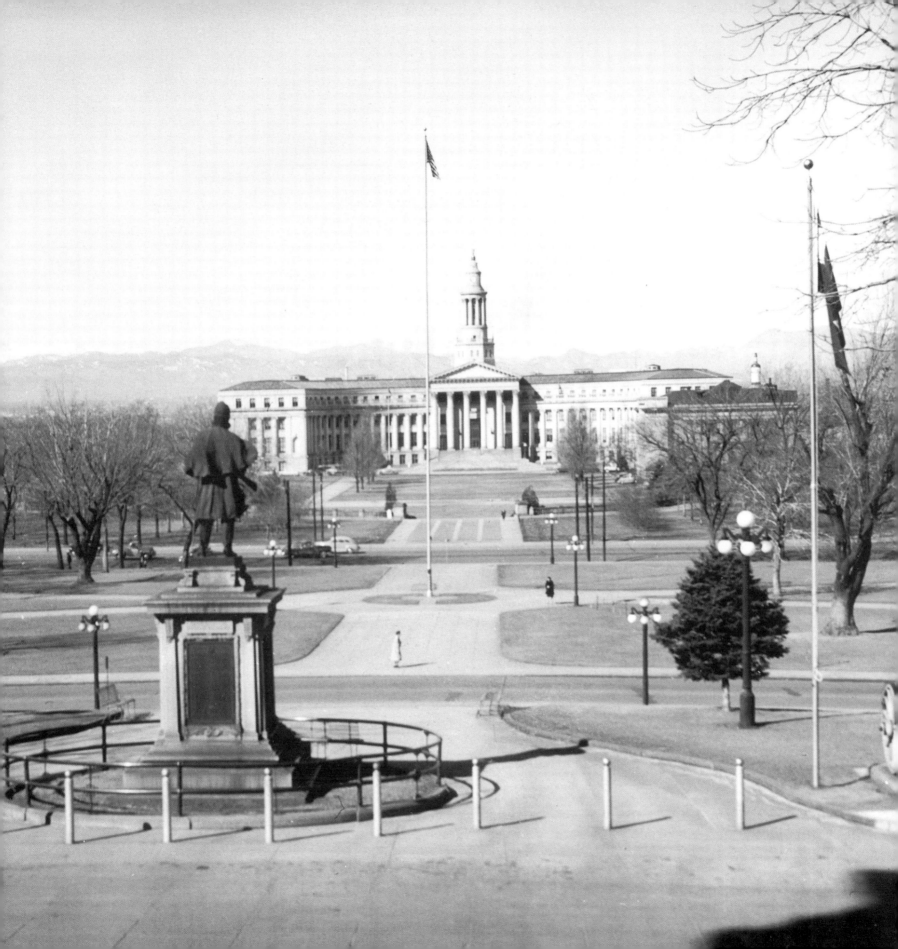

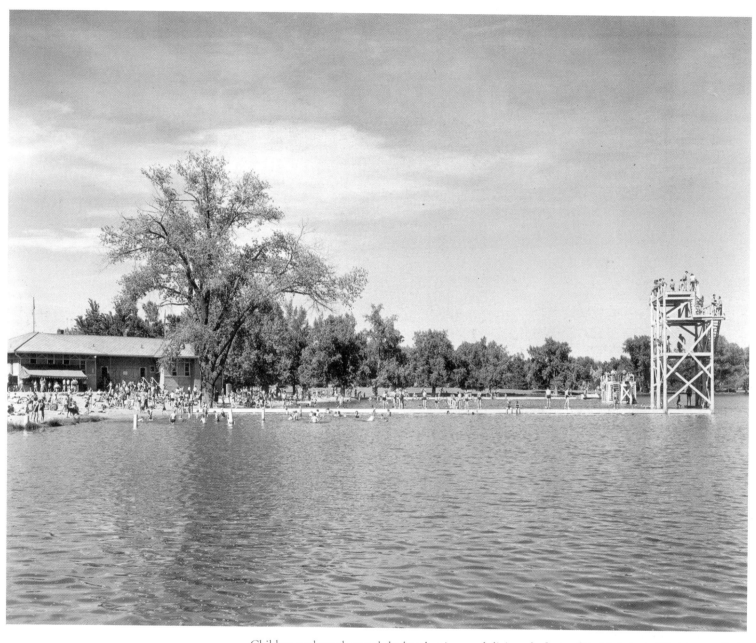

Children and youth crowd the beach, piers, and diving platform of Smith Lake in Washington Park.

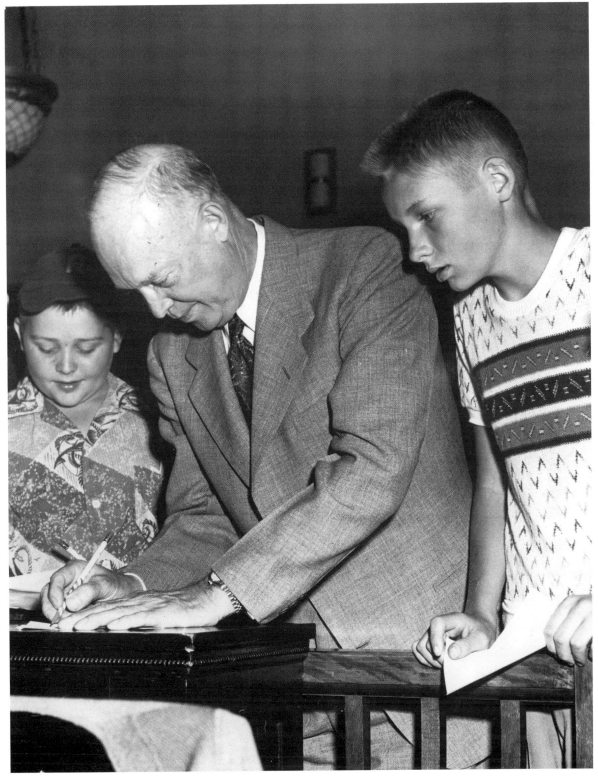

Dwight D. Eisenhower, still in the first year of his presidency, signs an autograph for two boys in June 1952. Eisenhower was a regular visitor to Denver and Colorado while president. His wife, Mamie, grew up on Lafayette Street; the couple was married at Fort Logan; and "Ike" considered the golf courses of Denver and the trout streams one hour away in the Rockies as parts of his western White House.

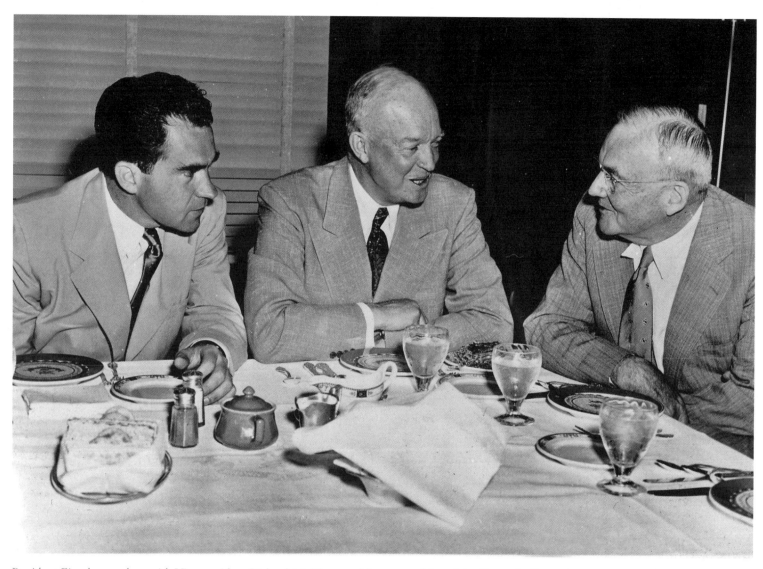

President Eisenhower chats with Vice-president Richard M. Nixon and Secretary of State John Foster Dulles at the Brown Palace Hotel on August 8, 1952. "Ike" usually stayed at the Brown Palace when in Denver. A suite in the hotel still bears his name today.

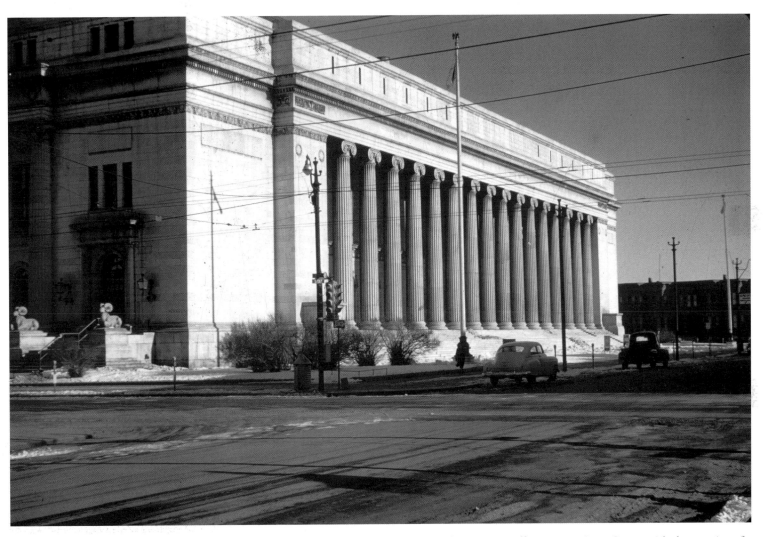

On a sunny winter day in 1953, Ionic capitals grace Denver's main post office at 1823 Stout Street, with the remains of a snowstorm visible on the grounds.

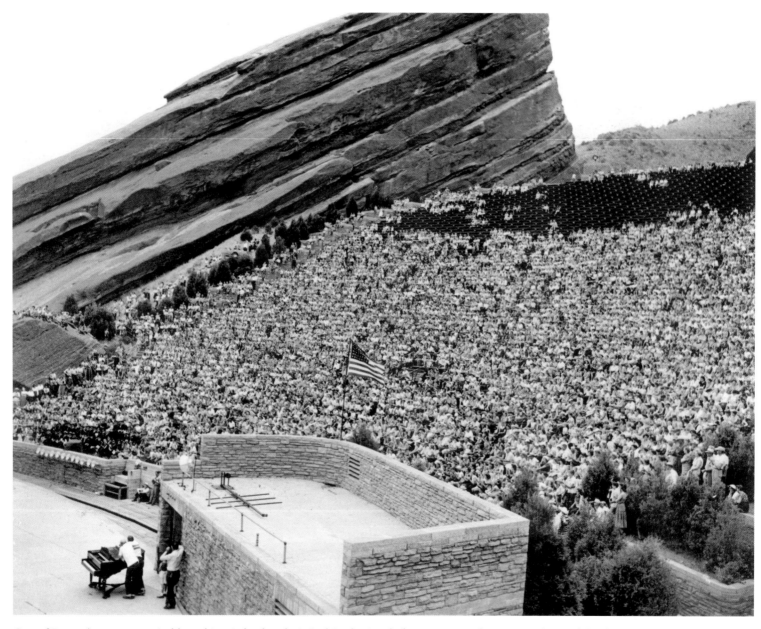

One of Denver's most recognizable and iconic landmarks is Red Rocks Amphitheatre, a natural stage carved out of the dramatic red sandstone flatirons in the foothills southwest of the city. Its plain wood benches, capable of seating 9,000 fans, were almost full for this performance of "Roundup Riders of the Rockies" in July 1952.

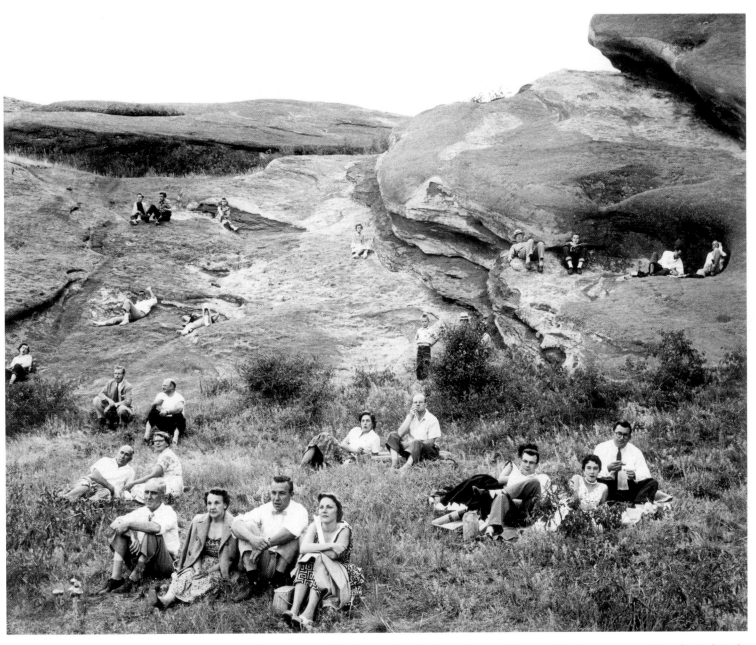

Concert-goers would often spread out blankets and picnics in and around the rough landscape surrounding the Red Rocks stage in the early years of the park. In later years, after several accidental falls from the overhanging rocks—some fatal—some areas were placed off-limits.

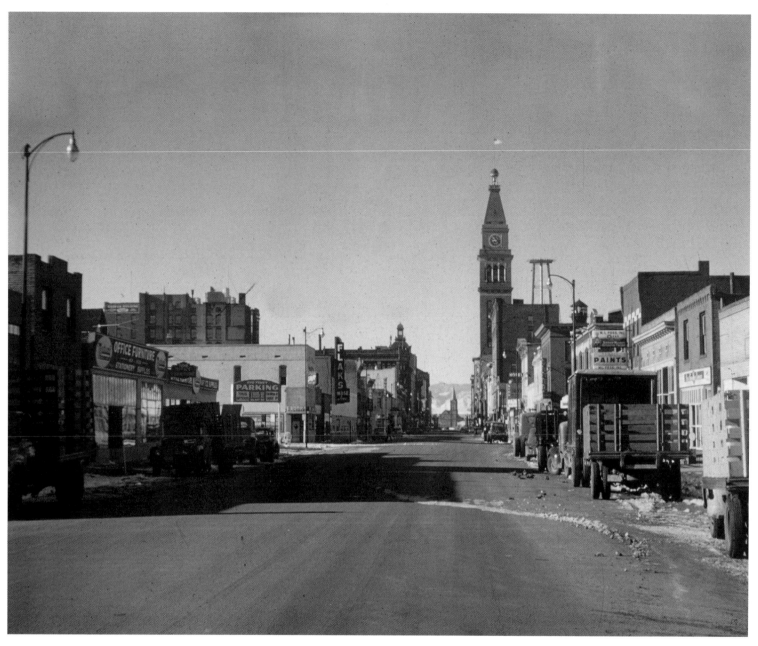

Trucks point the way down Arapahoe Street in 1953 toward the Daniels & Fisher Tower and at the very foot of the street, St. Elizabeth Catholic Church. The church would eventually be surrounded by the campus of Metropolitan State College when it was created in 1965, but the church continues to serve the community.

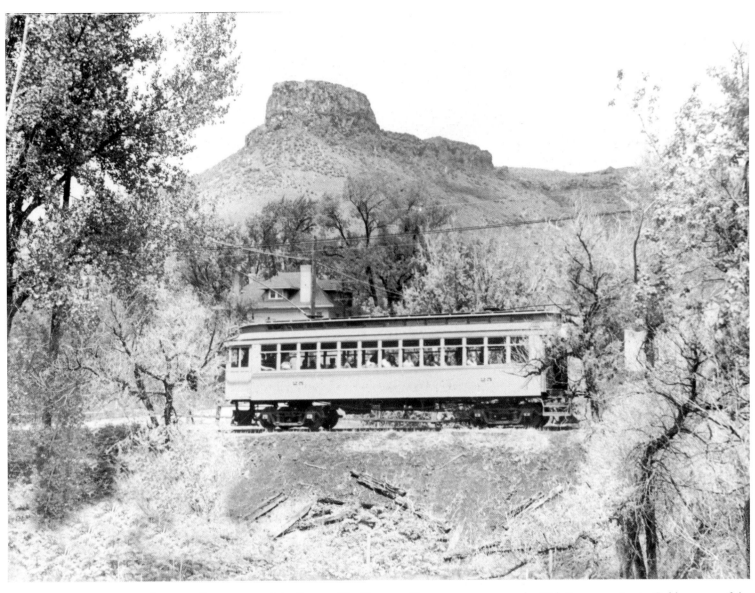

An electric trolley car, part of the Denver City Tramway Company, passes over the 19th Street crossing in Golden, west of the metropolis. Castle Rock, part of the Table Mesa formation, looms over Golden and is the iconic rock pictured on early bottles of Coors beer, still brewed in the town.

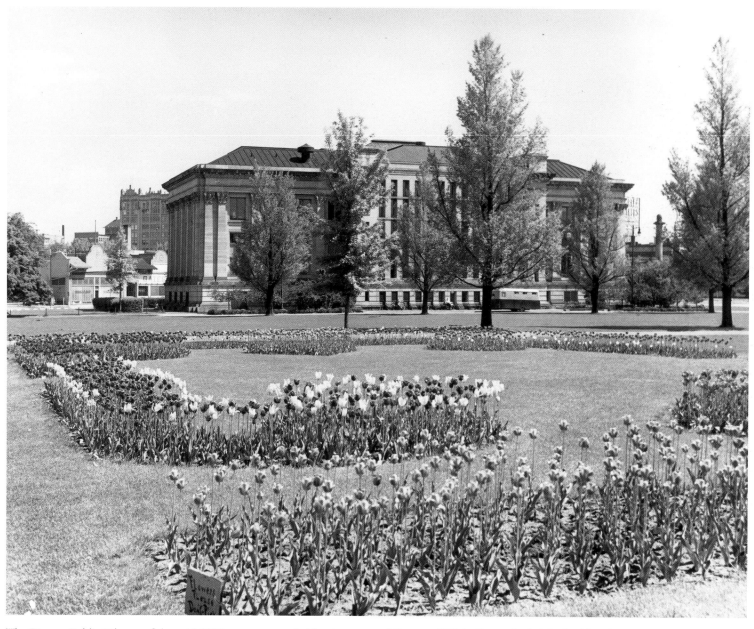

The Denver Public Library of the mid-1950s was surrounded by the trees and flowers of Civic Center Park. The building housed the library from 1910 to 1955. After the library moved across 14th Avenue to its new home, the old building was known as City and County Annex 2 and still later, the McNichols Building. Large beds of tulips adorn the park in this view of the grounds.

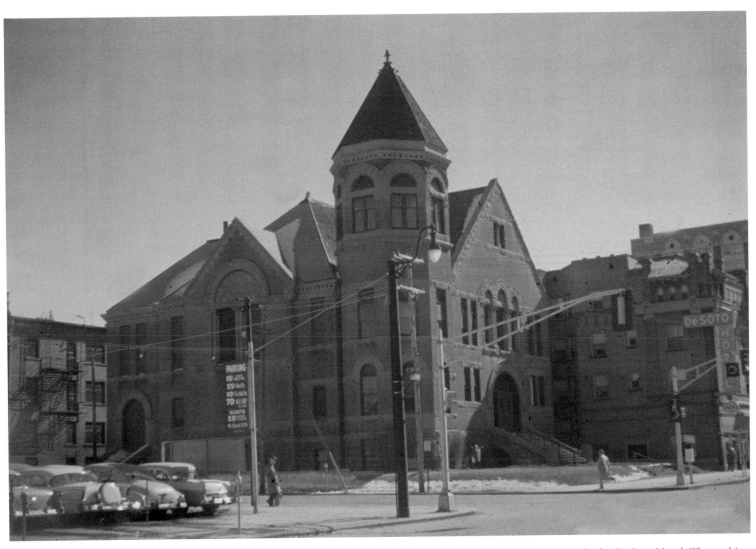

The First Unitarian Church anchored the corner of Broadway and 19th Avenue in 1953, alongside the DeSoto Hotel. The parking lot across the street charged 70 cents for all-day parking.

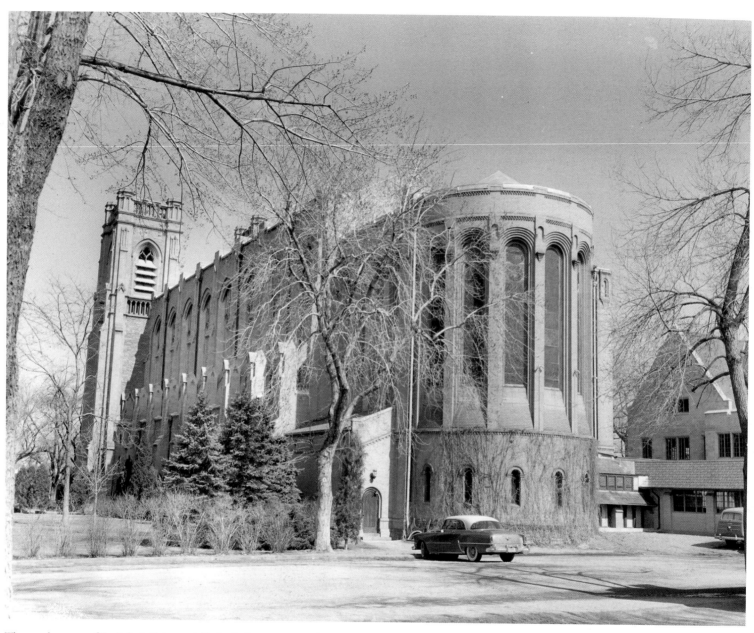

The predecessor of St. John's Episcopal Cathedral, at 1350 Washington Street, was known as St. John's Church in the Wilderness when it was chartered in 1860. The cornerstone for the cathedral was laid in 1909. In the 1950s, at the time of this photo, the congregation was led by Rector Paul Roberts, dubbed the "Red Dean" by many for his pacifist beliefs during World War II and the cold war and his stance on the social problems of the day.

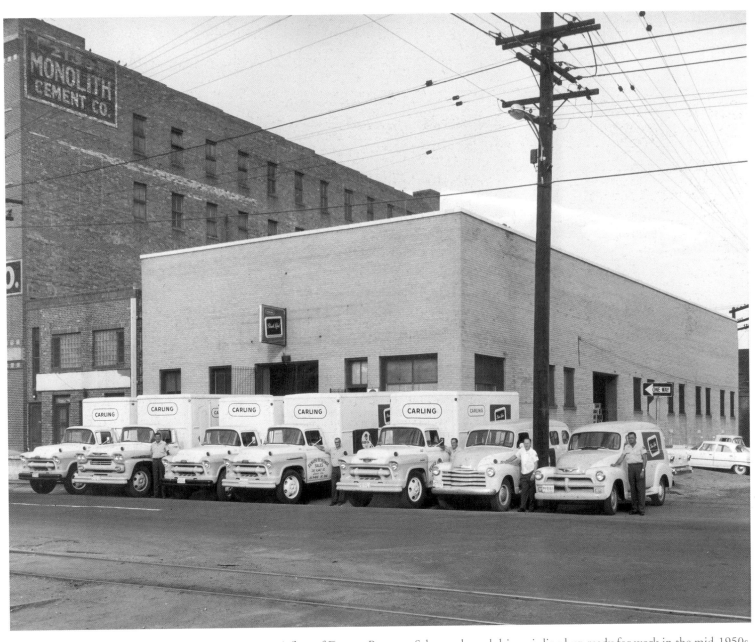

A fleet of Denver Beverage Sales trucks and drivers is lined up ready for work in the mid-1950s.

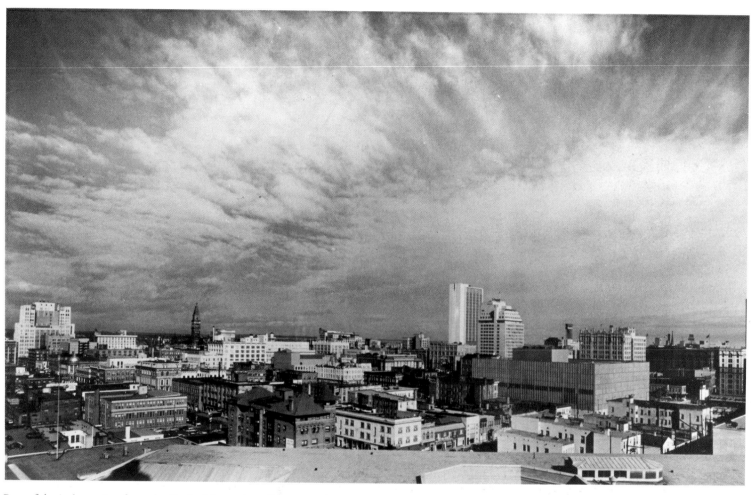

Powerful winds surging from the Rocky Mountains often create dramatic cloud formations over the city.

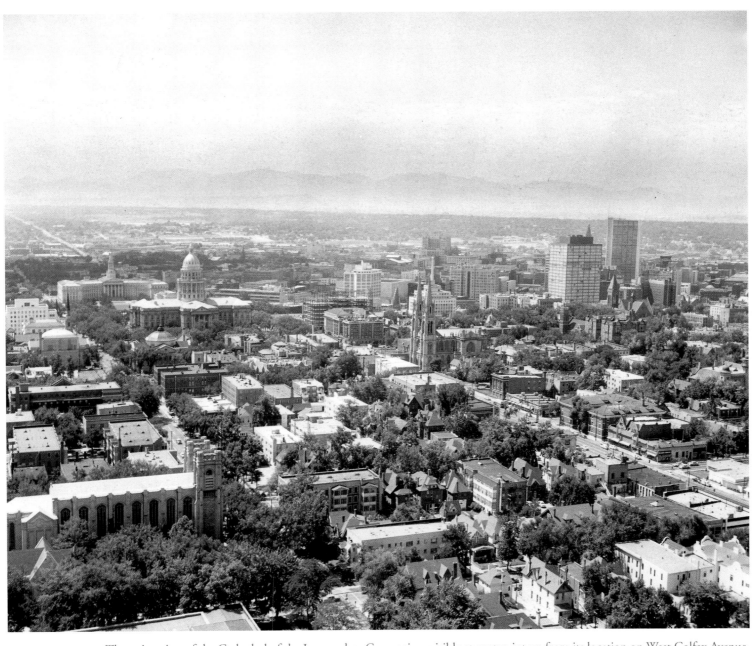

The twin spires of the Cathedral of the Immaculate Conception, visible at center, jut up from its location on West Colfax Avenue.

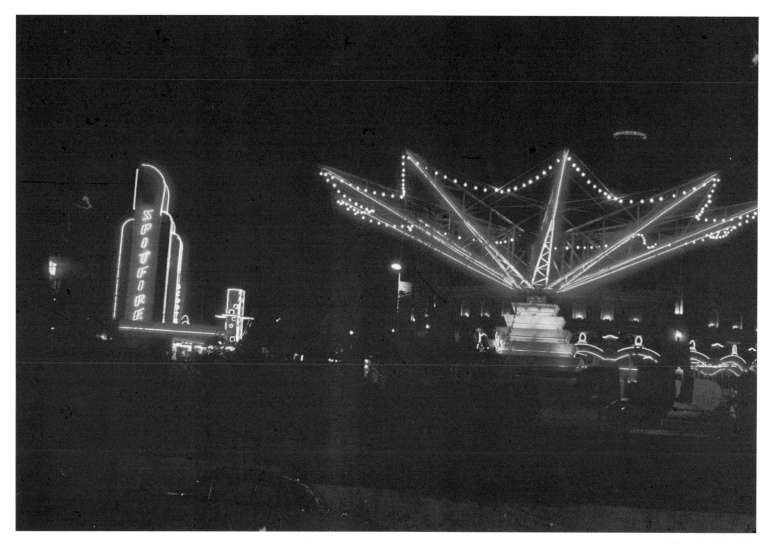

The bright lights and amusement rides of Elitch Gardens offered an exciting and romantic allure for thrill seekers in 1953. The Spitfire Lounge, at left, and Elitch Theatre were also popular attractions. The park, which opened in 1890 on farmland owned by Mary and John Elitch, was a magnet for youngsters and couples from across Denver. It operated for 97 years in the West Highland neighborhood at 38th and Tennyson streets. Located downtown alongside the South Platte River, a new Elitch Gardens continues to offer rides and amusements to the public.

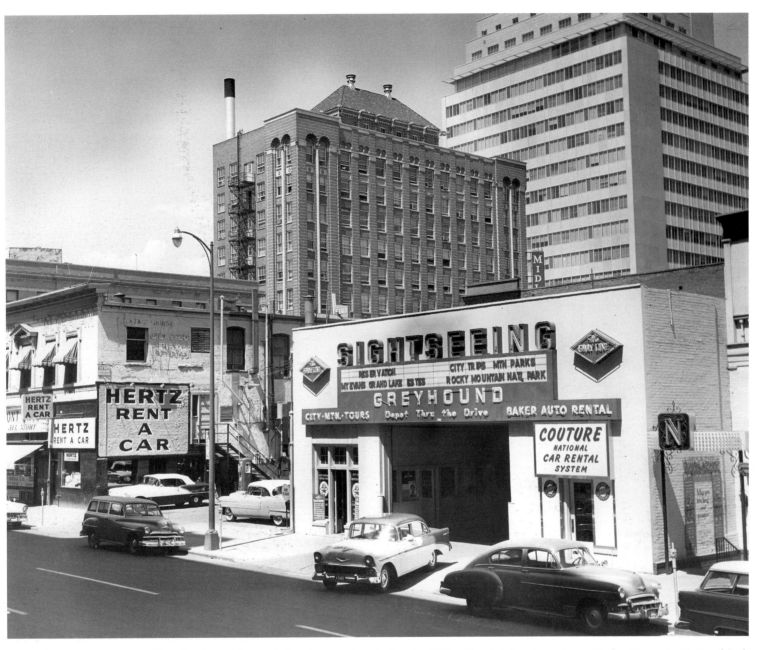

The Greyhound Bus and Gray Line station during the 1950s offered sightseeing trips to Rocky Mountain National Park and other popular destinations.

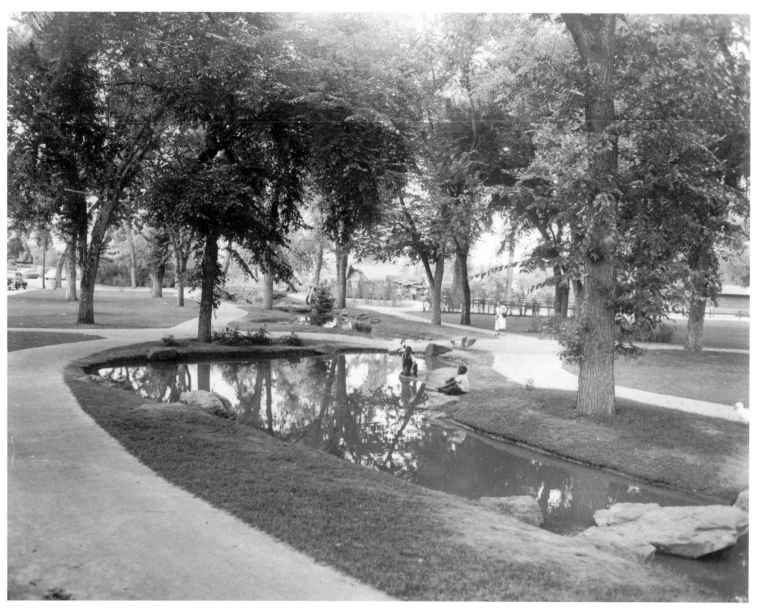

Children play at the edge of a pond in City Park. In the 1950s and 1960s, the park also operated a pony track and a children's farm, visible in the background.

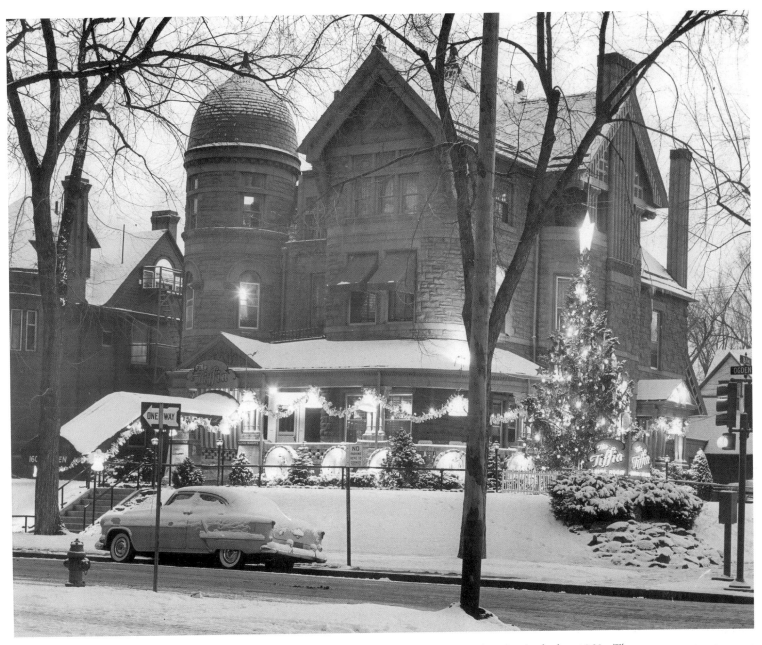

The Tiffin Inn Restaurant at 1600 Ogden Street presents a Christmas postcard setting in the late 1950s. The gray stone structure was built for local businessman George Bailey in 1889 and was long regarded as one of Denver's "great mansions."

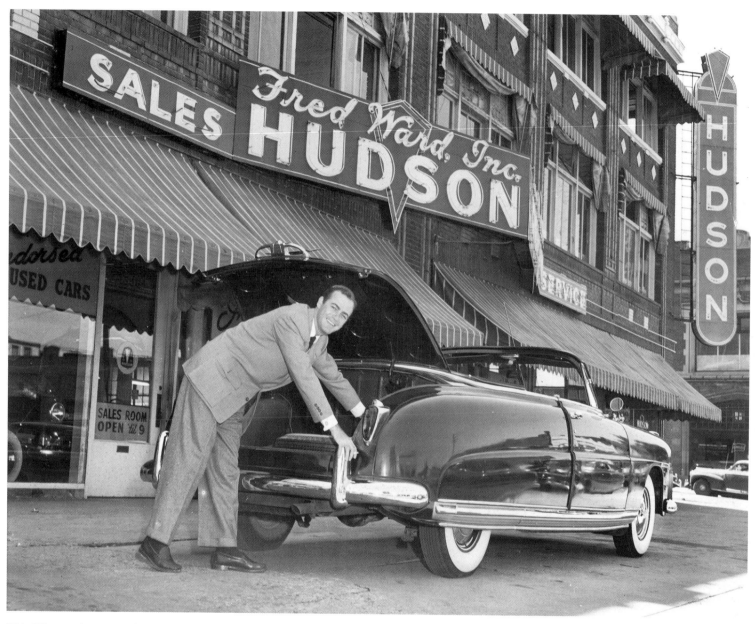

This fellow strikes a proud pose next to a new automobile outside Fred Ward Hudson, once one of Denver's most successful dealerships. Ward was a rotund high-flier who at the height of his career sold Hudsons in seven states. *Time* magazine, in a 1952 profile of the auto dealer, described him as a "200-lb. slicker who could talk a mole out of his hole."

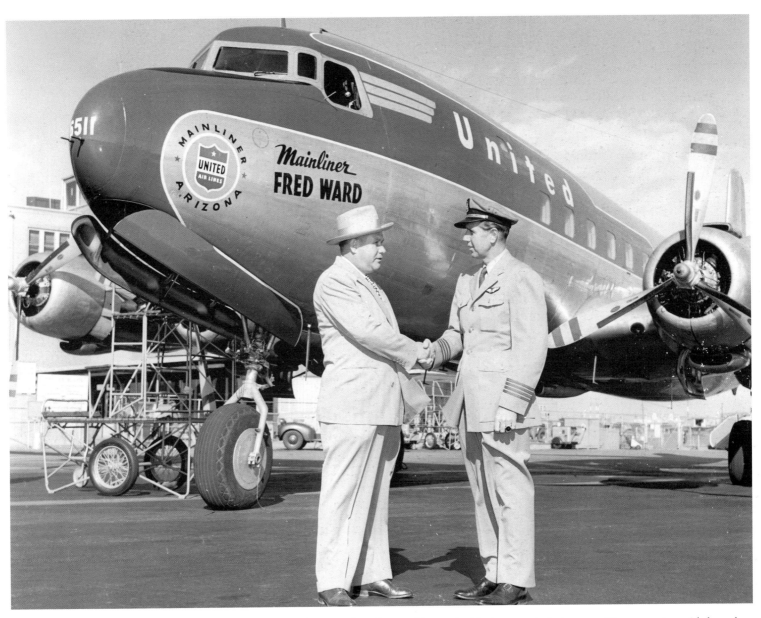

Fred Ward stands with a pilot in front of a United airplane emblazoned with the auto dealer's name. *Time* magazine said that when a guest at one of Ward's famous all-night parties at Hilltop Acres claimed a restaurant in Sante Fe served wonderful pancakes, Ward chartered a plane and flew his friends there for breakfast.

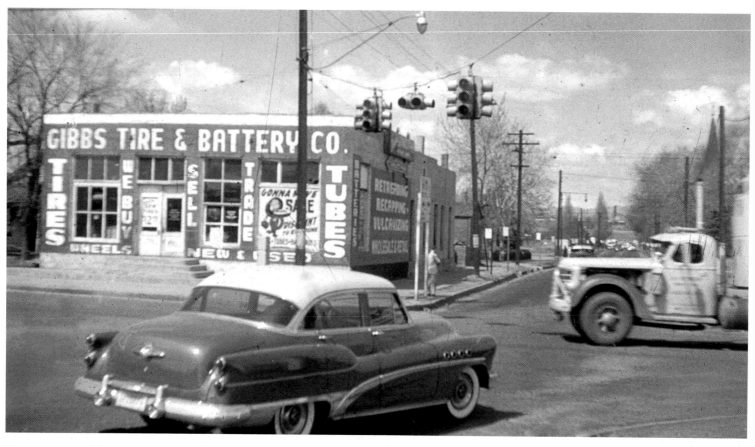

Here in 1953, Gibbs Tire & Battery Company offers tires and tubes at the corner of Washington Street and 46th Avenue in the Globeville neighborhood.

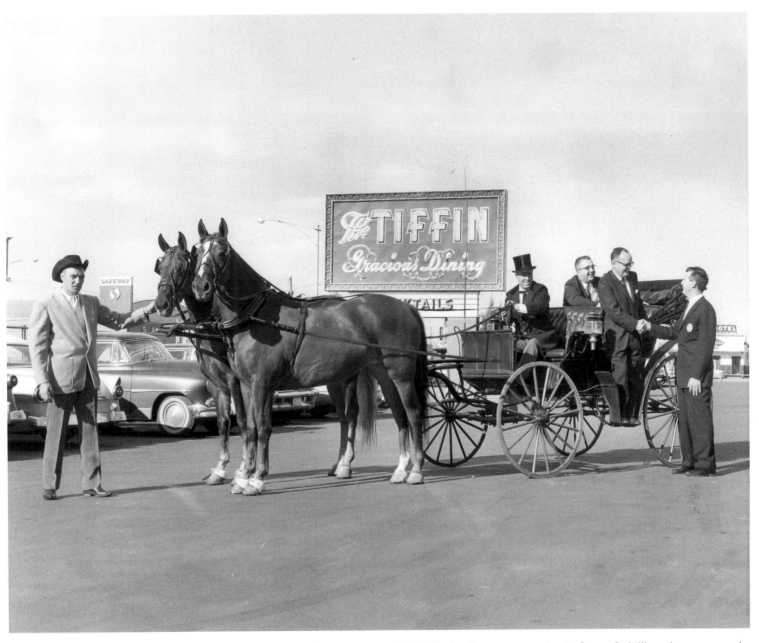

This carriage and team may have been a service of the Tiffin Inn Restaurant, posing in front of a billboard to promote the "gracious dining" offered there.

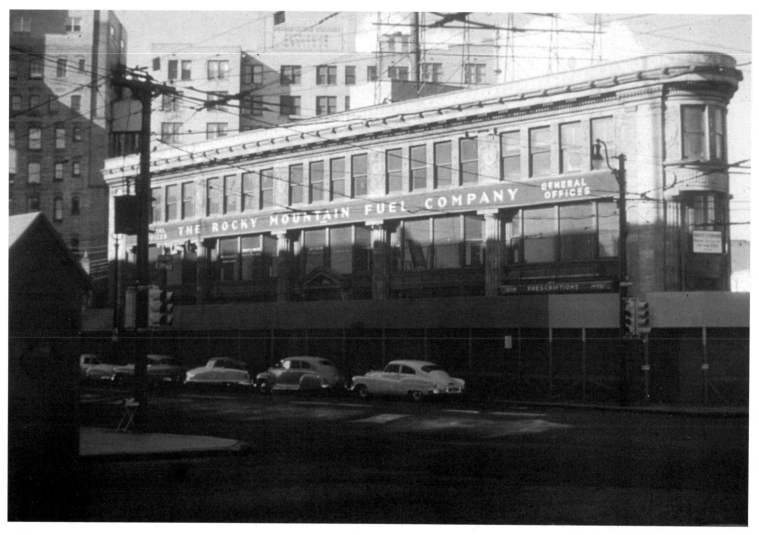

Offices of the Rocky Mountain Fuel Company were housed in the Flatiron Building at 16th and Broadway streets downtown.

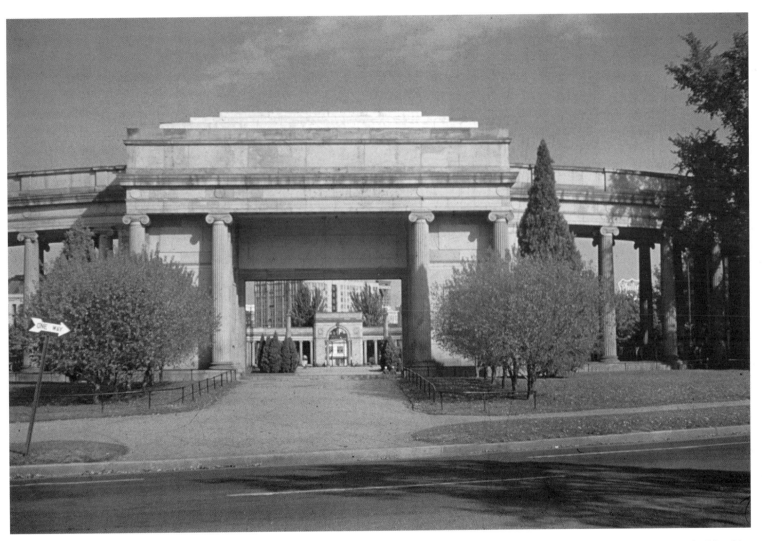

The classic architecture of the Greek Theater and Colonnade of Civic Benefactors and, framed by its entrance, the Voorhies Memorial opposite, form twin gateways into Civic Center. The two portals, both built with Turkey Creek sandstone, mark the south-north axis of the park.

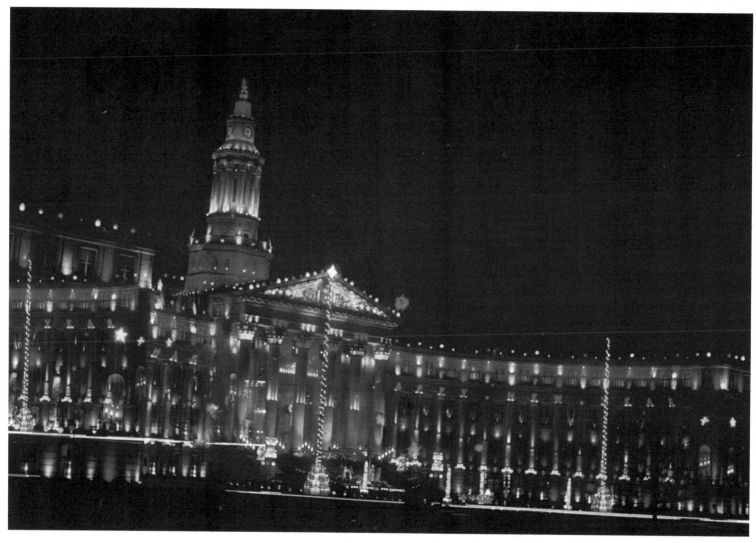

Following tradition, the City and County Building is decorated with a dazzling array of Christmas lights in 1953. And keeping with tradition, the holiday lights remain until the end of the National Western Stock Show in January.

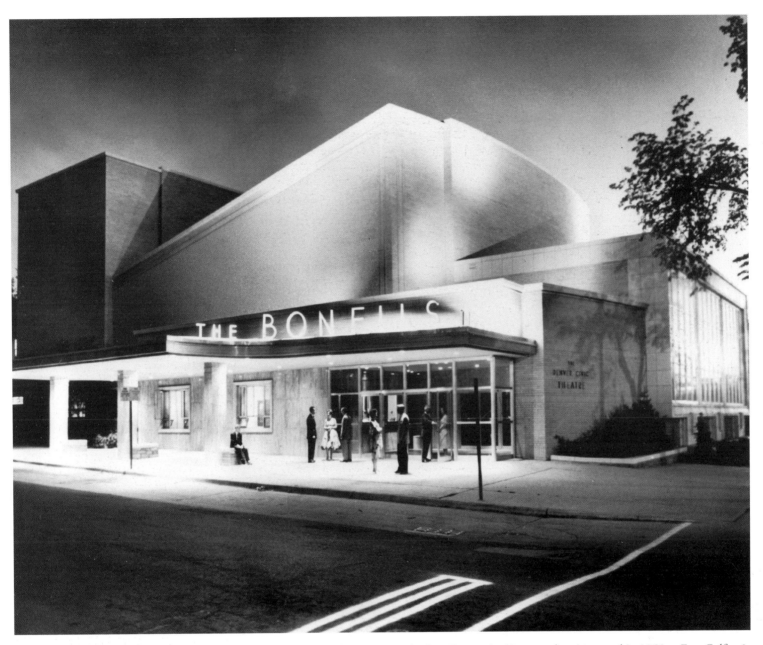

The Bonfils Memorial Theatre became the first new stage built in Denver in 40 years when it opened in 1953 at East Colfax & Elizabeth streets. Helen Bonfils, former publisher of the *Denver Post*, built the flamboyant structure in memory of her parents. It quickly became a magnet for Denver society. Kevin Kline, Paul Winfield, and Julia Child—TV's matron of French cooking— were among the hundreds of entertainers who took the stage.

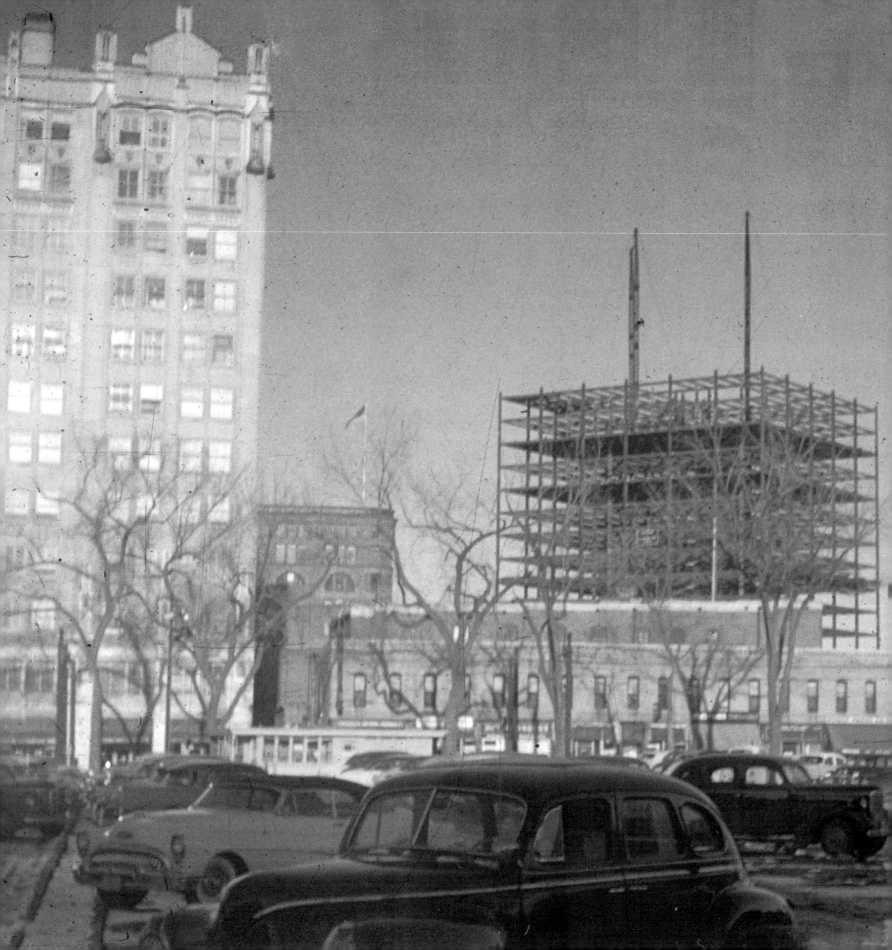

The Mile High Center was a new addition to the tri-corner of Tremont Place, 18th Street and Broadway the day after Christmas, 1953.

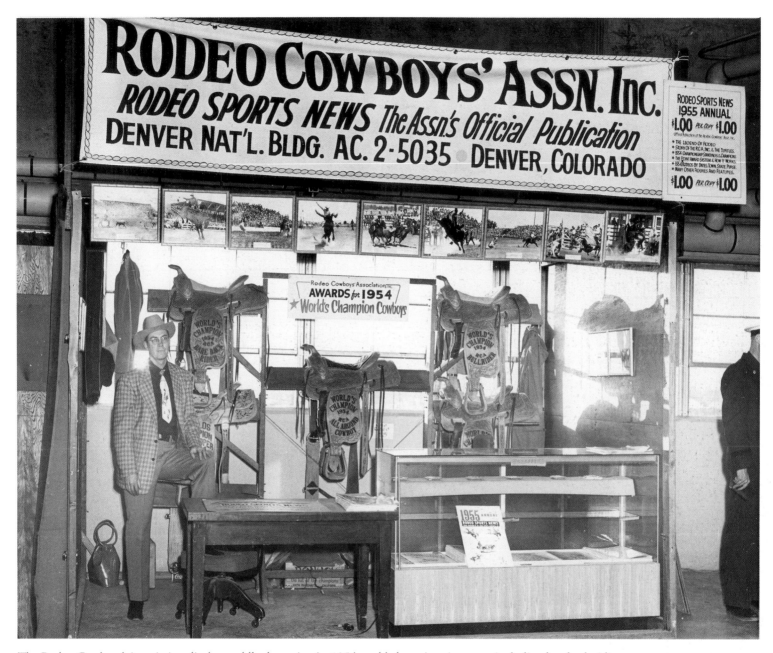

The Rodeo Cowboys' Association displays saddles honoring its 1954 world champions in events including bareback riding, bull riding, and all-around cowboy. This photo was probably taken at the 1955 National Western Stock Show in the Denver Coliseum, which opened only three years before.

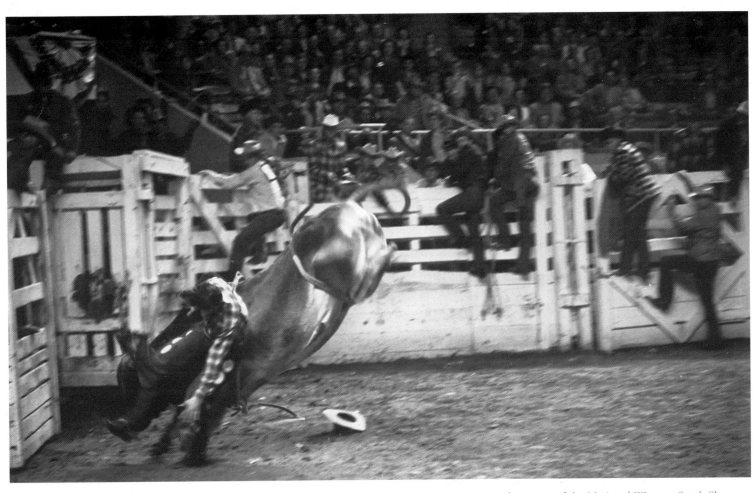

A rodeo bull rider appears to have run out of time and arena during a matinee performance of the National Western Stock Show on January 15, 1954. The stock show has been a major event in the city each year since 1906.

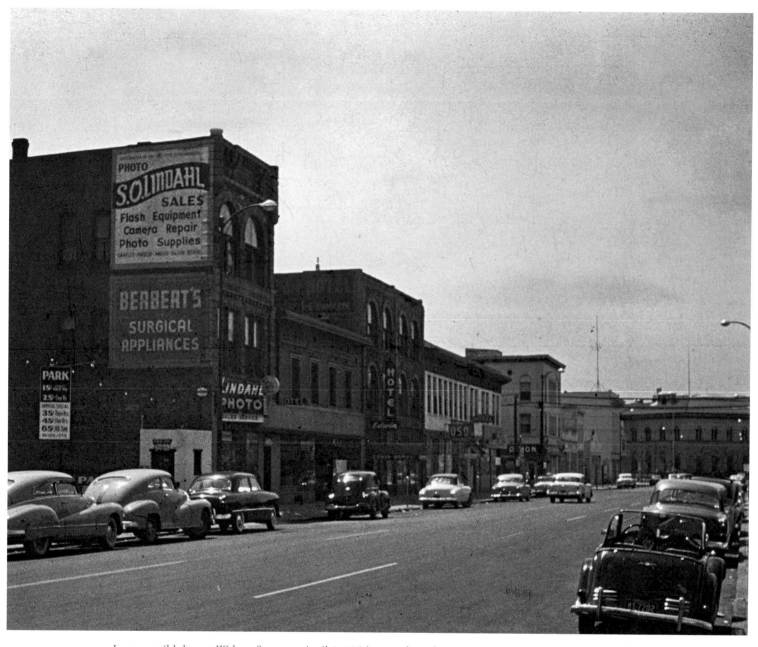

It was a mild day on Welton Street on April 1, 1954, enough so that motorists in convertibles could pull the rag top down. S.O. Lindahl Photo Sales, Berbert's Surgical Appliances, and the USO were open for business.

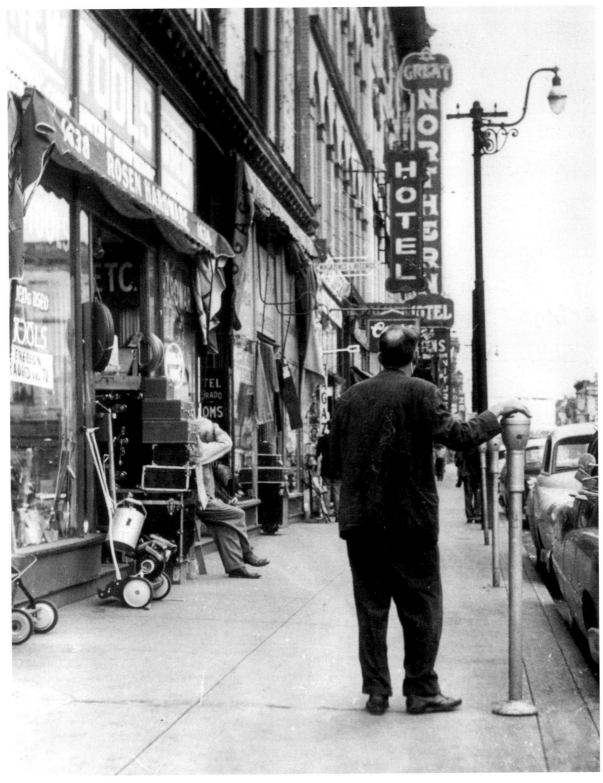

Rosen Hardware at 1638 Larimer Street sold everything from luggage to lawn mowers in 1954. A few doors down, the Great Northern Hotel kept the lights on for boarders.

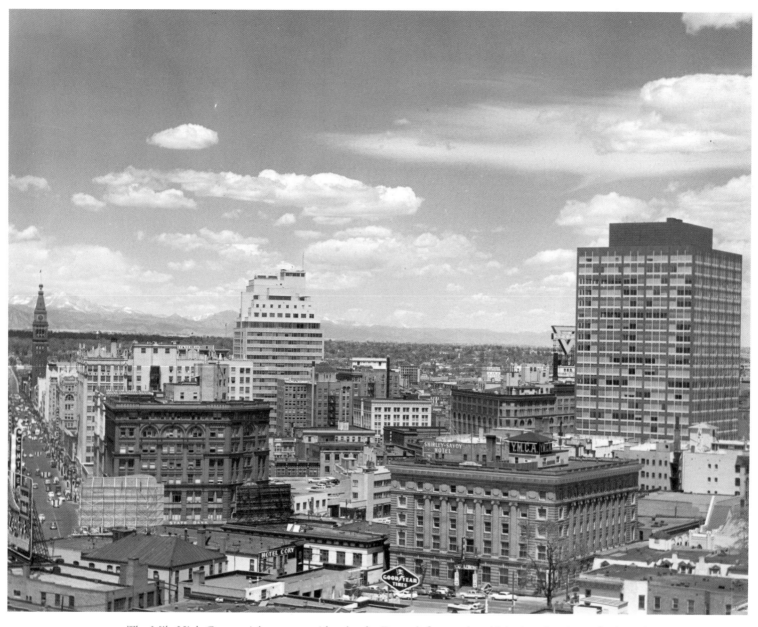

The Mile High Center, right, was considered to be Denver's first modern high-rise when it was built in the mid-1950s. It was designed by architect I. M. Pei, who created numerous well-known downtown structures.

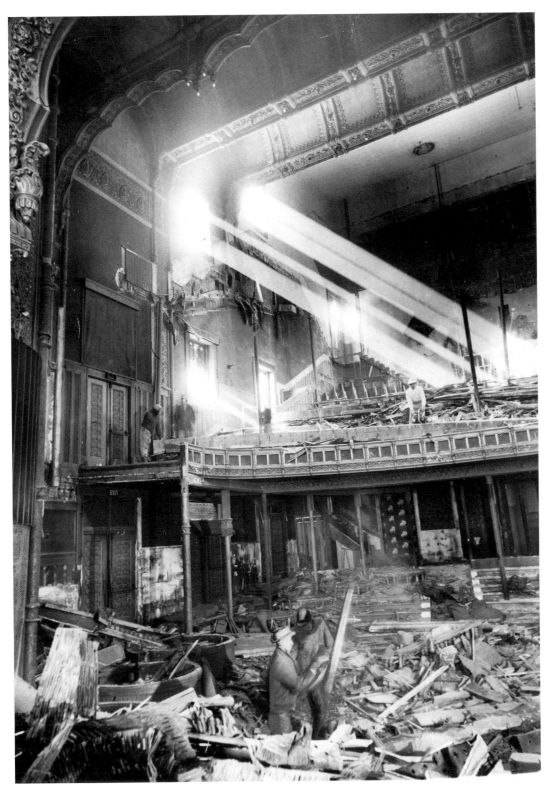

Shafts of sunlight expose the final curtain for the Broadway Theatre at 1756 Broadway as workers go about demolishing the building. Beneath its coffered ceiling and from its wide balcony, fans came to see Al Jolson, Will Rogers, Mae West, and John Barrymore. A new parking garage for the Cosmopolitan Hotel would replace the theater.

Pathways separating carefully groomed flower beds make up the maze of Washington Park in 1955. In the background, the Park Lane Hotel is obscured by maturing trees.

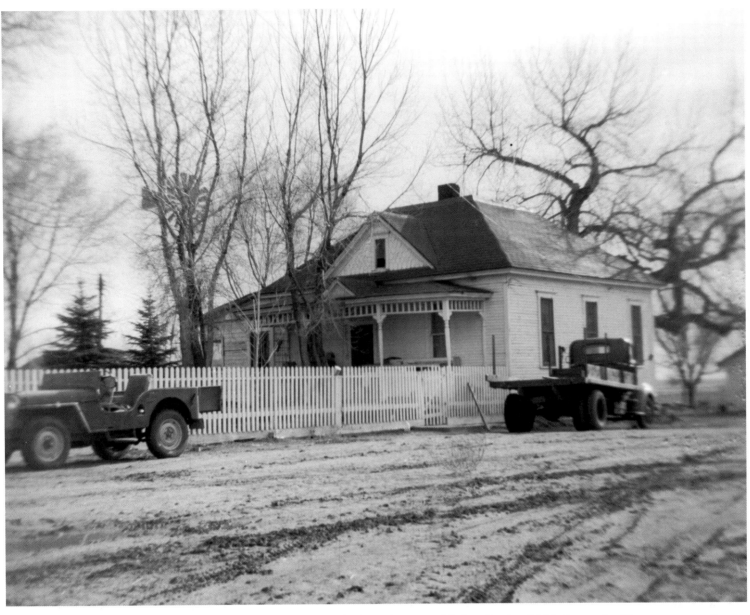

Ray Beierle's family lived in the cottage and worked Beierle Farm at Hudson Road and 96th Avenue for 50 years as tenant farmers under three different landlords. The original negative of this photo, taken in 1955, was found in the Beierle barn.

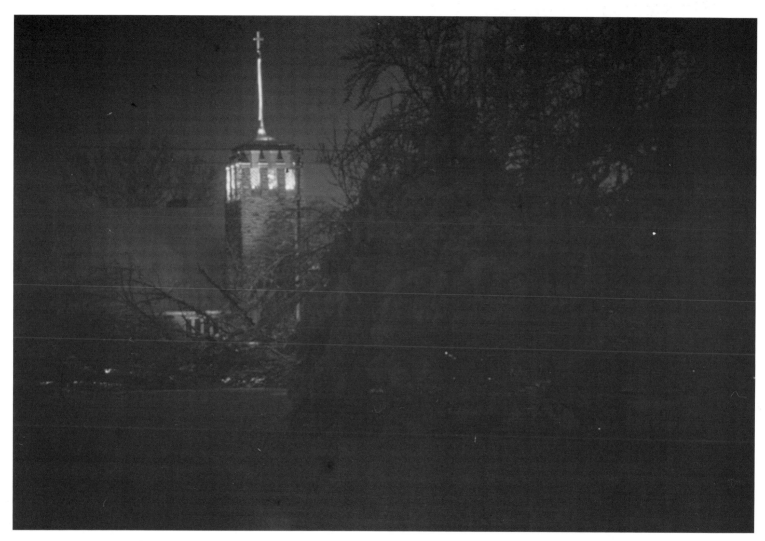

Messiah Lutheran Church at 1750 Colorado Boulevard casts a ghostly glow over the South Park Hill neighborhood.

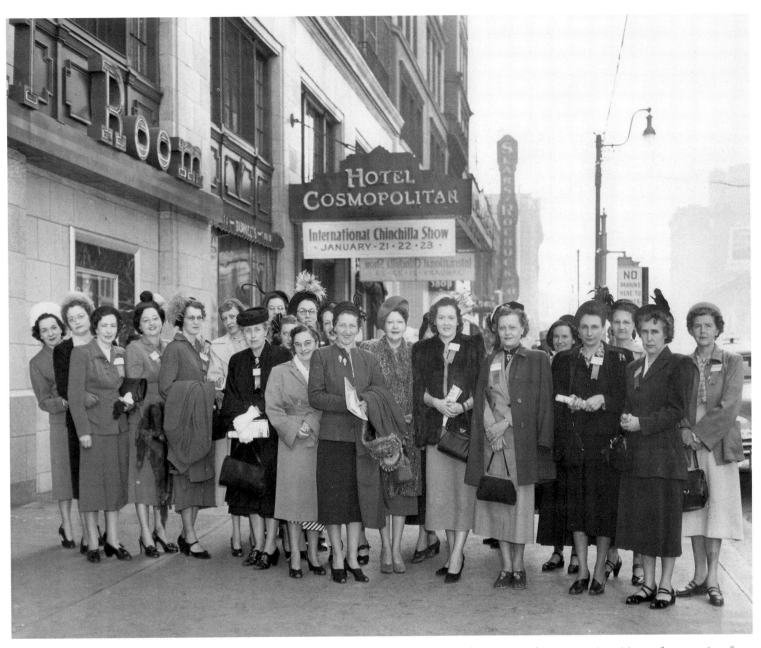

The Cosmopolitan Hotel on 18th Street was one of Denver's most popular meeting places, attracting visitors of every stripe, from aviator Charles Lindbergh to this group of ladies gathered for the International Chinchilla Show during the 1950s. The photo was taken by Ralph Morgan, official photographer for the Cosmopolitan.

Why the International Chinchilla Show chose to meet in Denver is not known. Perhaps it had something to do with this chinchilla farm, operated in the area around the same time. Native to the Andes, chinchilla were introduced into the United States in 1923 and are still raised worldwide as pets and for their fur.

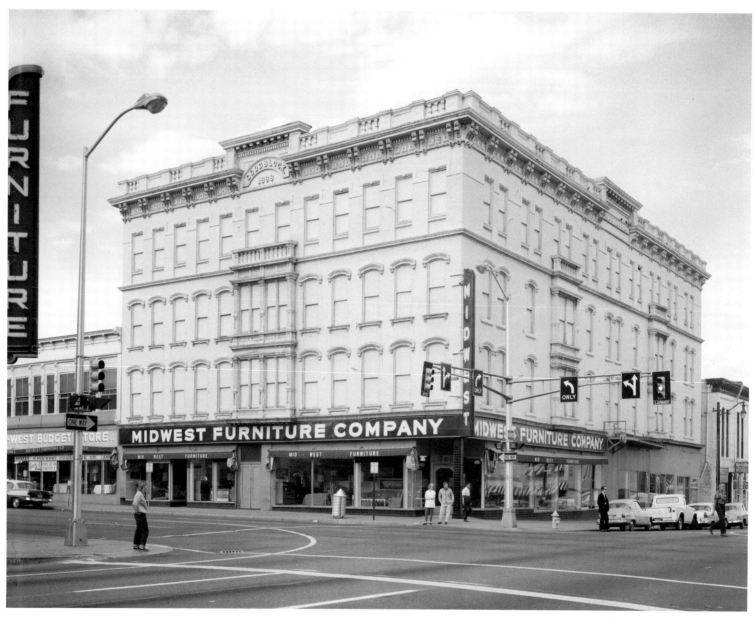

In the 1950s, the Midwest Furniture Company operated in the Goodblock Building at 16th and Larimer streets.

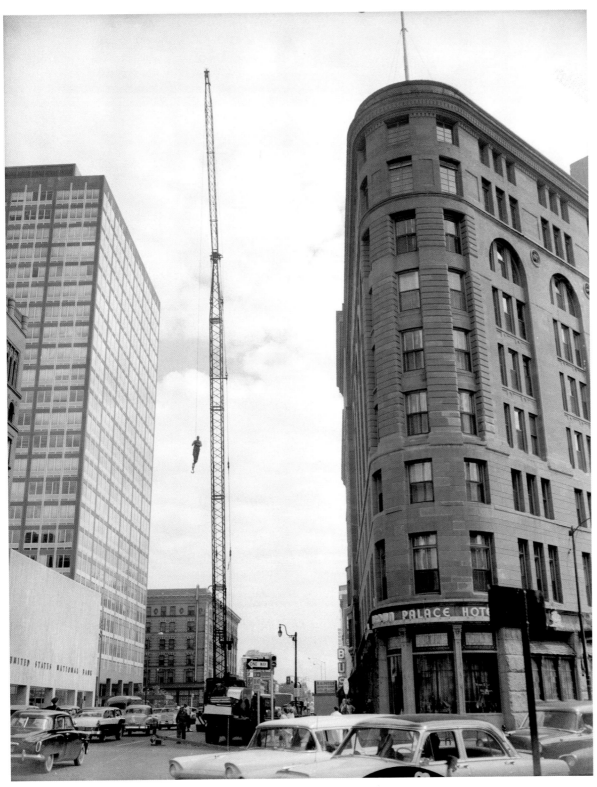

A construction worker rides the crane ball during work outside the Brown Palace Hotel at the tri-corner of Broadway, Tremont Place, and 18th Street.

A group of Continental Air Lines stewardesses—as they were still called in 1956—mark their graduation. Denver was the early headquarters for Bob Six's innovative air carrier, and remained so through the early 1970s. It is possible the "22" displayed by the stewardesses celebrated a significant expansion by the airlines into 22 smaller cities, which had taken place sometime earlier.

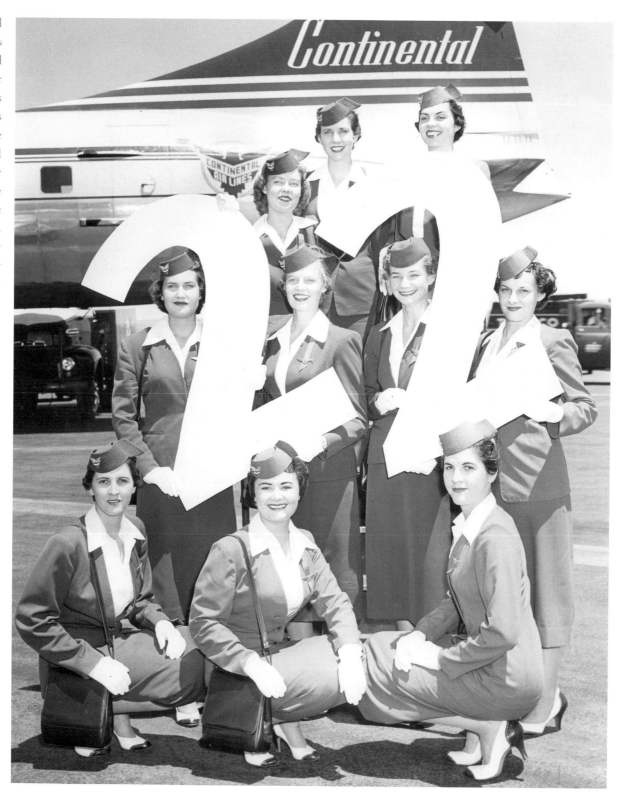

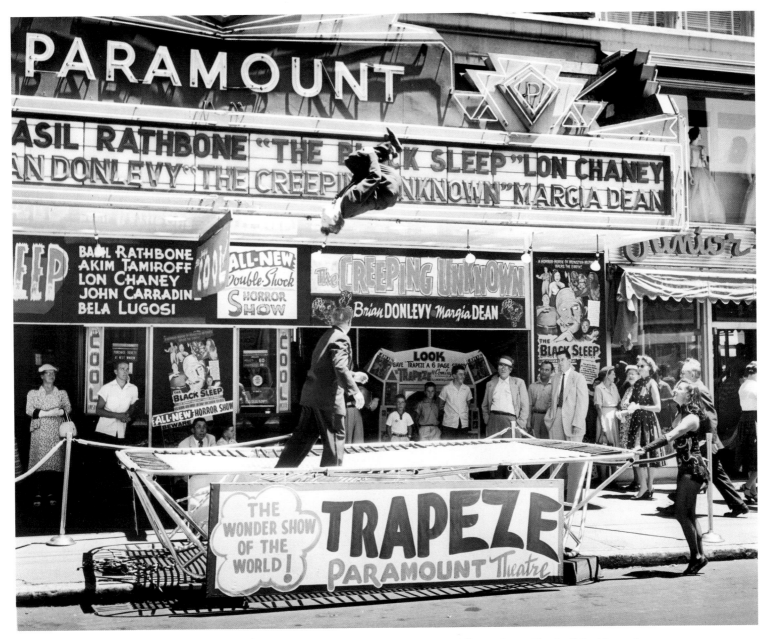

The Paramount Theatre at 16th and Glenarm streets showed first-run movies with big Hollywood stars like Basil Rathbone, Lon Chaney, and Bela Lugosi. But on a mild summer day, such as here on August 18, 1956, the theater wasn't above clowning it up with a sidewalk trampoline stunt to attract customers.

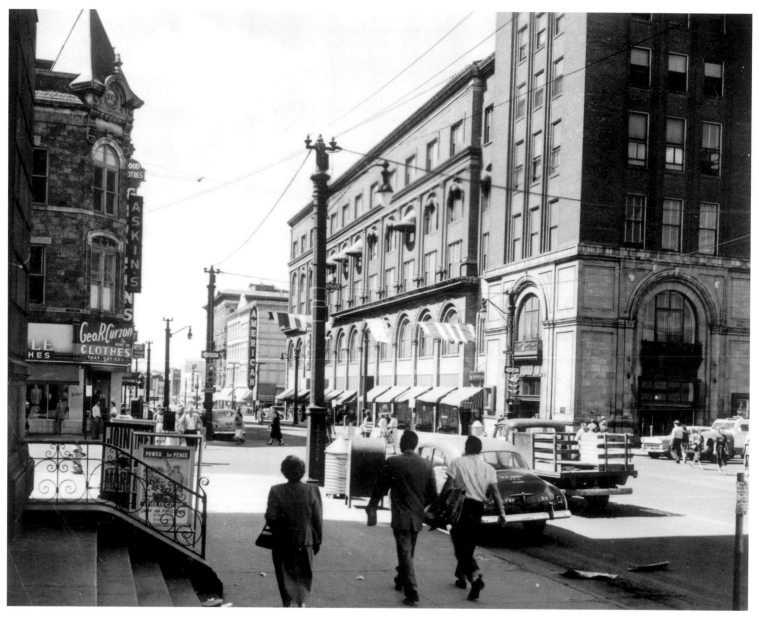

This 1957 photo of the Daniels & Fisher department store cuts off the building's most recognizable feature—its tower, which anchored the corner of 16th and Arapahoe streets. It was about this time that the May Company bought out Daniels & Fisher, whereupon the building and tower sat vacant for many years.

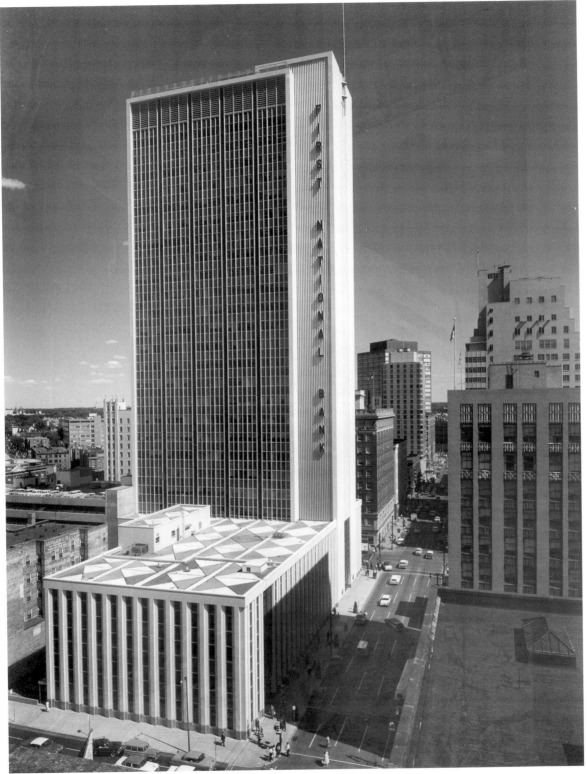

When the 28-story First National Bank building was completed in 1957, it became the tallest structure built in Denver in the 1950s. Its distinctively sleek tower still stands today at 621 17th Street.

Civic Center is the only interruption to Colfax Avenue, which stretches the breadth of the city from west to east. This 1957 aerial view to the east captures numerous civic landmarks, starting at bottom with the roof of the United States Mint, the City and County Building, Civic Center Park, the State Capitol, and Cathedral of the Immaculate Conception left of the capitol.

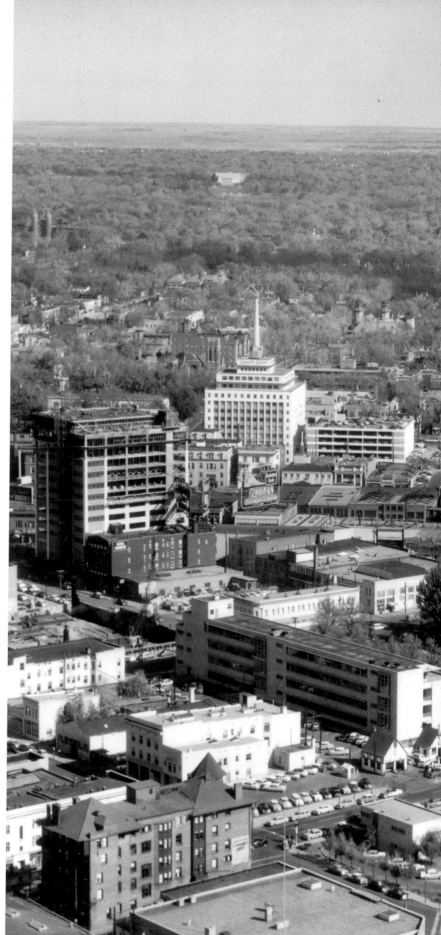

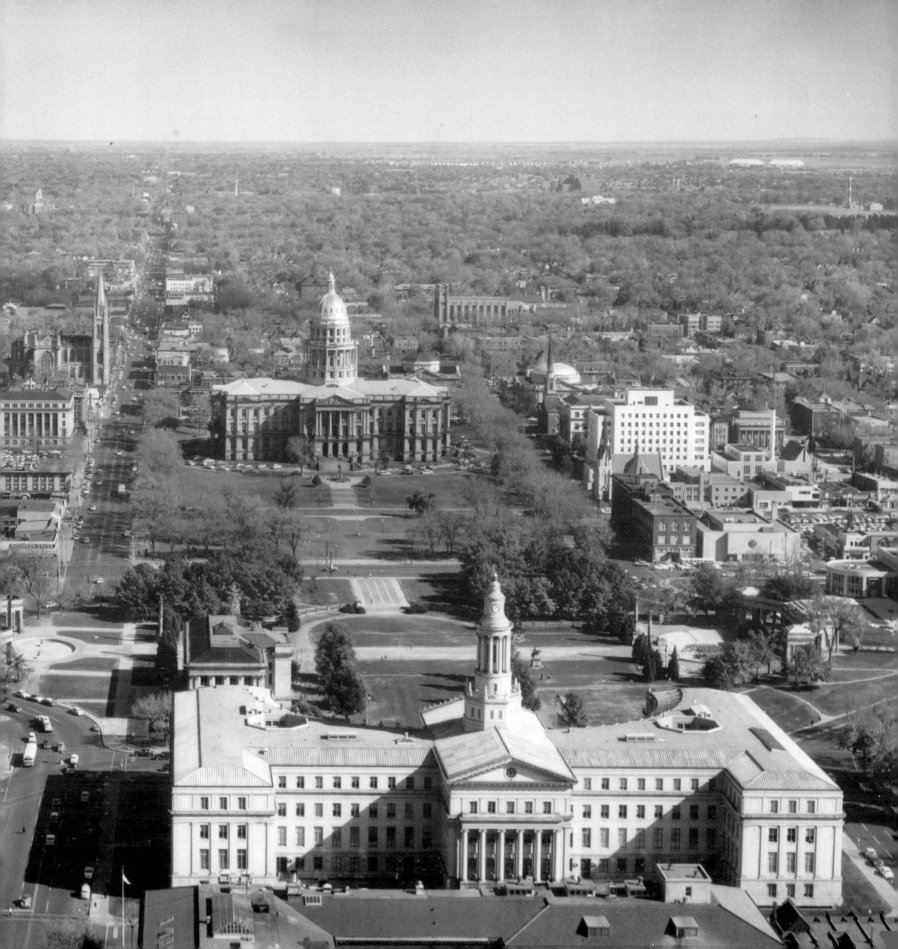

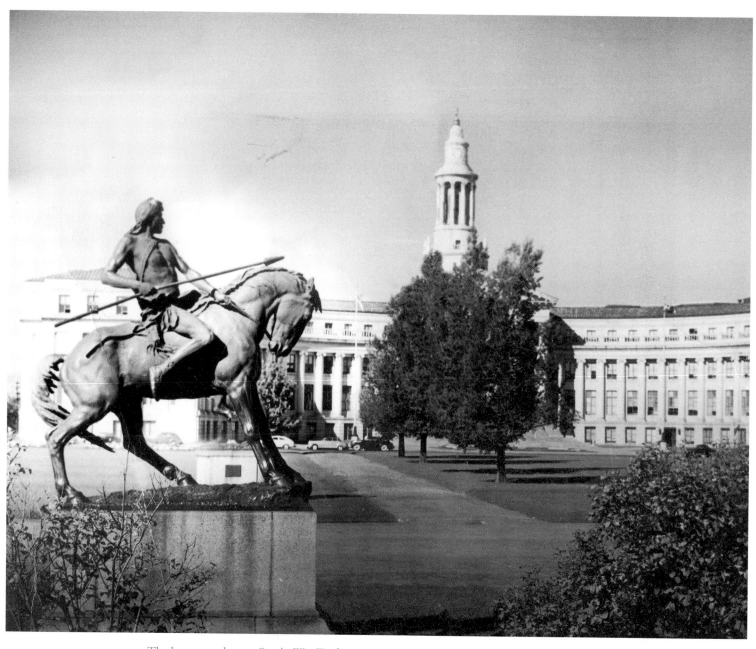

The bronze sculpture *On the War Trail* in Civic Center Park was donated to the city by sculptor Stephen Knight in 1922.

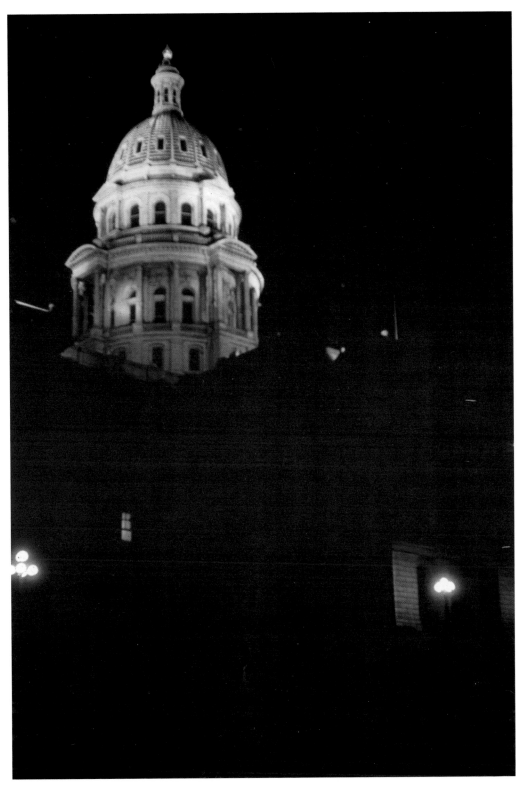

The State Capitol is lighted at night to enhance its dome—plated with real gold to commemorate Colorado's gold rush heritage of the late 1850s and early 1860s. Even though the cornerstone for the capitol was set in 1890, the gold plate wasn't added until 18 years later.

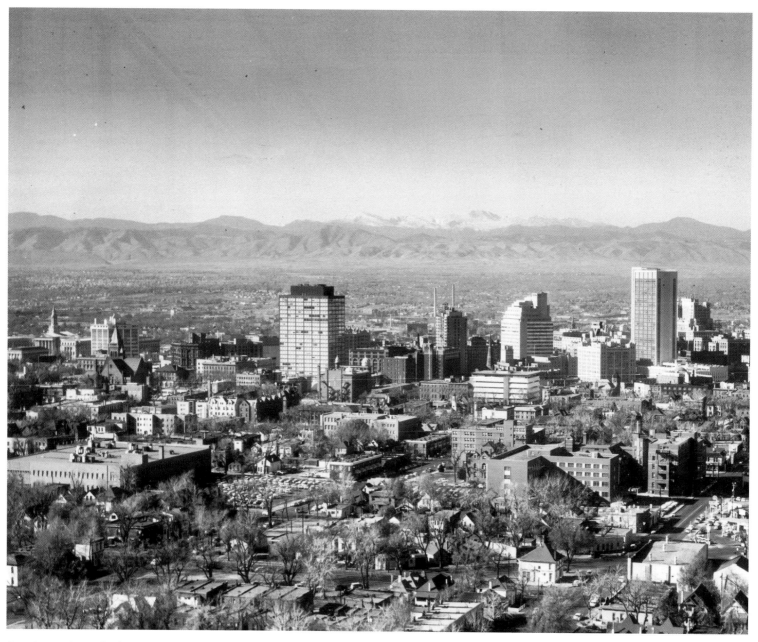

A 1958 aerial view looks across Denver from about 22nd and Downing streets all the way to 14,240-foot Mount Evans, the summit of which can be reached driving on the highest paved road in America.

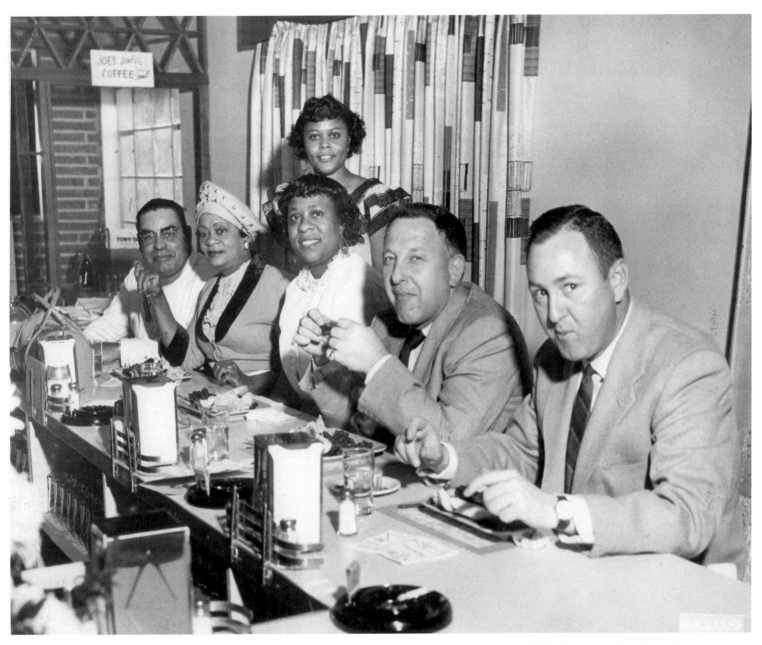

A group of businessmen and women, including Fannie Mae Duncan, seated at middle, share a meal in a local diner. Duncan is credited with helping to desegregate the city of Colorado Springs in the 1950s and 1960s when she opened the Cotton Club and brought the jazz greats of that era to town. Next to her is Aniece Smith, seated, and Salina Bragg, standing.

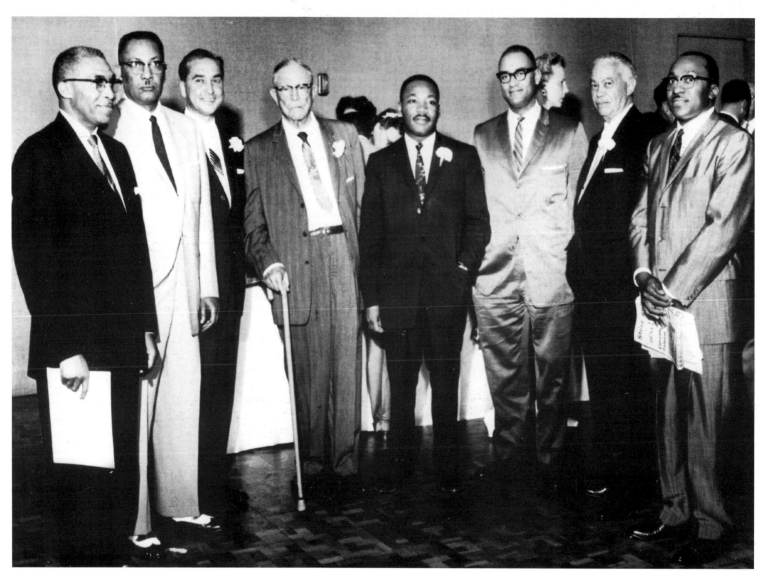

Dr. Martin Luther King, Jr., was the center of attention as the guest of honor of the International Opportunity Life Insurance Company in Denver on July 14, 1959. King visited Denver often and was friends with a number of local ministers.

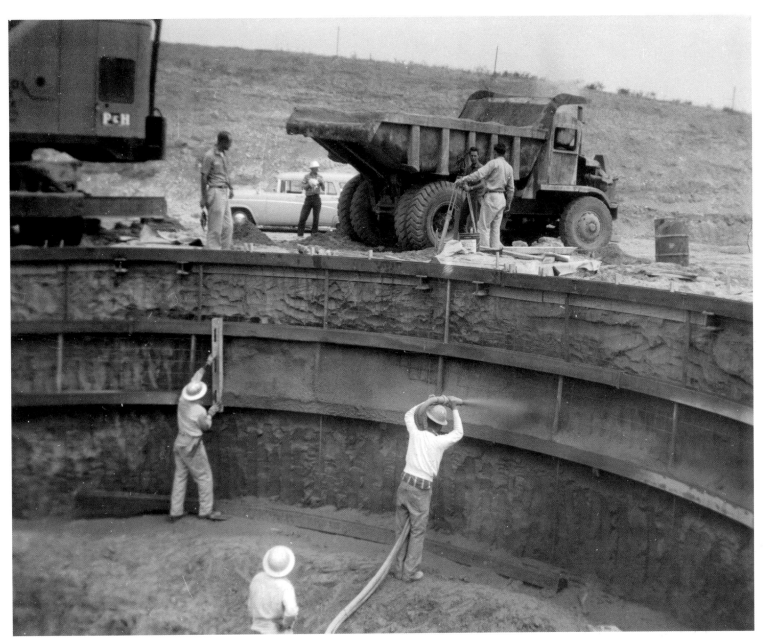

Workers construct the hard base for the test site of the Martin Company's Titan missile at Lowry Air Base in 1959.

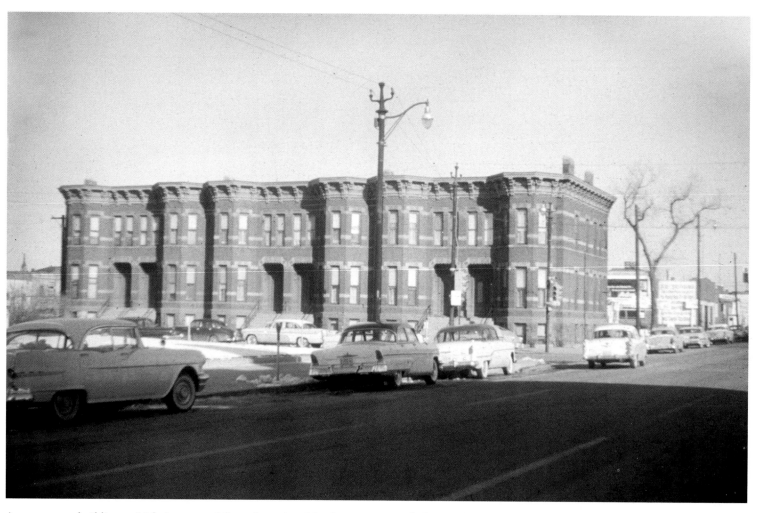

An apartment building at 18th Avenue and Stout Street in 1959. Stout was named after Elisha P. Stout, a founder of Denver City and the first president of the Denver Town Company.

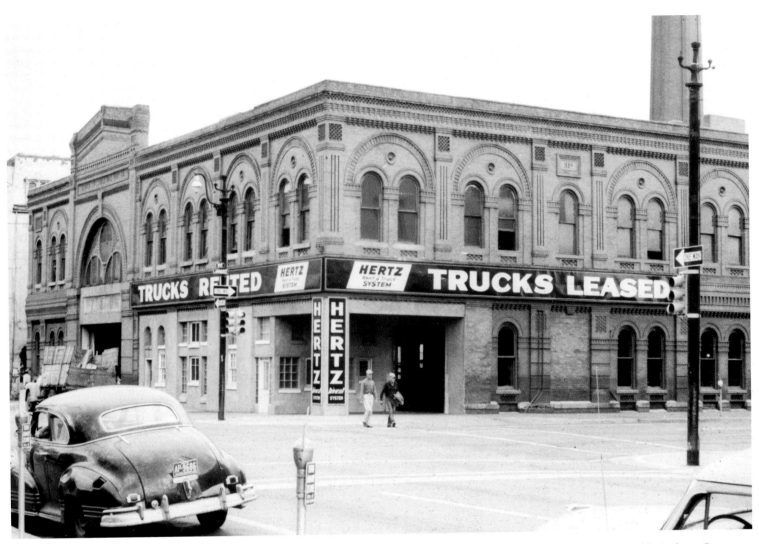

This building at the corner of 18th and Lawrence streets in 1959 was once home to the Denver City Cable Railway Company. Hertz was now operating here.

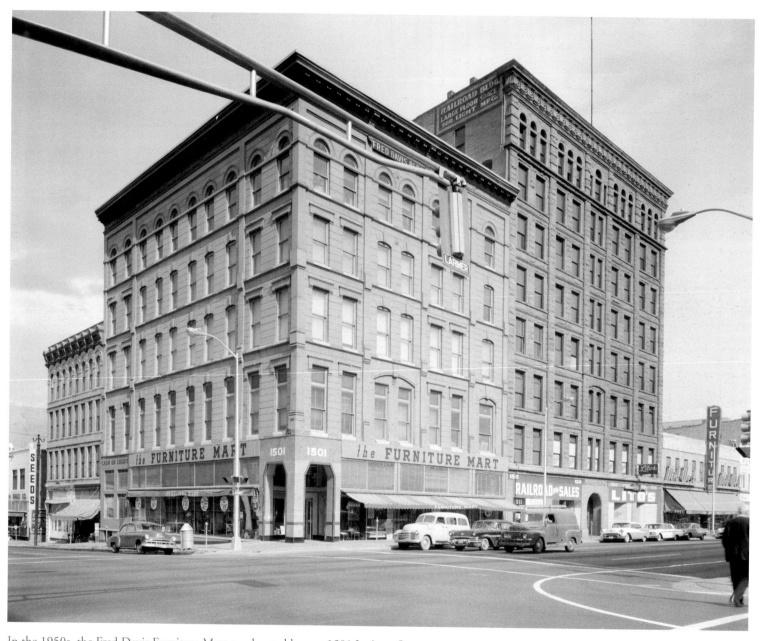

In the 1950s, the Fred Davis Furniture Mart was located here at 1501 Larimer Street.

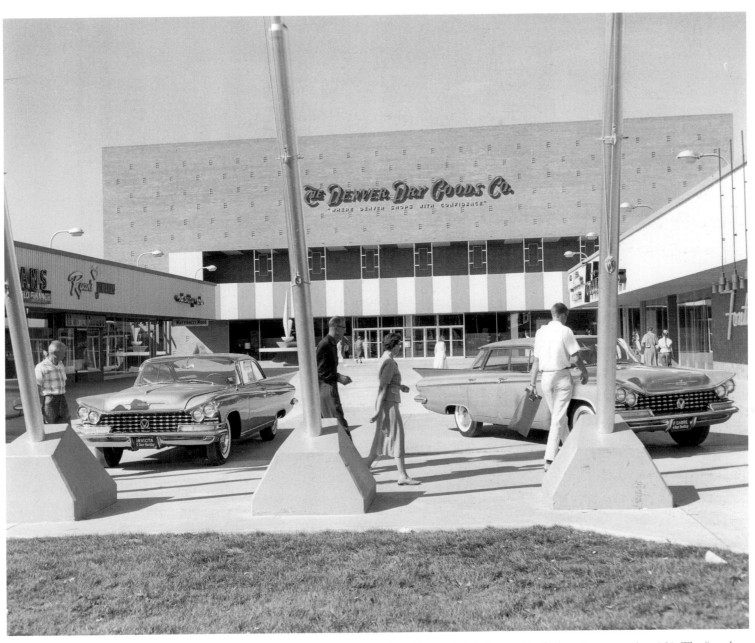

The Denver Dry Goods Company department store anchored the original Cherry Creek shopping center in 1959. The "outdoor mall" continued the increasingly popular trend toward clustered shopping. In the pedestrian court, these 1959 Invictas, Buick's contribution to the roll call of quirky automobile designs, are drawing glances from shoppers.

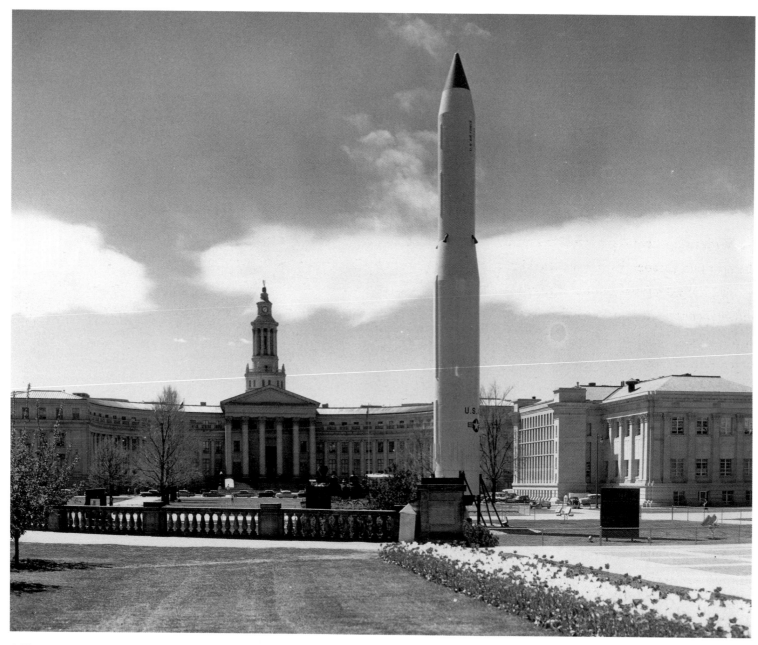

A Titan intercontinental ballistic missile seems slightly out of place in the middle of Civic Center Park across from the City and County Building. The missile was placed on display in 1959 by its builder, the Martin Company of Denver, to celebrate Colorado's Centennial. Only a few years later, ICBMs would become key chess pieces when the U.S. faced the Cuban missile crisis.

GROWING PAINS

(1960–1969)

With its boisterous growth and a revitalized infrastructure, Denver appeared now to know what it wanted to be. Over the next two decades, its citizens would be reminded that a great city also needed to shape *who* it wanted to be.

Ironically, Denver's success in rebuilding itself contributed to some conditions that threatened to become new obstacles and challenges. Government Urban Renewal projects changed the city's landscape. But along with the buildings it knocked down, it also bulldozed the lives of some of its less fortunate residents. An already sizable Hispanic population grew even larger. And louder. New-old social causes sparked a host of marches and protests demanding a better quality of life. A former local professional boxer named Rodolfo "Corky" Gonzales rose in stature as a leader and formed a rallying point for his people, Crusade for Justice. The city's African-American population already felt disfranchised, and confrontations with police increased and intensified. The American Indian Movement and other social causes also attracted attention and supporters.

Automobile traffic seemed to overflow its concrete and asphalt banks as quickly as roads could be built. When the first interstate, I-25 or the Valley Highway, bisected the city from north to south, and soon after Interstate 70 crossed it east to west, veteran radio traffic reporter Don Martin observed that the intersection "reminded me of one of those mazes used for mice." It would be cursed as the Denver Mousetrap for years to come. Traffic also caused the return of an age-old city scourge—air pollution. It wasn't long before Denver's "brown cloud" earned a national reputation second only to that of Los Angeles.

In June 1965, after two days of constant rain, the South Platte River began to flood the city. Three days later the deluge left behind the costliest disaster in Colorado history—21 deaths and more than $100 million in damage.

A drumbeat of death that began with the assassination of President John F. Kennedy in 1963 seemed relentless. Dr. Martin Luther King, Jr., was killed in 1968, and Senator Robert Kennedy fell to yet another assassin only two months later. Denver's citizens, hearing the news, each time gathered around black-and-white televisions, sometimes in downtown department stores, to watch in disbelief.

The city continued to grow. But with each new challenge, it seemed to veer in a different direction.

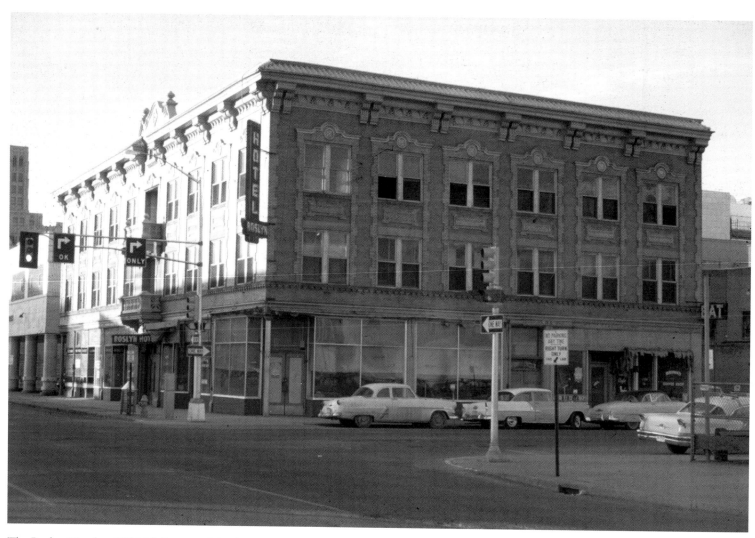

The Roslyn Hotel at 607 14th Street on March 20, 1960. Around the corner in the same building, Browns Coffee Shop advertised its presence on a storefront window.

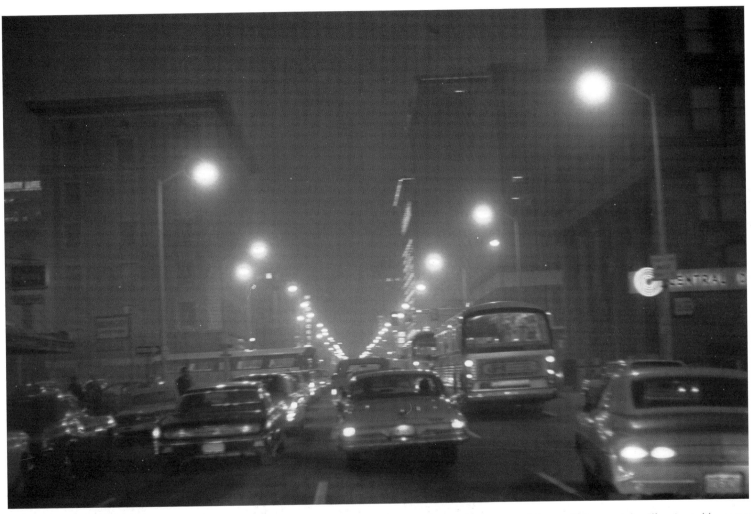

The Denver Gas & Electric Building on the right side of 15th Street competes with streetlights at night. Illuminated by some 13,000 light bulbs, the building at 15th and Champa streets was a distinctive landmark downtown in 1953.

The bronze sculpture *Grizzly's Last Stand* was created by Louis Paul Jonas for City Park. It depicts a bear sow protecting her two cubs.

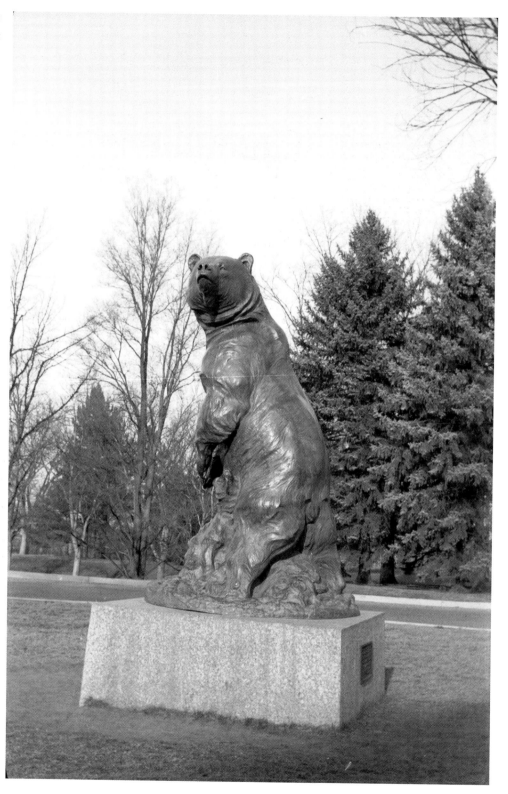

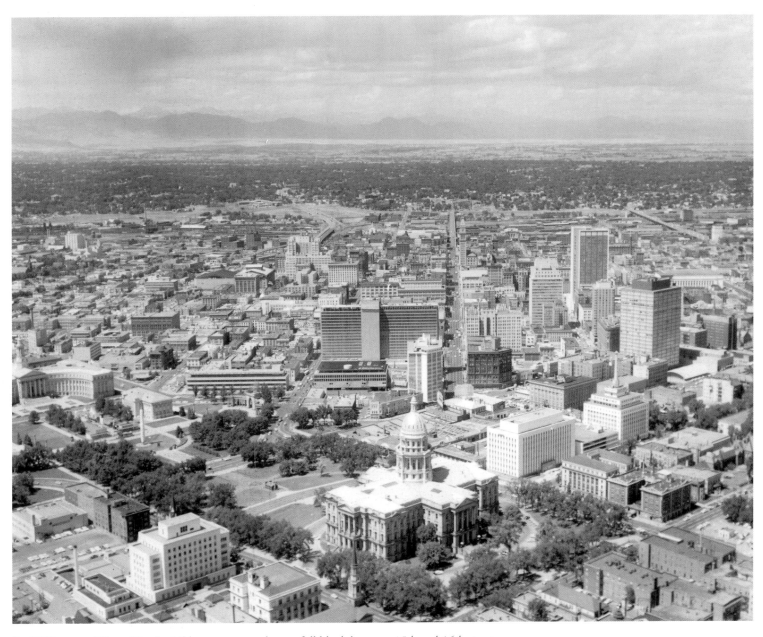

By 1960, a new Hilton Hotel, visible at center, took up a full block between 15th and 16th streets.

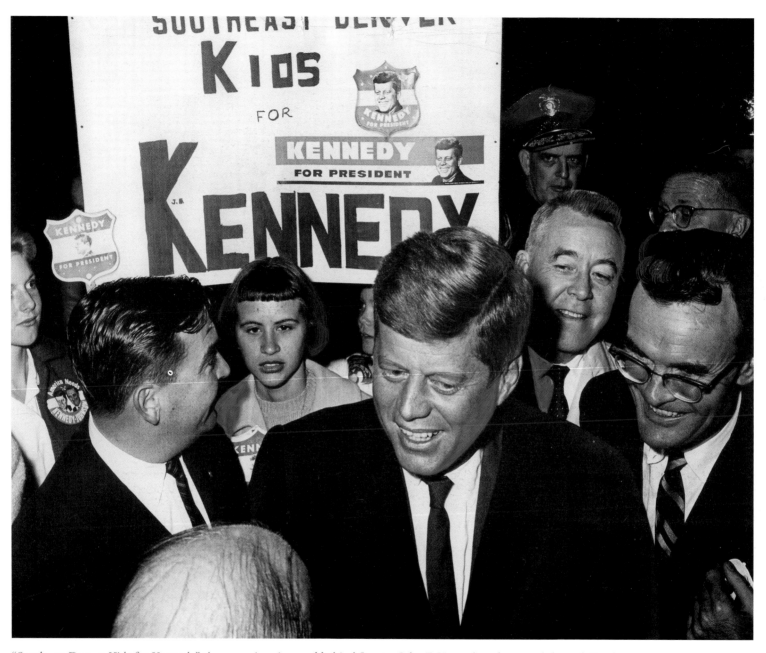

"Southeast Denver Kids for Kennedy" the campaign sign read behind Senator John F. Kennedy as he passed through Stapleton Airfield on September 22, 1960. JFK was escorted by Senator John Carroll, behind him, and Lawrence Henry, at right, a Democratic national committeeman from Colorado.

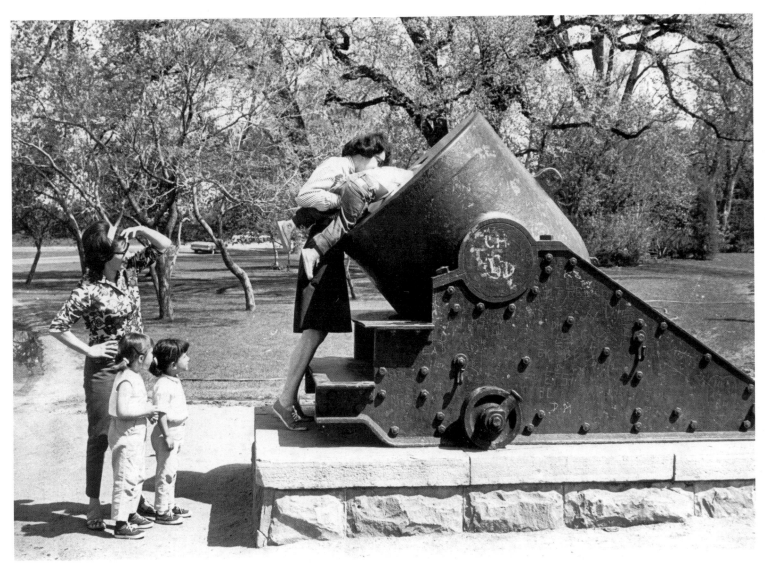

A woman helps a curious youngster achieve just the right view of an old siege mortar mounted and graffiti-scrawled in City Park in 1964.

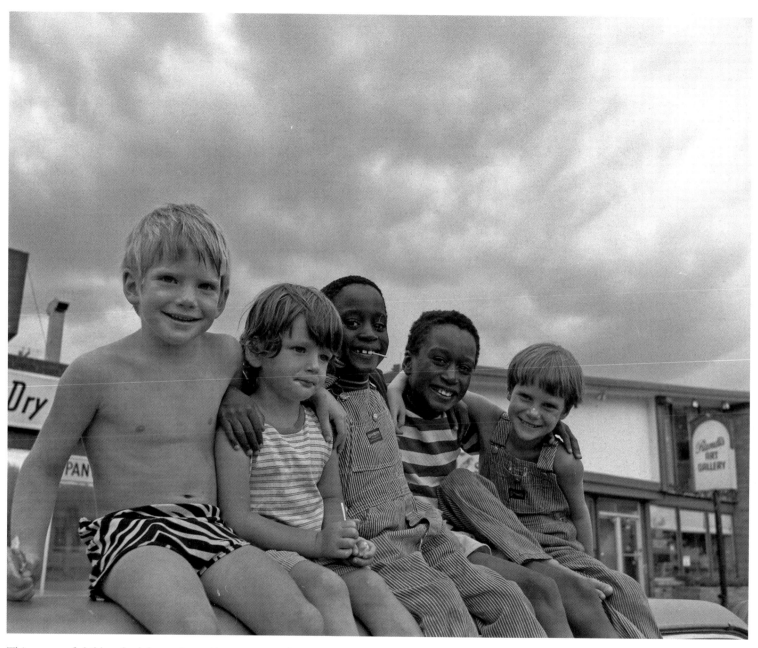

This group of children look happy just to hang out together.

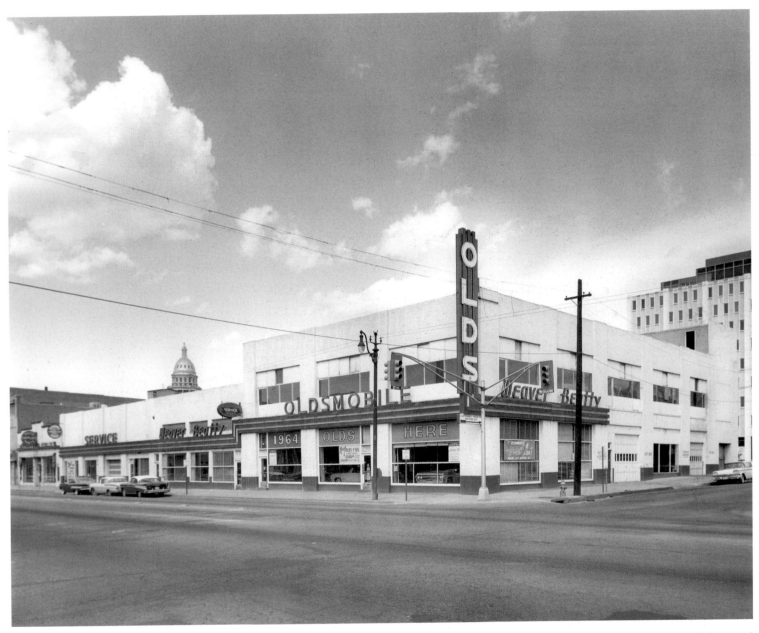

Weaver Beatty Oldsmobile still carried the name of its founder, Roy Weaver, in 1964. But by then the Denver automobile mogul
was in failing health and had sold the dealership. His sons-in-law assumed ownership of Weaver's other Oldsmobile dealerships.
One of them, Ralph Schomp, carried on the legacy of the Denver automobile dynasty.

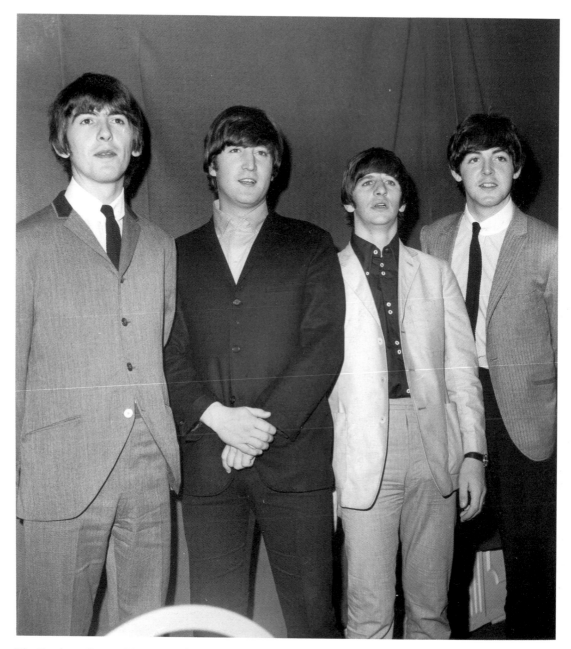

The Beatles—George Harrison, John Lennon, Ringo Starr, and Paul McCartney—made only one appearance as a group in Denver, at Red Rocks Amphitheatre in 1964 before more than 9,000 screaming fans. Tickets sold for $6.50 to see the group that led the "British invasion" into the United States and changed the pop music world.

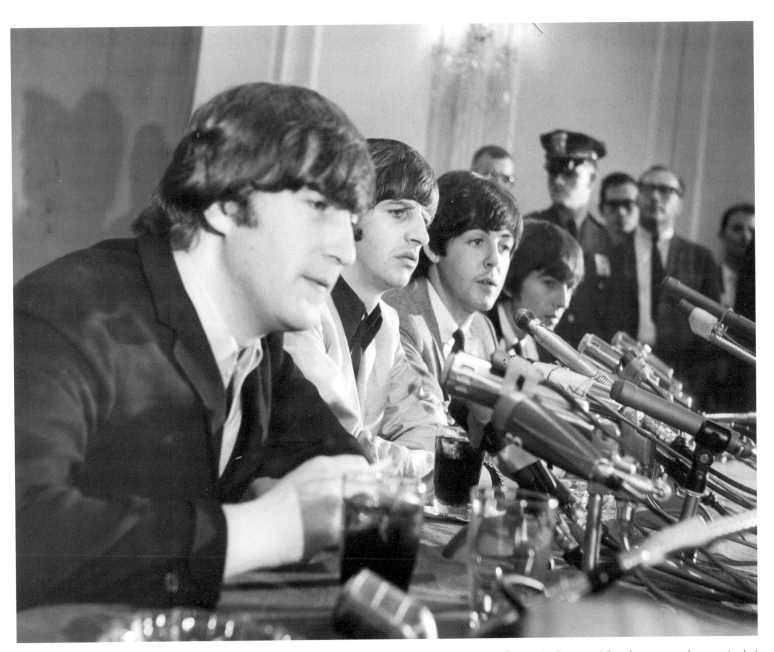

Beatles drummer Ringo Starr appears puzzled by a question at a press conference in Denver. After the concert, he was singled out in the review by the *Rocky Mountain News,* which stated, "The unsung hero of the group is Ringo Starr, the hard-working drummer-boy. . . . About the only untoward event, if it was that, was the intermittent shower of jelly beans which the crowd threw onstage. But, undaunted, the British foursome played on."

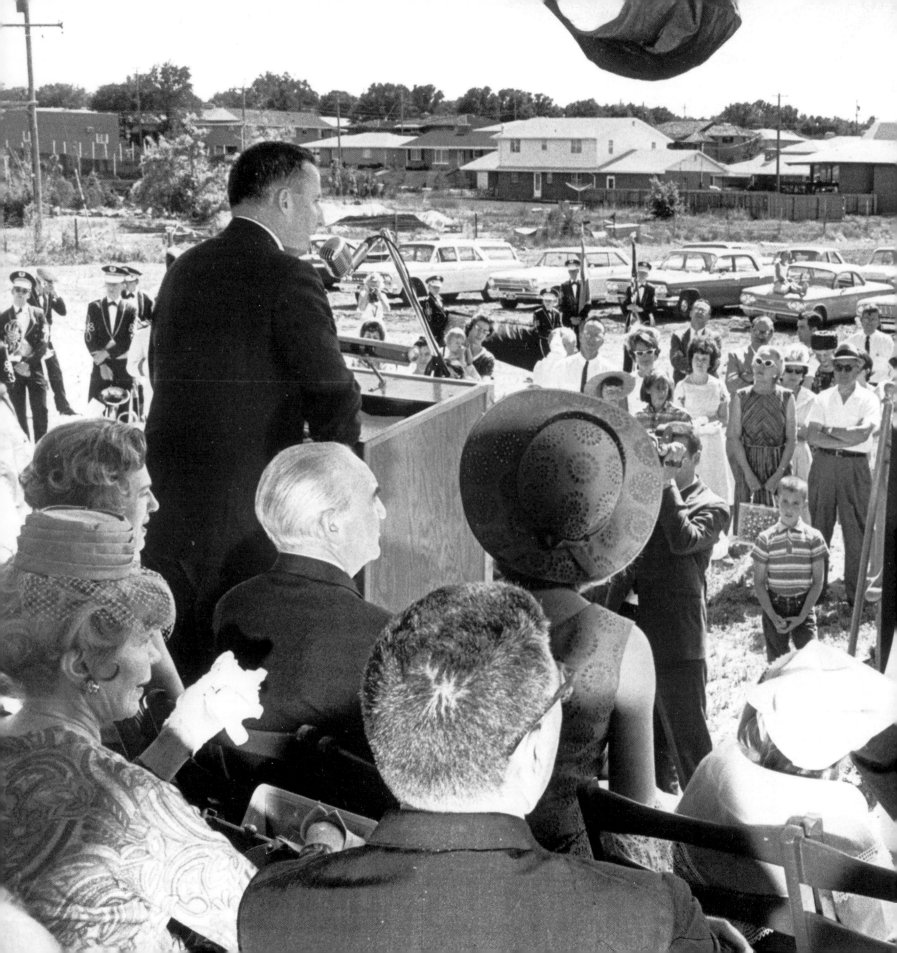

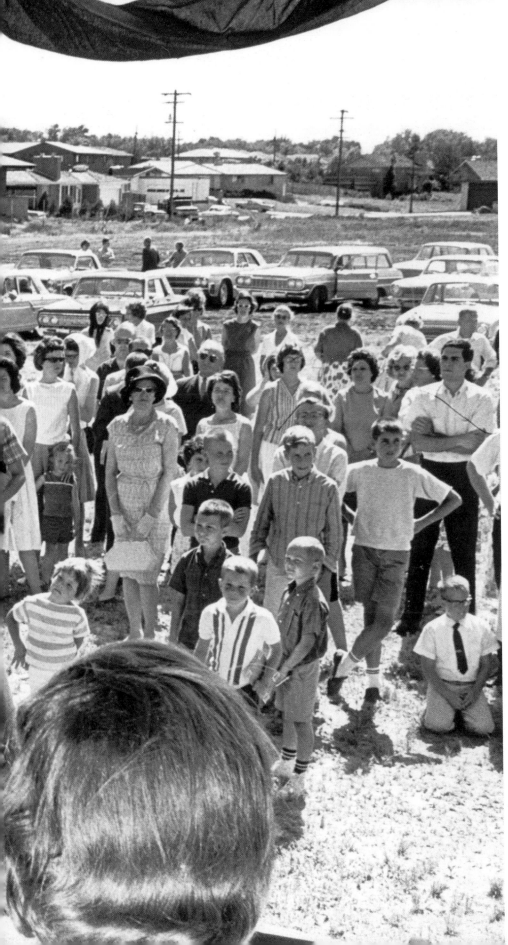

Ladies wore hats with veils and Chevrolet Corvairs had a front-row seat as one man speaks at the dedication of the City of Brest Park on June 16, 1964. The park, located near Cherry Creek and Colorado Boulevard, was built to honor the French town that became the first "sister city" to Denver in 1948. During World War II, Brest endured six weeks of Allied bombing before the Germans finally surrendered the city.

Completed in 1960, Zeckendorf Plaza, consisting of the kite-shaped annex to the May D&F department store and its adjacent ice-skating rink, became one of Denver's most iconic and beloved landmarks for days exactly like this one on November 22, 1964. Crisp fall weather. Thanksgiving holiday skaters. Set before the unmistakable hyperbolic paraboloid design by I. M. Pei. Despite its distinctive design, the plaza, too, would become a victim of urban renewal some years later.

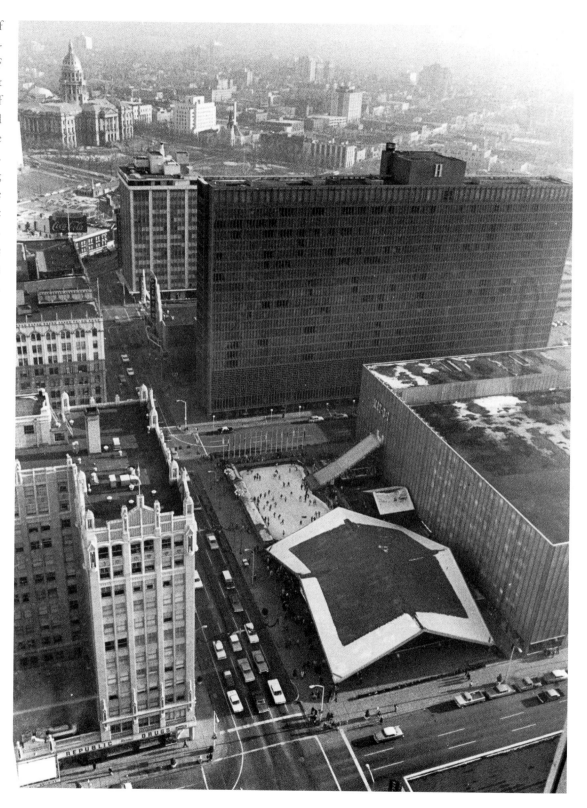

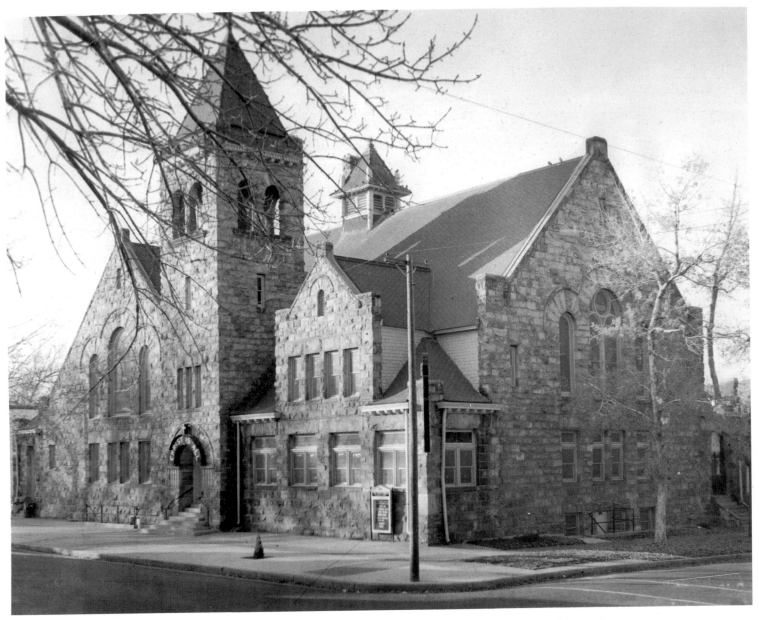

The Zion Baptist Church at 933 E. 24th Avenue is a historic landmark. It was established in 1865 by former slaves and became home to Colorado's first black congregation. The church is located southeast of lower downtown in the Clement's Addition Historic District.

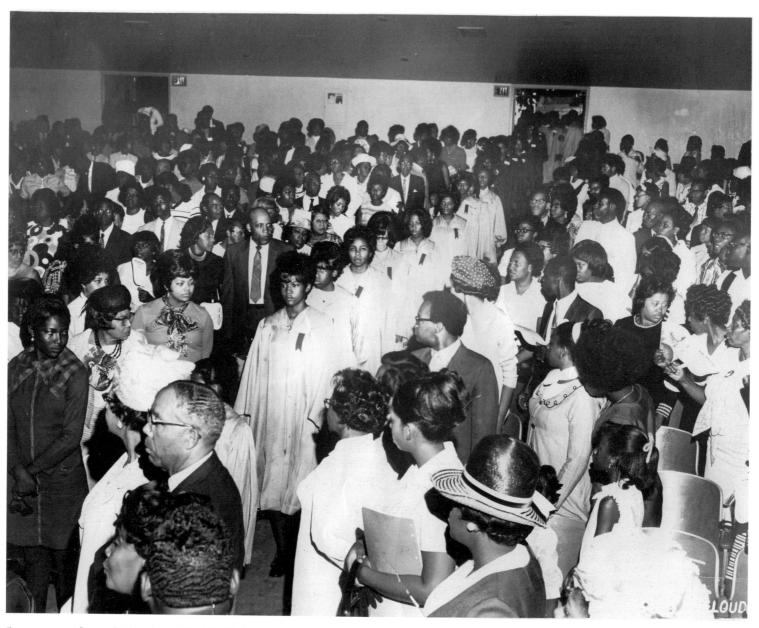

Scene at one of several Churches of God in Christ in Denver. At least a dozen congregations of this Pentecostal denomination, which originated in the South in the 1890s as part of the Holiness Movement, held worship services in the city between 1950 and 1979.

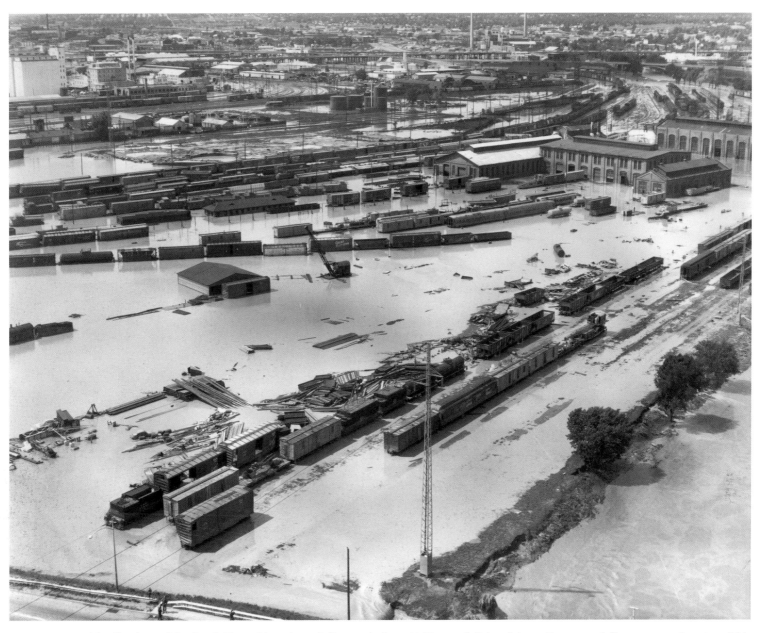

The flooding of the South Platte River through Denver in June 1965 caused Colorado's costliest natural disaster up to that time. This aerial photograph of the railroad yards south of the 14th Street viaduct was taken on June 17 and shows the swamping of the Colorado and Southern Railway shops. Pummeling rain began on June 15. Four days later the flood had killed 21 people and caused more than $100 million in damages.

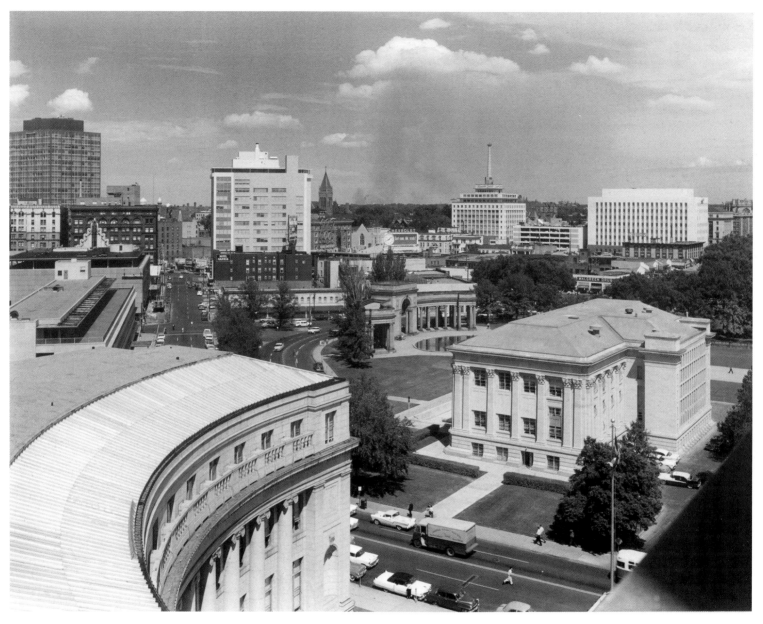

In the mid-1960s, City and County Annex 2 seemed a drab name for the Greek Revival building in Civic Center after the Denver Public Library moved out. Philanthropist and industrialist Andrew Carnegie provided the wherewithal to build it with a $200,000 grant in 1910 but reportedly hated the final design.

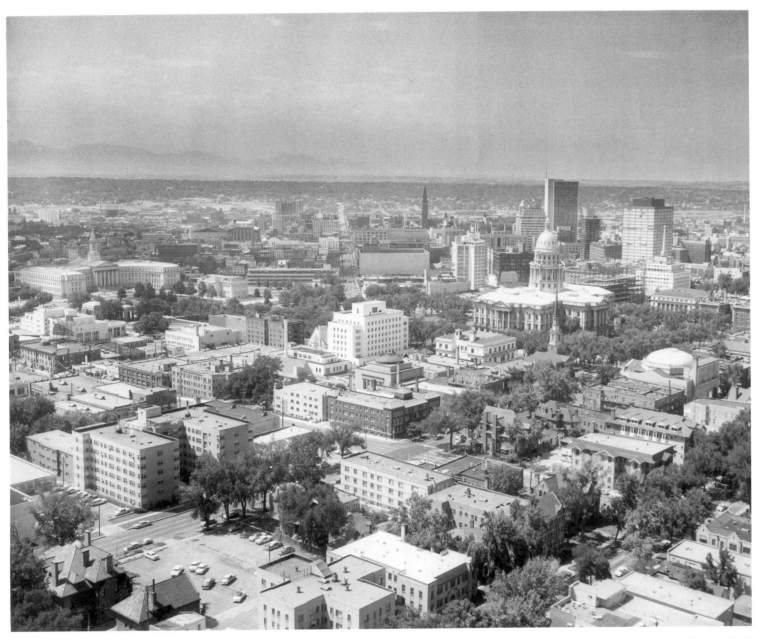

The Capitol Hill neighborhood, with its blocks and blocks of apartment buildings, was within easy walking distance of the capitol, Civic Center Park, and downtown.

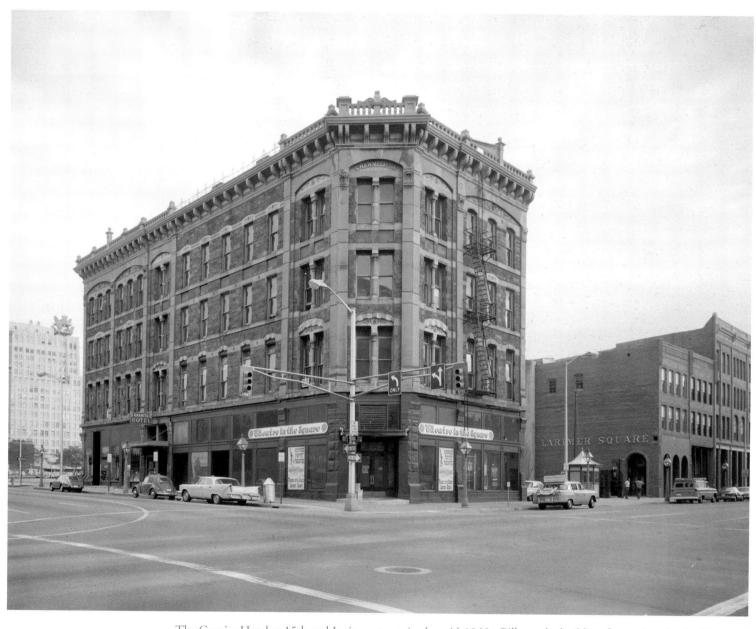

The Granite Hotel at 15th and Larimer streets in the mid-1960s. Bills on the building front advertise the Norwood Puppet Theatre in Larimer Square.

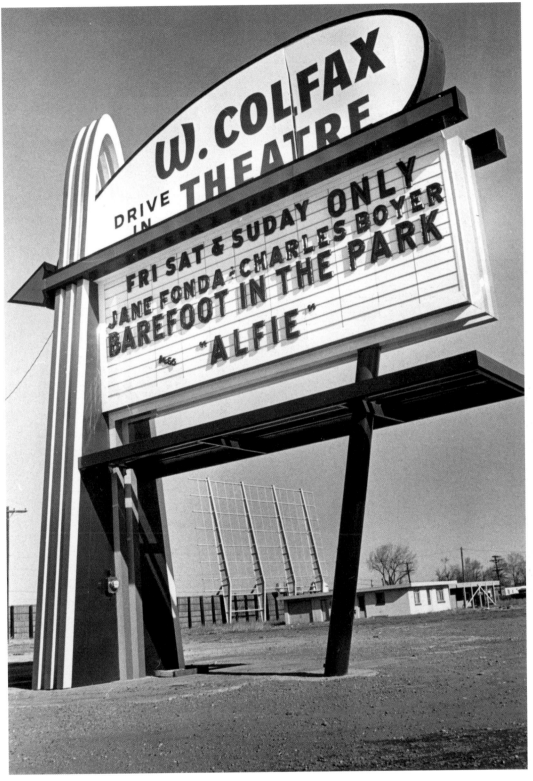

Couples and families could still watch a double feature at the W. Colfax Drive-In in December 1967.

In the 1960s, the Florsheim Shoes store anchored the corner of 16th and California streets.

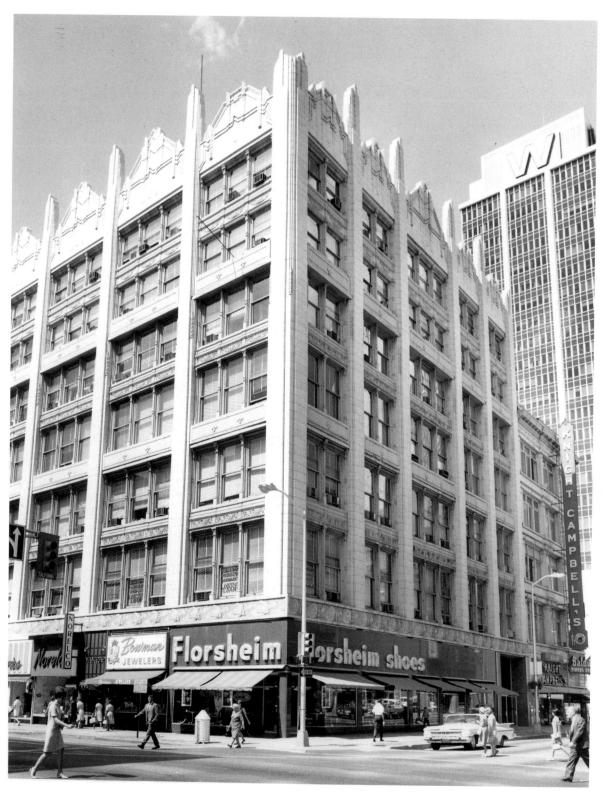

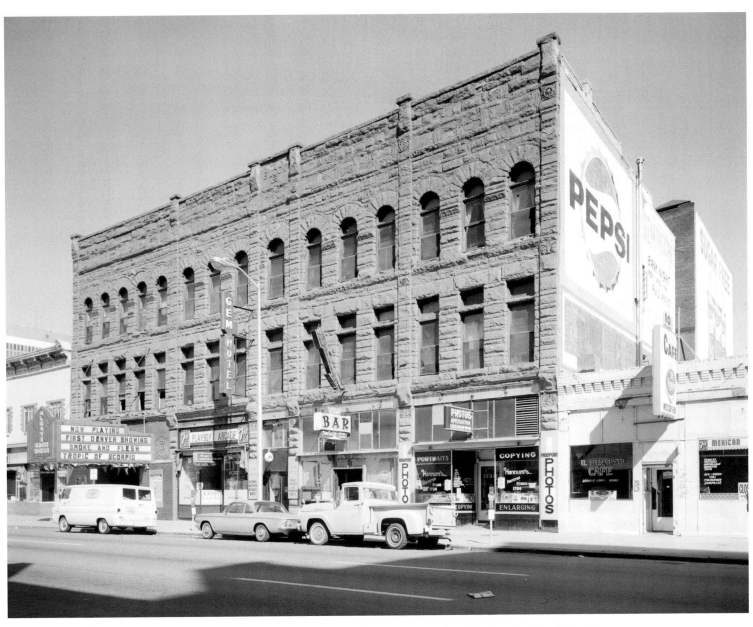

The marquee outside the Gem Hotel and Playboy Arcade at a seedy 1746 Curtis Street in 1968 advertised the "First Denver Showing" of *Smoke and Flesh*, a bizarre drug cult film.

Pedestrians, bicycles, and automobiles compete
for the right of way on a busy downtown street.

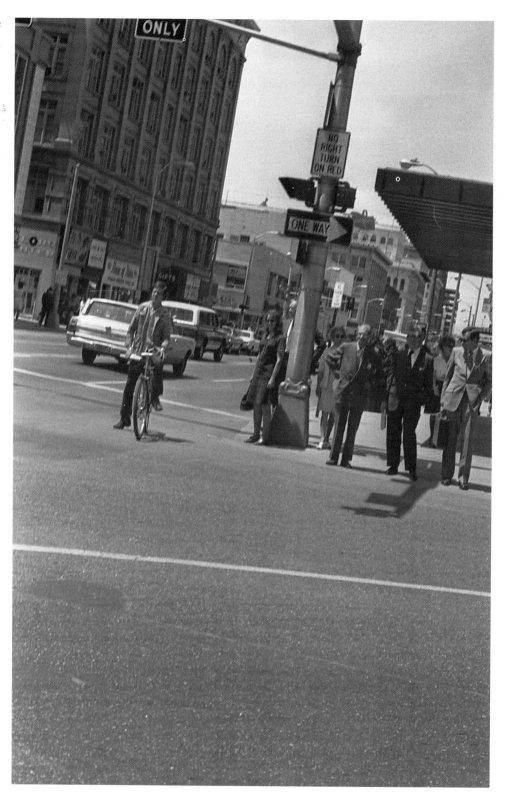

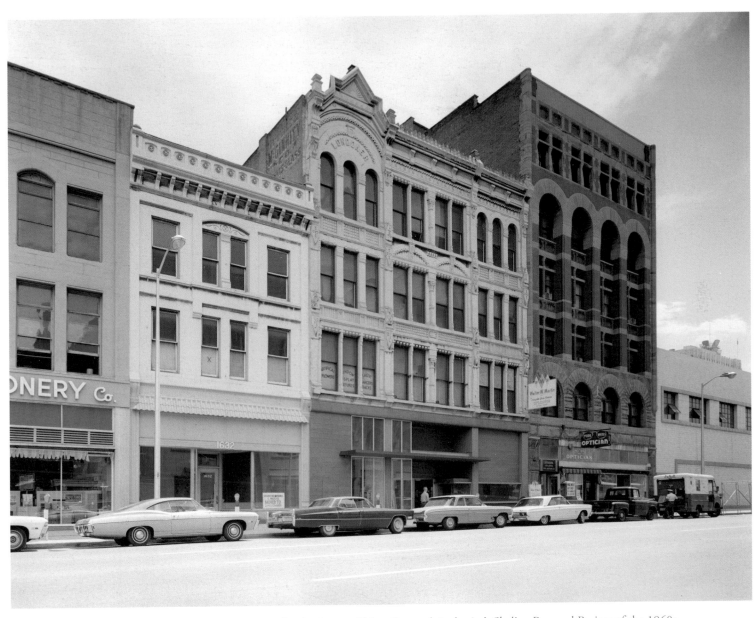

Buildings in the block of 1600 Arapahoe were targets for the Denver Urban Renewal Authority's Skyline Renewal Project of the 1960s and 1970s. Wrecking balls pounded the area from 1969 to 1974. Not until much of the downtown core had been demolished did architects of the destruction weigh gains against losses. Parking lots would replace many of the leveled buildings for a decade or more.

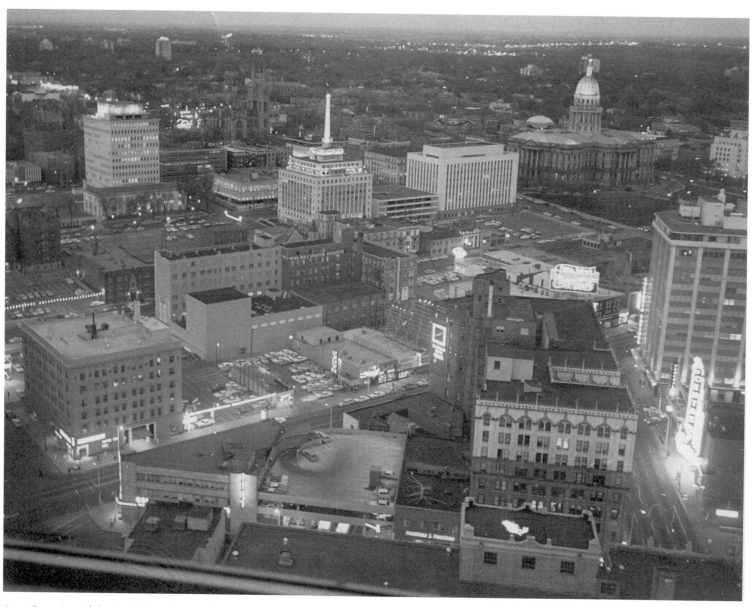

A rooftop view of the city lights of 1960s downtown Denver.

Construction scaffolding scales the sides of a new control tower built at Stapleton Airfield in the mid-1960s. A new jet runway and terminal building added by 1964 made Stapleton one of the country's best-equipped airports at the time.

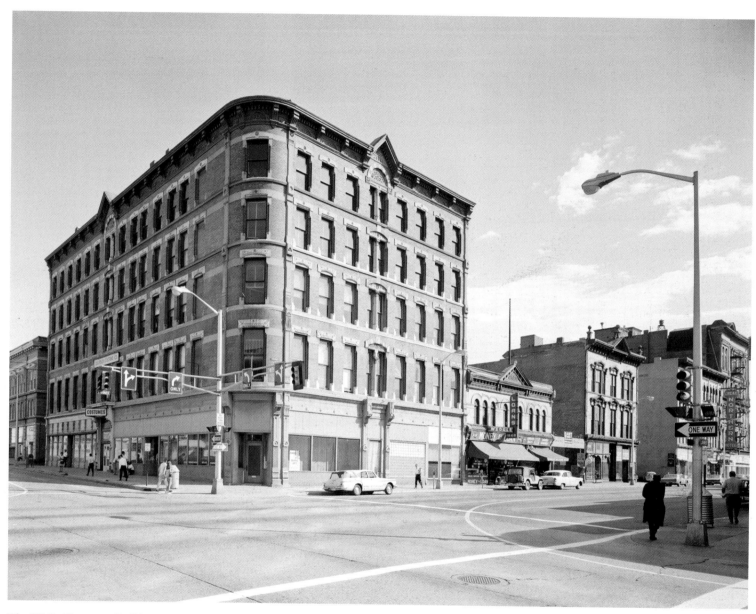

The W. S. Cheesman Building at 17th and Larimer streets was built in 1881 by one of Denver's pioneer leaders. Walter Scott Cheesman collaborated with David Moffat and John Evans to build the Denver Pacific Railroad to Cheyenne, Wyoming. Soon after, Cheesman became one of the principal investors, raising nearly $150,000 through supplying water to Denver when the population was only about 6,000. The company was later valued at $25,000,000.

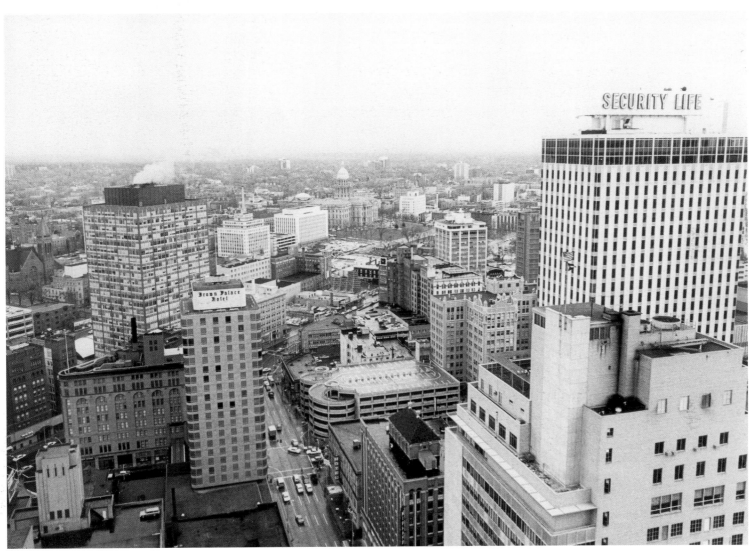

A view from north of the historic Brown Palace Hotel on October 31, 1966. The original, uniquely triangle-shaped main hotel is partly visible at left behind the taller, newer structure bearing the hotel name.

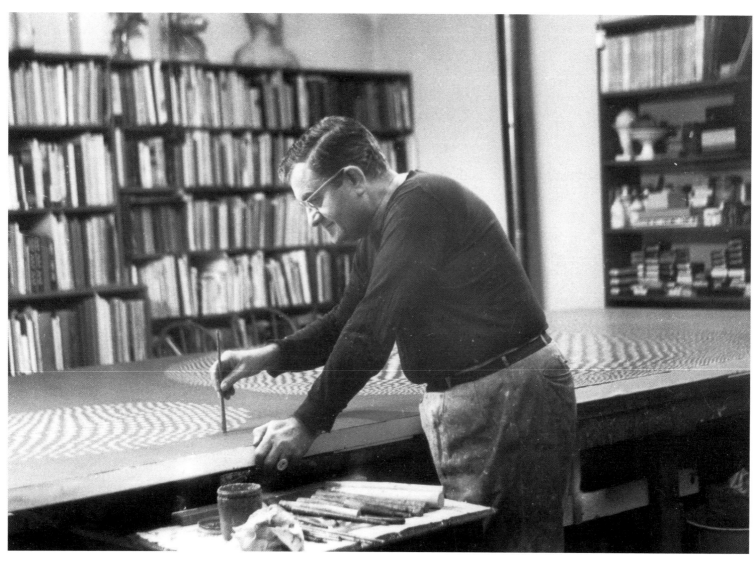

Denver artist Vance Kirkland works in his studio in 1967. Kirkland became well known throughout the world for his surrealist watercolors and abstract expressionist paintings over a 54-year career.

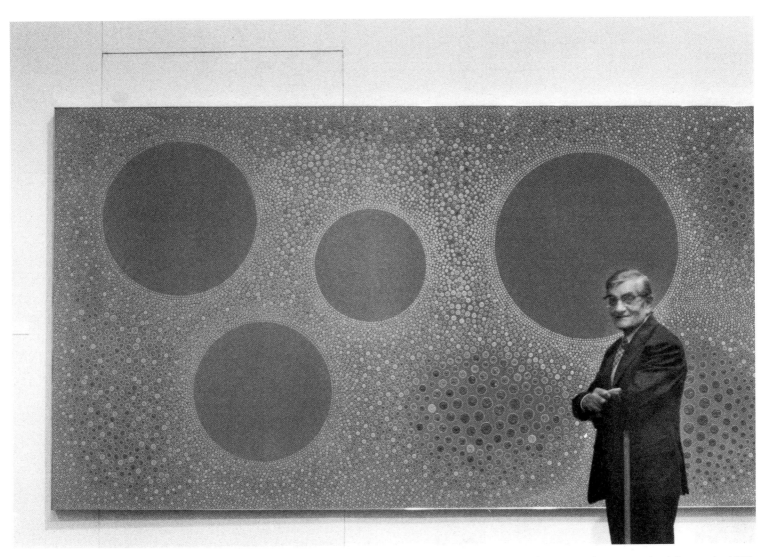

Artist Vance Kirkland with one of his abstract pieces at a showing at the Denver Art Museum in 1978.

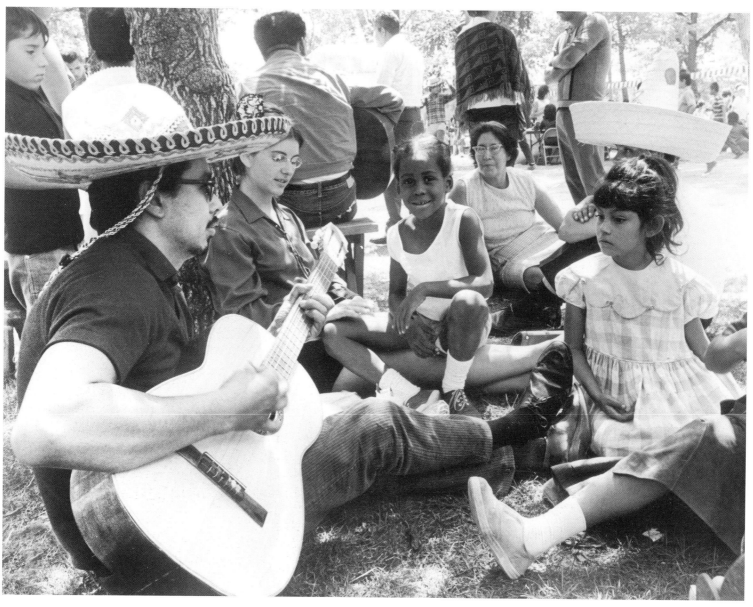

A musician with guitar entertains youngsters at a neighborhood festival.

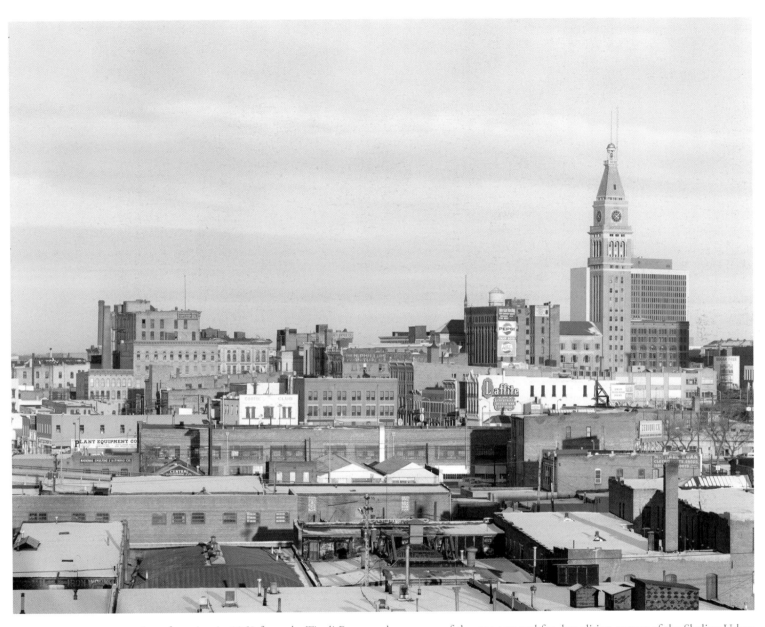

A rooftop view in 1968 from the Tivoli Brewery shows some of the area targeted for demolition as part of the Skyline Urban Renewal Project, including the former Daniels & Fisher department store and its attached tower, opened in 1912. Public outcry over the plan eventually saved the tower, but the department store building was razed. One year later, the tower was listed on the National Register of Historic Places.

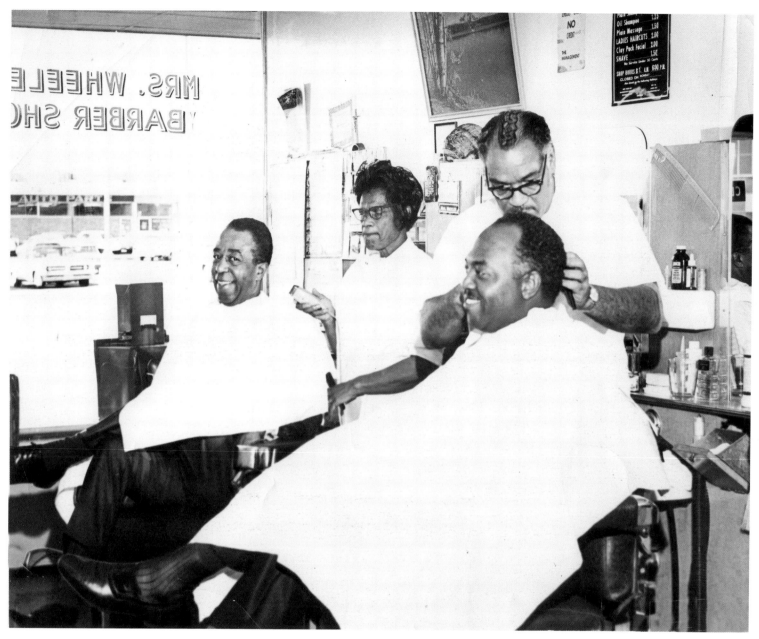

Two barbers trim up customers in the Mrs. Wheeler Barber Shop. Seated are Alvin Moore, left, and Acen Phillips.

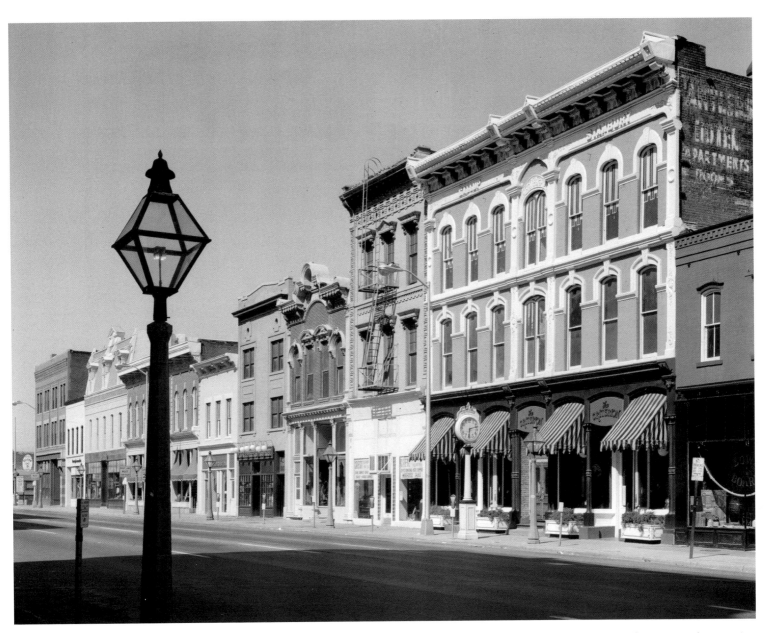

The 1400 block of Larimer Street in 1968. One of the successes of the Skyline Urban Renewal Project was the continued restoration and preservation of Larimer Square, as old as Denver City.

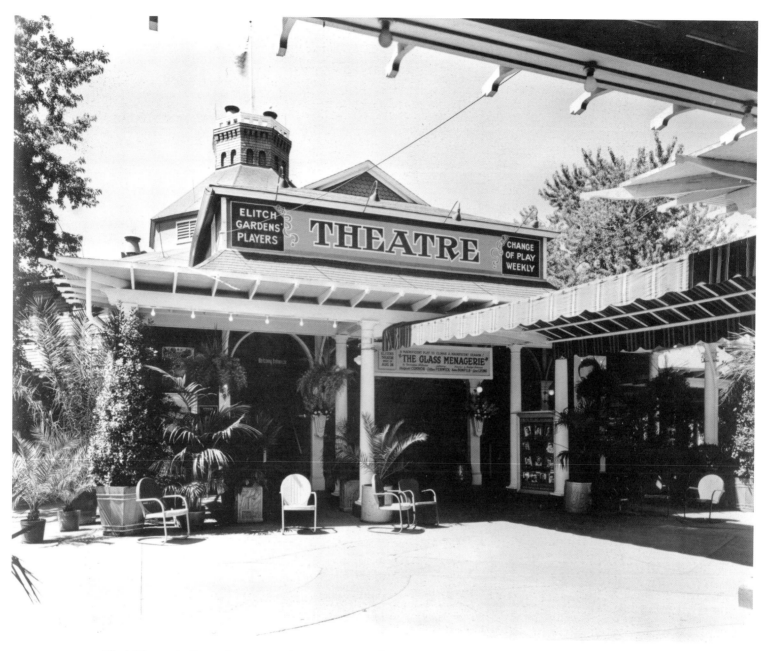

Elitch Theatre in Denver's most popular amusement park gained national acclaim as the oldest summer stock venue in the country, starting in 1897 and continuing until 1987, when it closed. *The Glass Menagerie* was being performed onstage here in 1968.

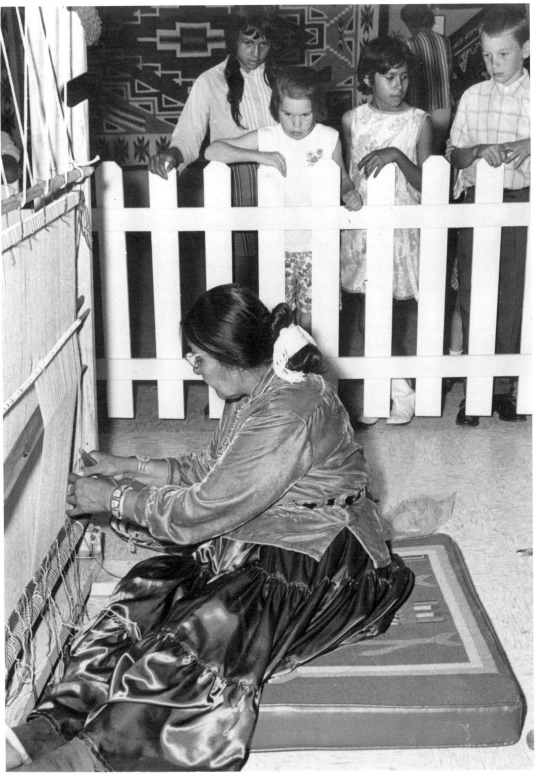

Mabel Burnside Myers, a Native American Navajo, demonstrates her weaving for children at a loom in the Denver Museum of Natural History on July 15, 1968. Myers was a prominent weaver of vegetable-dye materials.

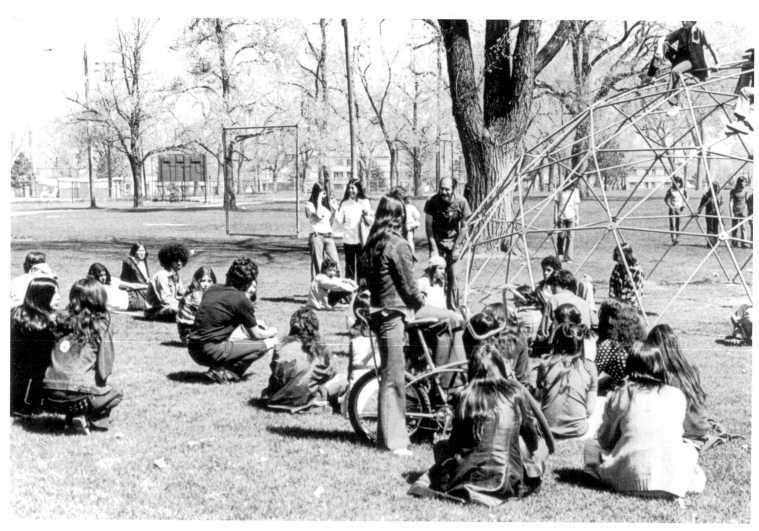

A group of young people gather in a neighborhood park, sporting bell-bottom trousers and long hair, trends in fashion that would cross the nation beginning in the late 1960s. One youth sits on a "spider bike," a new style that featured high handlebars and a banana-shaped seat.

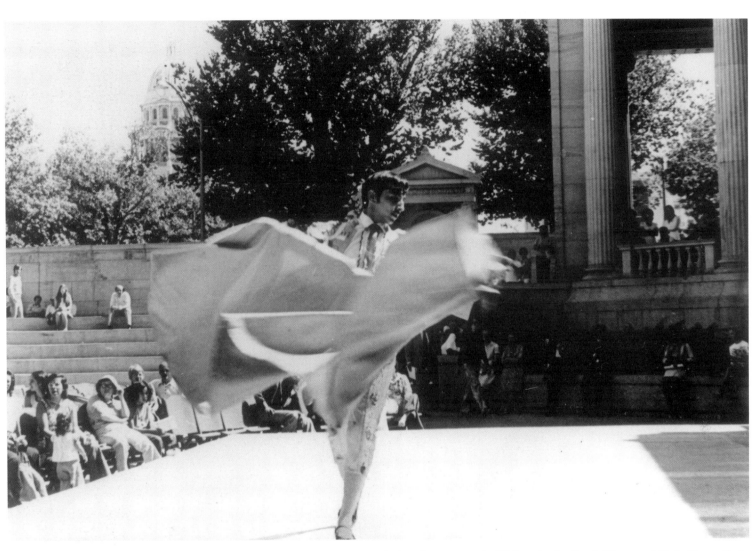

An actor in matador's garb portrays a bullfighter in the Greek Theater of Civic Center Park.

Members of the "Crusade for Justice" movement protest post office hiring and firing practices outside Denver's U.S. Post Office and Federal Building at 1823 Stout Street on February 4, 1969. Crusade for Justice was founded by Rodolfo "Corky" Gonzales, a local former pro boxer turned activist, and played a prominent role in the national Chicano rights movement.

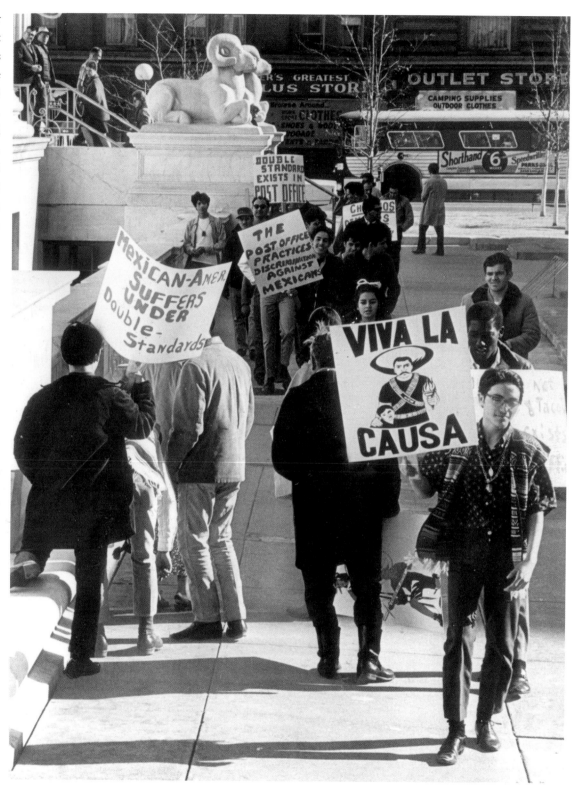

122

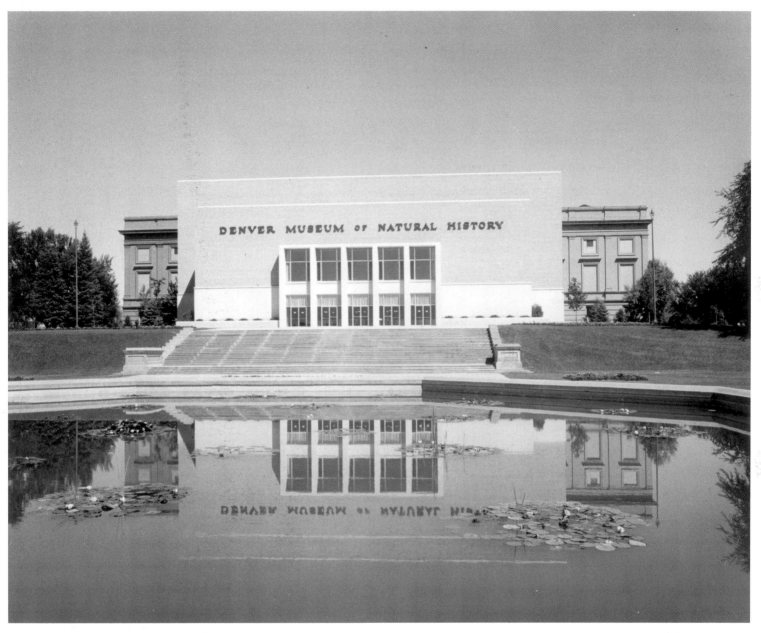

A lily pond reflects the main entrance to one of Denver's most popular attractions in the late 1960s, the Museum of Natural History in City Park. Edwin Carter put the museum's initial collection together, housing it in a log cabin in 1900.

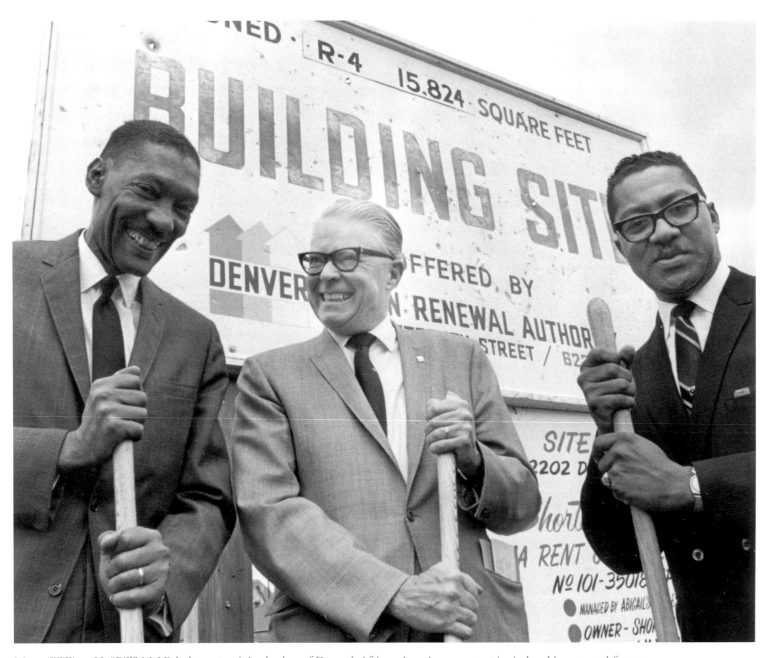

Mayor William H. "Bill" McNichols, center, joins leaders of Denver's African-American community in breaking ground for an Urban Renewal housing project in the Whittier neighborhood on April 13, 1969. Omar Blair, at left, represented the Urban Renewal Authority, and Cecil W. Howard was pastor of the Shorter Community A.M.E. Church.

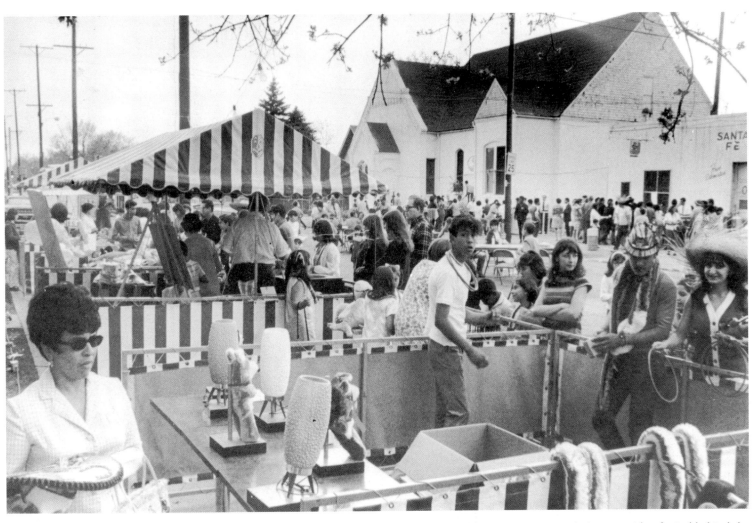

A crowd celebrates the grand opening of the Centro Cultural building at 935 West 11th Avenue with a festival behind the center on May 4, 1969.

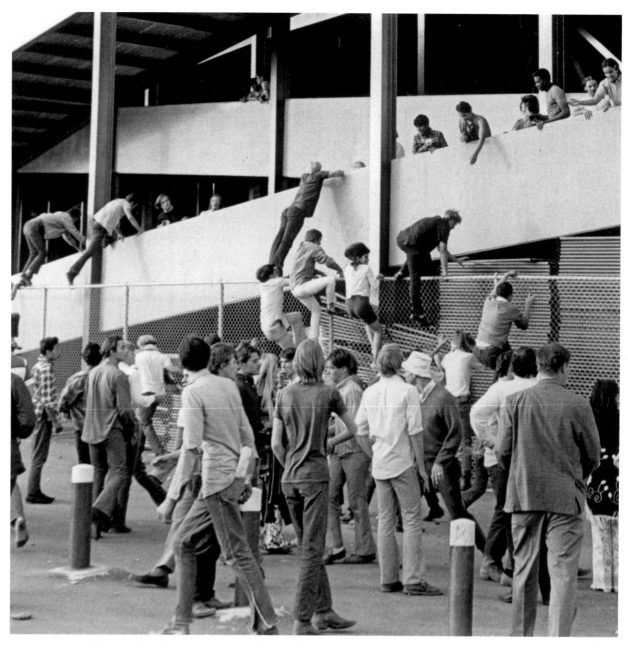

Gate-crashers climb the fence outside Mile High Stadium on June 29, 1969, the last day of legendary rock promoter Barry Fey's three-day Denver Pop Festival. The final three acts inside: Joe Cocker, Three Dog Night, and the Jimi Hendrix Experience. Peak attendance was 50,000. The Denver festival's vibe was overshadowed, though, two months later by Woodstock in New York State.

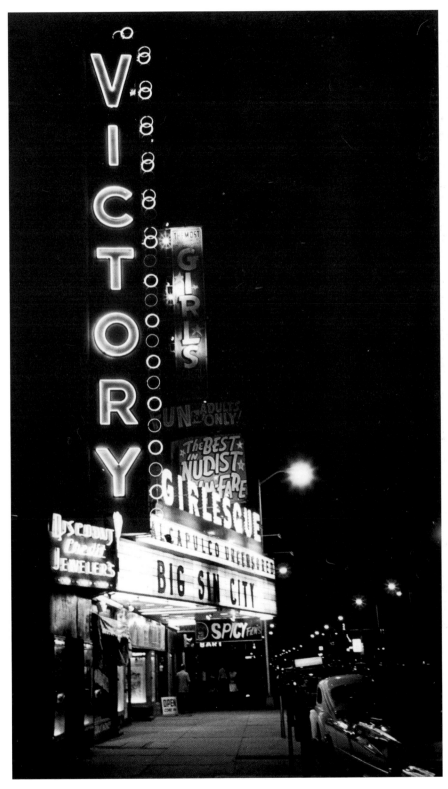

By the late 1960s, Denver had its share of adult entertainment houses. The marquee outside the Victory Theater shouted "Big Sin City" and "Girlesque," and neon signs promised "Acapulco Uncensored" and other bawdy attractions.

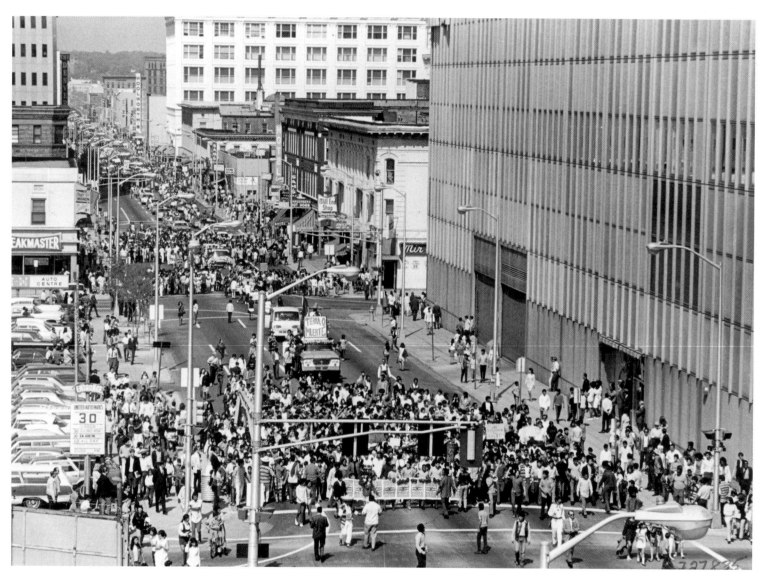

Marchers, many from the Hispanic community, parade down 15th Street on September 16, 1969, the date celebrated in Mexico as Mexican Independence Day. Some of the marchers carry signs reading "Tierra O Muerte"—Land Or Death—recognizing a land rights struggle waged in New Mexico for decades.

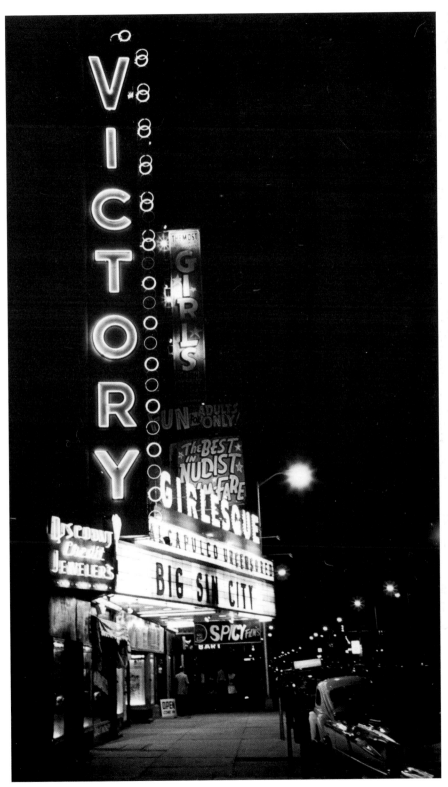

By the late 1960s, Denver had its share of adult entertainment houses. The marquee outside the Victory Theater shouted "Big Sin City" and "Girlesque," and neon signs promised "Acapulco Uncensored" and other bawdy attractions.

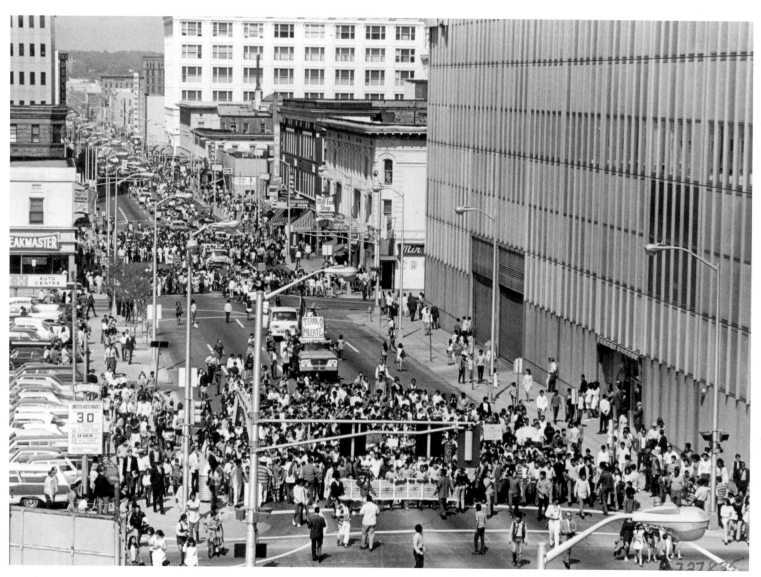

Marchers, many from the Hispanic community, parade down 15th Street on September 16, 1969, the date celebrated in Mexico as Mexican Independence Day. Some of the marchers carry signs reading "Tierra O Muerte"—Land Or Death—recognizing a land rights struggle waged in New Mexico for decades.

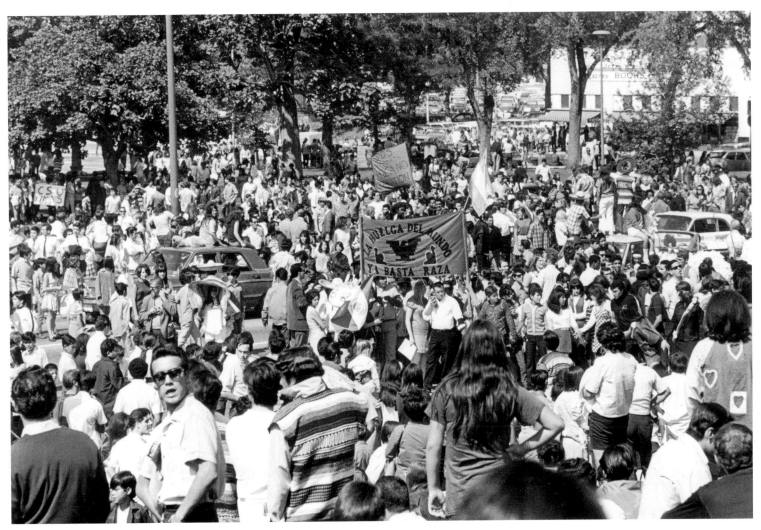

A large crowd gathers downtown, part of the march marking Mexican Independence Day.

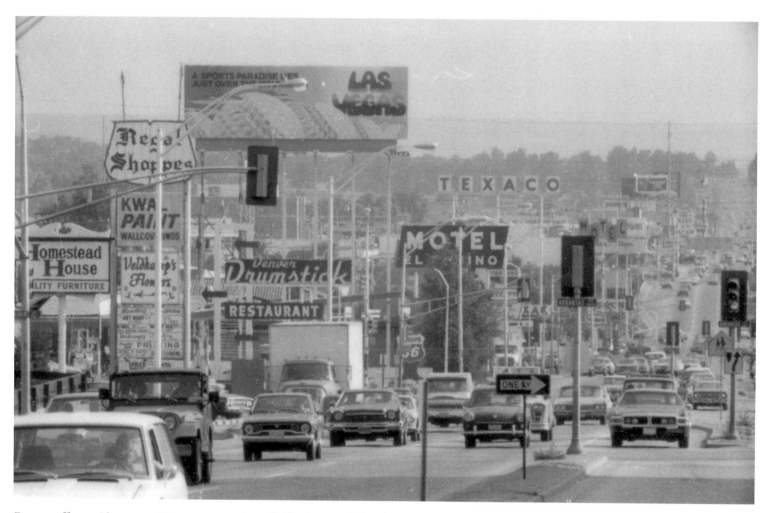

Dense traffic corridors across Denver, among them Colfax Avenue, Colorado Boulevard, and Broadway, contributed to the city's growing air pollution. A state health department report in the mid-1960s blamed the problem that became known as Denver's "brown cloud" on hundreds of tons of pollutants spewing from automobile exhaust pipes.

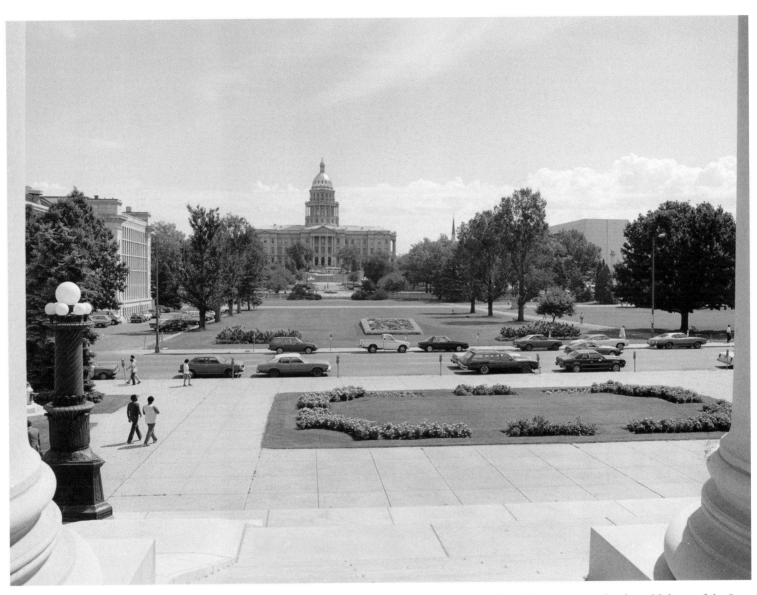

Denver's mayor, looking from the steps of the City and County Building, and Colorado's governor, under the gold dome of the State Capitol, can wave to each other going to work every morning. In between is Civic Center Park, and behind the City and County Building is the U.S. Mint.

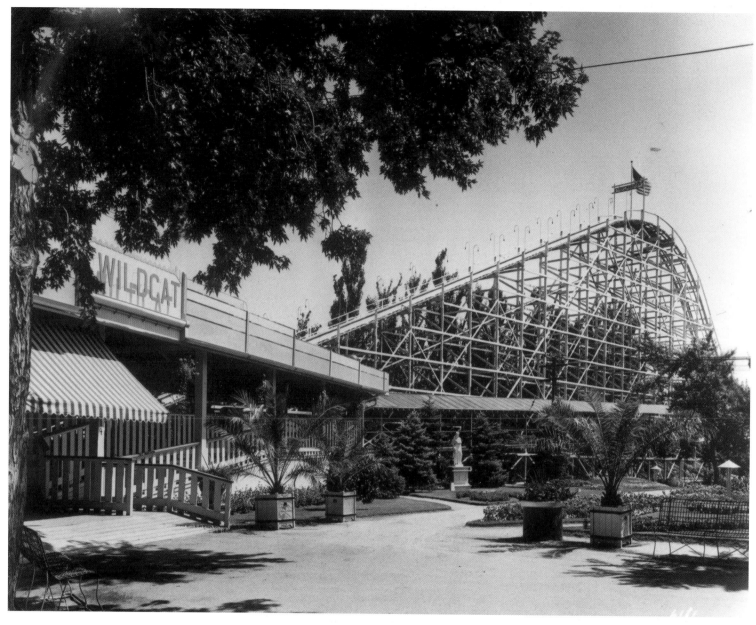

The Wildcat was Colorado's first roller coaster when it opened at Elitch Gardens in 1922. It featured an out-and-back design by Herbert Schmeck of the Philadelphia Toboggan Company. When the original amusement park closed in 1995, the Wildcat was demolished to make room for residential housing.

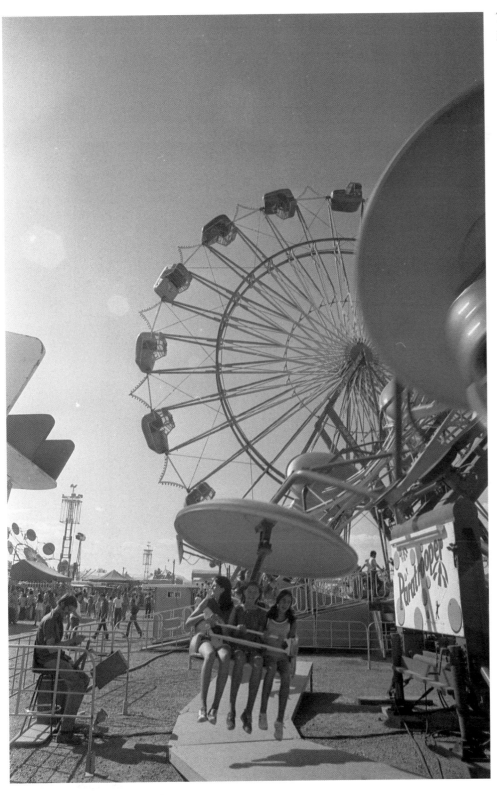

The Paratrooper was another popular ride at Elitch Gardens in the late 1960s and early 1970s.

Young mini-car drivers line up to race at an asphalt racetrack.

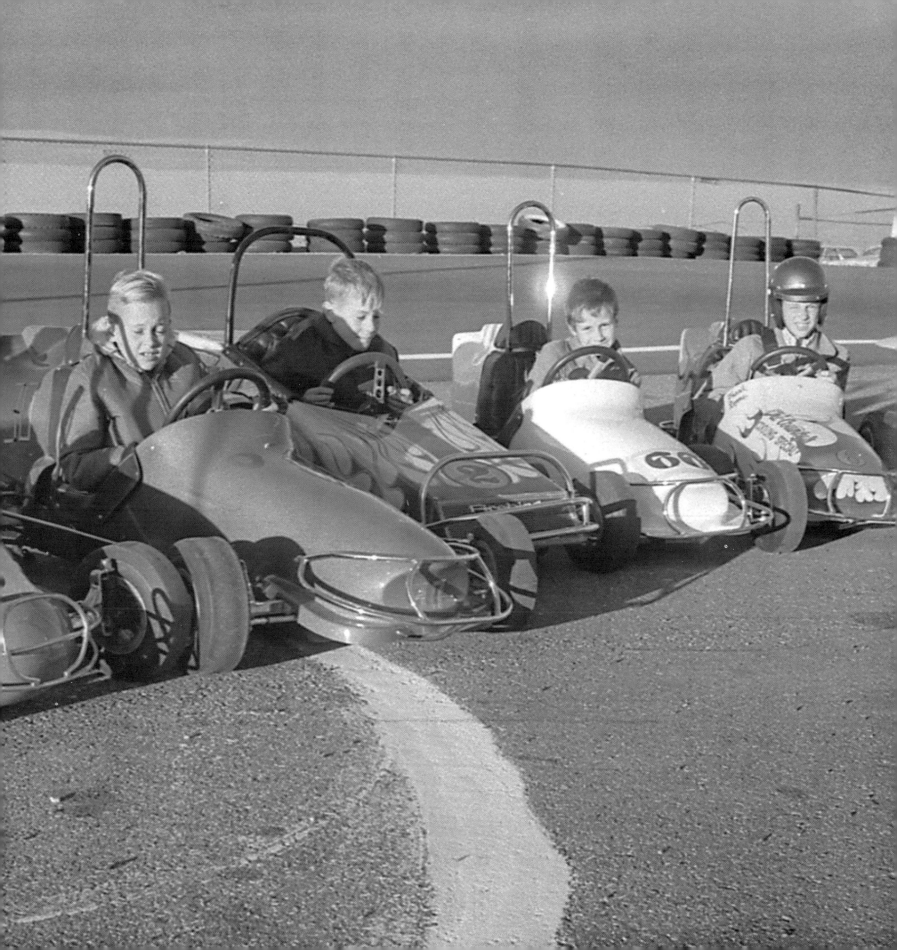

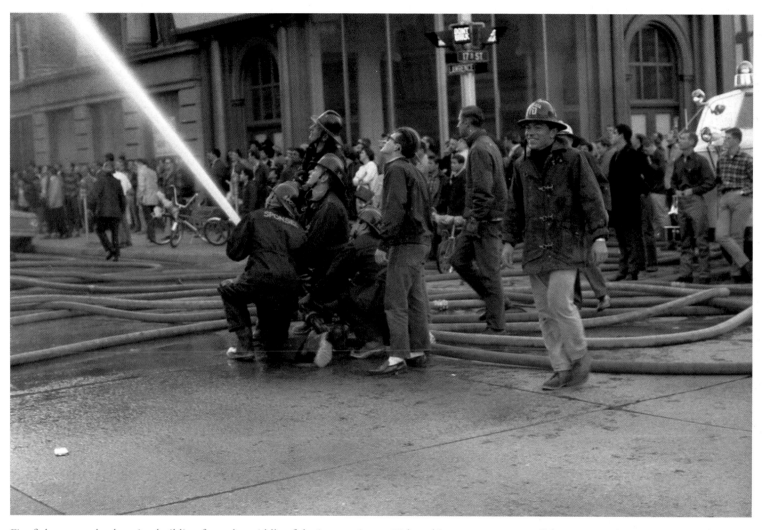

Fire fighters attack a burning building from the middle of the intersection at 17th and Lawrence streets on February 2, 1969. Hoses fill the streets and onlookers crowd the sidewalk.

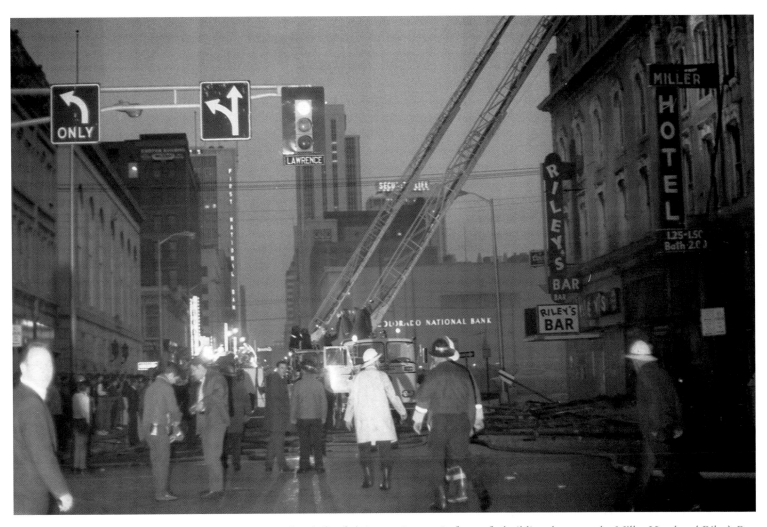

Seventeenth Street is jammed with fire-fighting equipment in front of a building, home to the Miller Hotel and Riley's Bar.

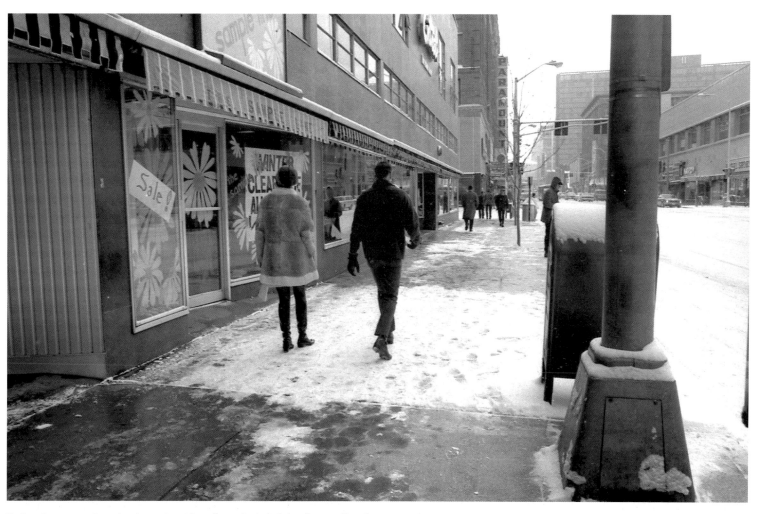

Pedestrians step gingerly along the sidewalk packed slick by foot traffic after a March snowstorm in 1969. At left are Cottrell's men's store on 16th Street, and in the distance, the Paramount Theater.

FROM COWTOWN TO THE BIG LEAGUES

(1970–1979)

The Old West aura of longhorn steers being driven through downtown streets, the traditional start of the National Western Stock Show, had been a point of pride in Denver for decades. But now, some saw it as perpetuating the city's "cowtown" image.

In the 1970s, everyone wanted everything to be "big-league." The city's bursting skyline reflected the tone. The local joke was that the construction crane had been designated the new official state bird of Colorado. A booming ski industry had snatched the world's imagination, and Denver became the gateway to snow likened to "champagne powder" and glamour destinations Aspen and Vail. The city had even won the rights to host the 1976 Winter Olympics. Then in a startling reversal, a coalition of anti-growth leaders succeeded in voting the Olympics out, the first time any city had ever turned away the international event. Some saw it as yet another cow parade down the streets, but there would be consolation for sports fans. The sports-crazy city had grown up with minor league teams, so in 1976, when Denver gained admittance to both the National Hockey League and the National Basketball Association, people felt that, indeed, the city had finally become "big-league."

On the political front, as demonstrations against the Vietnam War rippled across the American landscape, protesters erected a "Woodstock West" tent city on the University of Denver campus, as if to prove that they, too, deserved national attention.

Adding to the economic euphoria, Colorado had once again tapped its rich natural resources—oil, coal, even the sun—initiating an energy rush to Denver. The cranes couldn't build multistory office nests fast enough. Starting in 1974, nine of the city's ten tallest buildings would be erected within the next ten years. Denver's newest boom was fated to fade, although it wouldn't for another decade. But what a change over three decades: Starting in 1950, metropolitan Denver's population tripled—from 563,832 to more than 1.6 million by the 1970s.

Testimony to Denver's past and its future, longhorns still stroll the downtown streets each year, and winter sports zealots pour through the city on their way to snow-covered mountains and resorts.

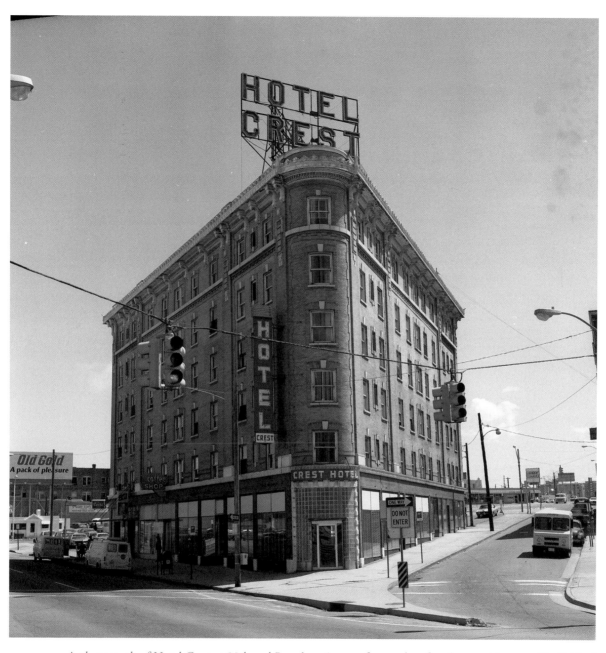

A photograph of Hotel Crest at 20th and Broadway is one of more than five thousand images of individual buildings and landmarks taken by photographer Roger Whitacre over his 35-year career, starting in 1970.

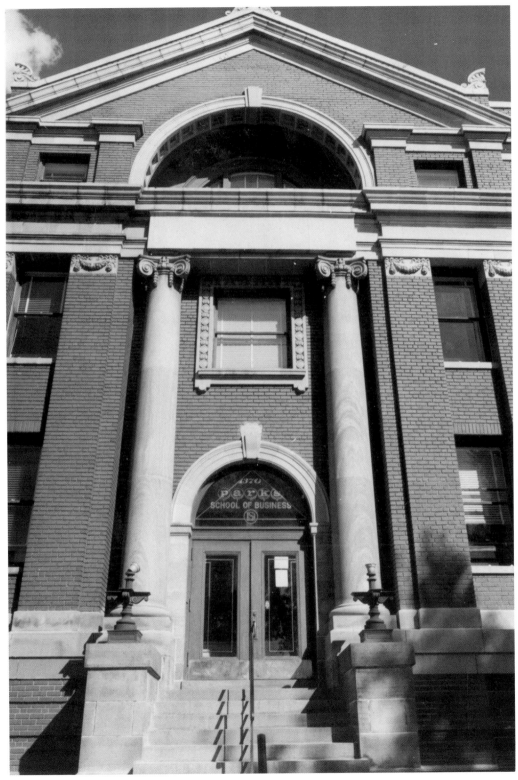

A classic view from the early 1970s of the front entrance to the Parks School of Business at 1370 Pennsylvania Street in the city's Capitol Hill neighborhood. The building originally housed St. Mary's Academy.

The Daniels & Fisher Tower on 16th Street appears forlorn in 1971 after its adjoining department store disappeared under the wrecking ball of the Skyline Urban Renewal Project. The tower was modeled after the Campanile in Venice, Italy, when construction began in 1910, and it was the tallest structure west of the Mississippi River when it opened two years later. The clock's hour hand is six feet long, and the minute hand is eight feet.

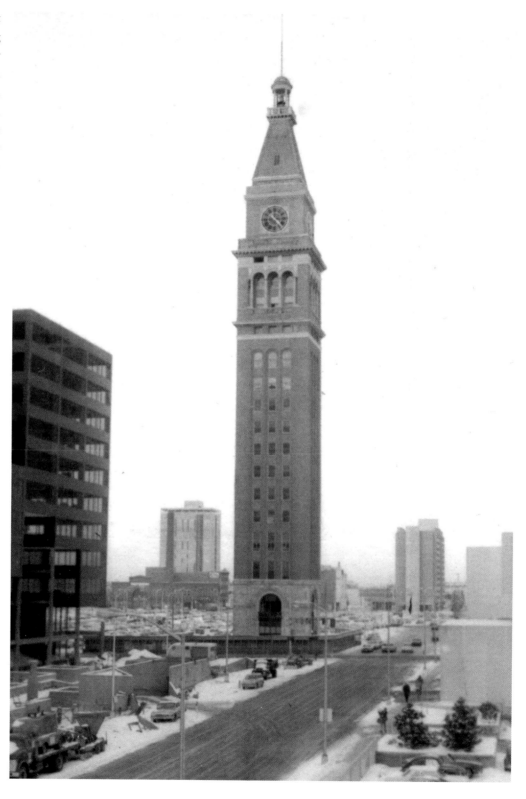

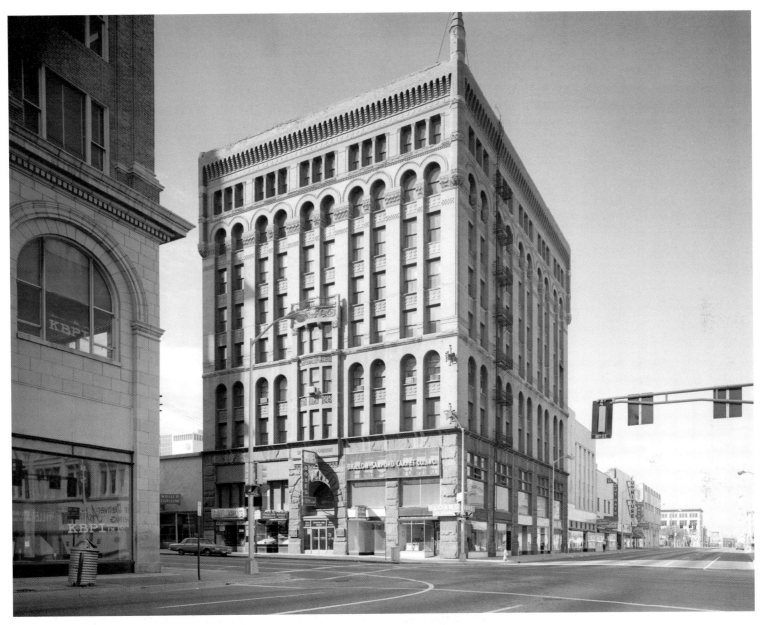

The Interstate Trust Building stood at 16th and Lawrence streets. Across the street in the early 1970s, a new rock radio station, KBPI, was breaking into the highly competitive Denver market. KBPI became known for a series of television commercials showing only the mouth of an attractive woman lip-syncing the station's catchphrase "KBPI Rrrrrrrrocks the Rrrrockies!" Kelly Harmon, the sister of actor Mark Harmon, was a huge hit as the woman behind the lips.

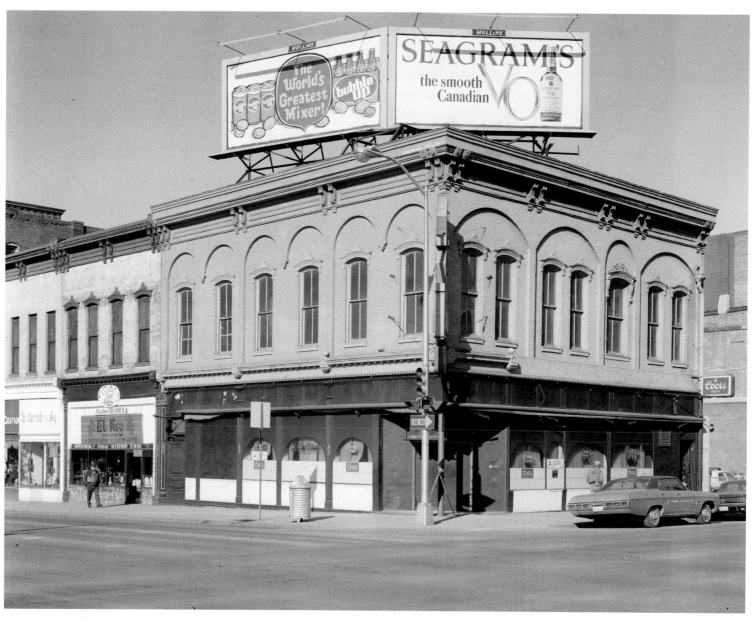

At the corner of 15th and Lawrence streets, El Rey's offers "individually styled wedding rings" and custom leather. The pedestrian passing the store seems to be more interested in the photographer across the street taking his picture. Next door to El Rey's, Coors beer is advertised in neon.

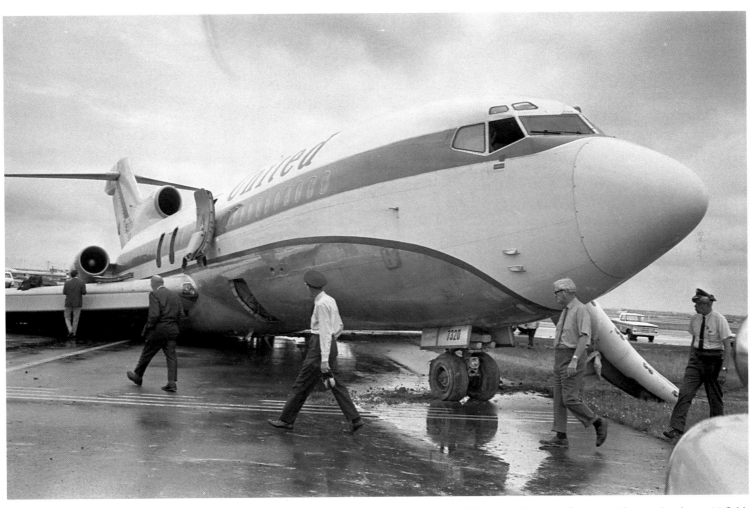

Officials inspect damage to a United Airlines jet after an accident at Stapleton Airfield.

A round corner tower, upper bay window, and ornate spindled stoop still grace this nineteenth-century home at 1555 W. 37th Avenue in the Highland neighborhood in 1970.

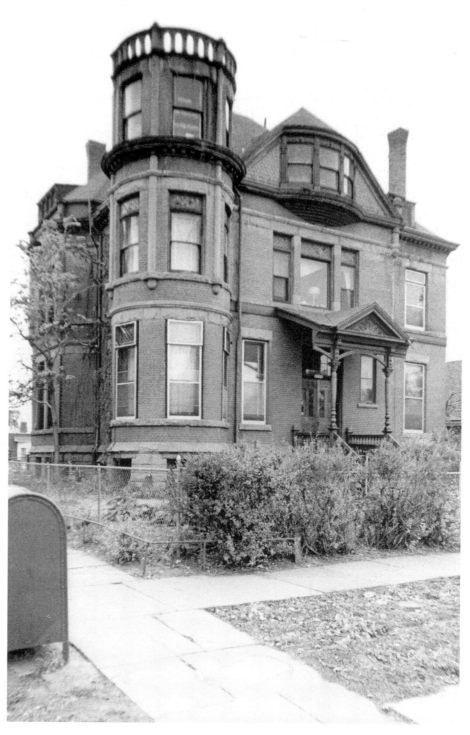

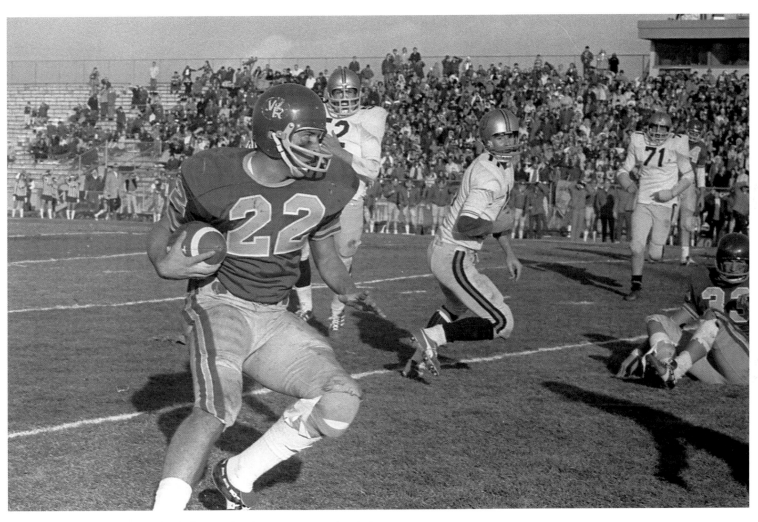

Two Denver-area high school football teams battle it out in an early 1970s game.

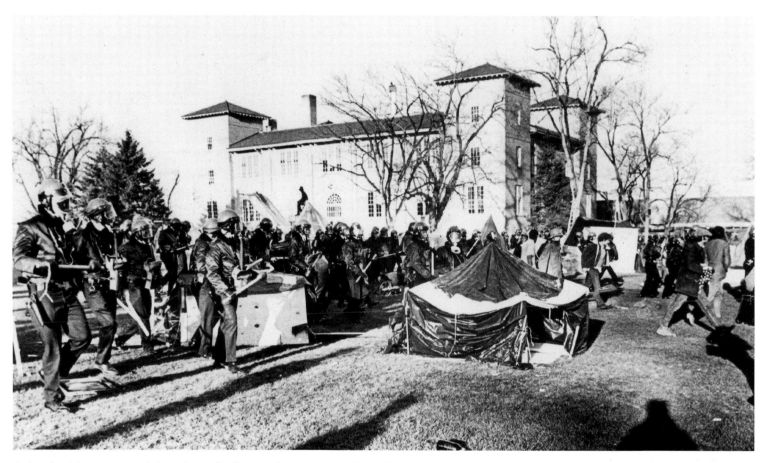

Colorado cities experienced their share of college student protests in the early 1970s. On May 12, 1970, masked and helmeted police moved in on University of Denver students who had erected a "Woodstock West" tent city in the middle of campus, their stated goal being to protest the shooting of four students at Kent State.

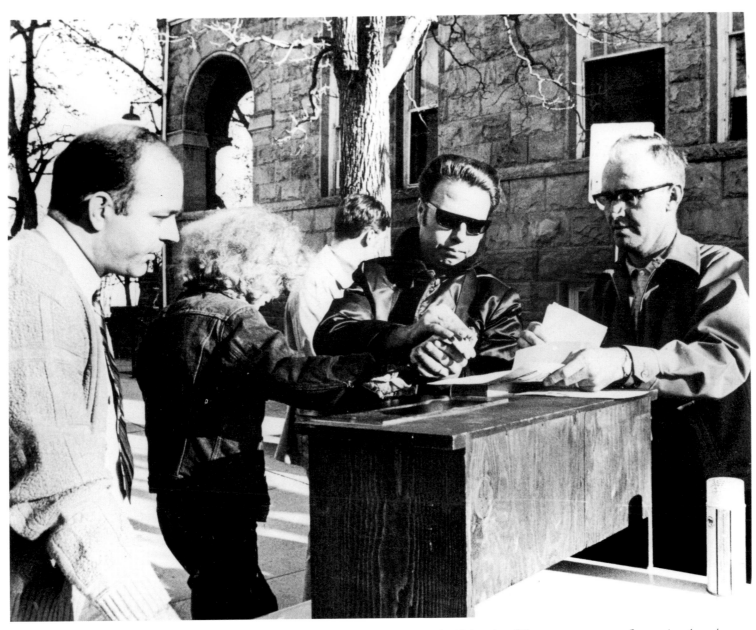

"Woodstock West" offenders arrested by police on the University of Denver campus were fingerprinted on the spot by law enforcement officials.

A barrier blocks vehicle access to Washington Park in the early 1970s.

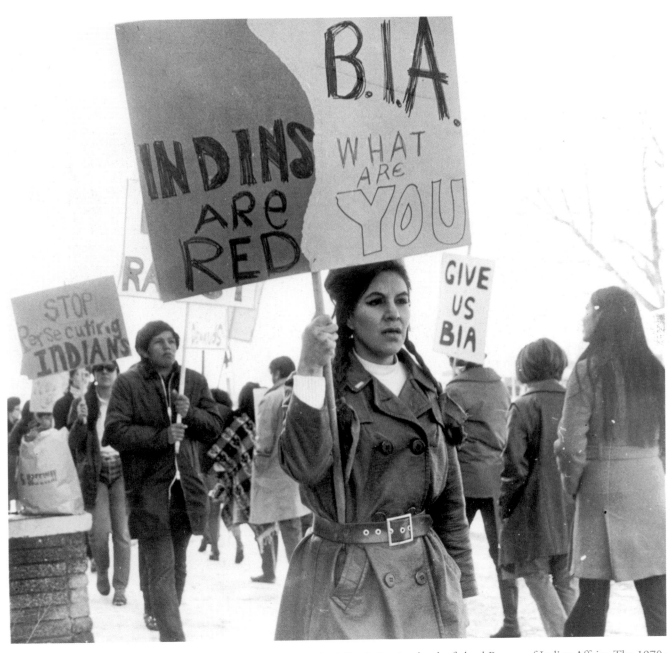

Native American activists protest perceived discrimination by the federal Bureau of Indian Affairs. The 1970s were a flashpoint for social protest movements that had gathered momentum in the 1960s. The American Indian Movement was extremely active.

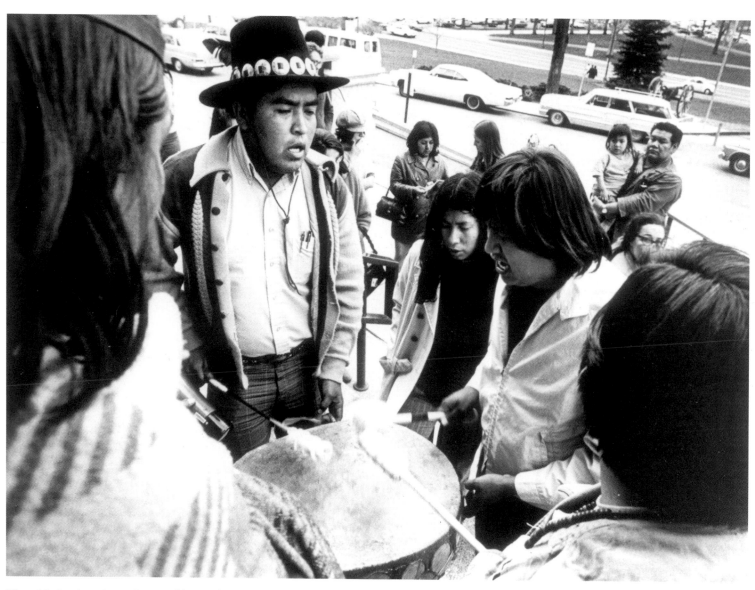

Three Native Americans chant and beat a drum on the steps of the State Capitol on April 24, 1971. They were part of a protest against a bill in the legislature that would allow only resident Indians free tuition at Fort Lewis College.

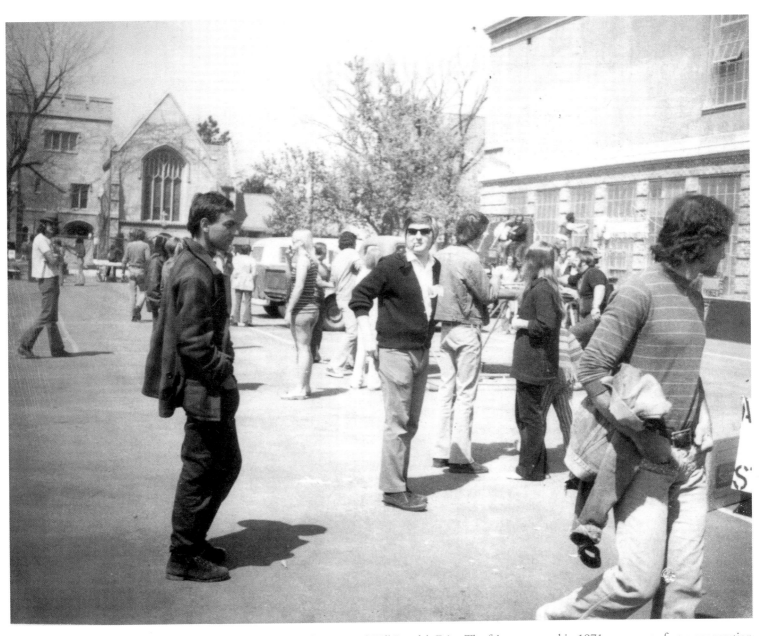

Some early participants in one of the first Capitol Hill People's Fairs. The fair was started in 1971 as a way to foster cooperation between City Hall, the Denver Police Department, and Capitol Hill residents. It continues today under the direction of Capitol Hill United Neighborhoods.

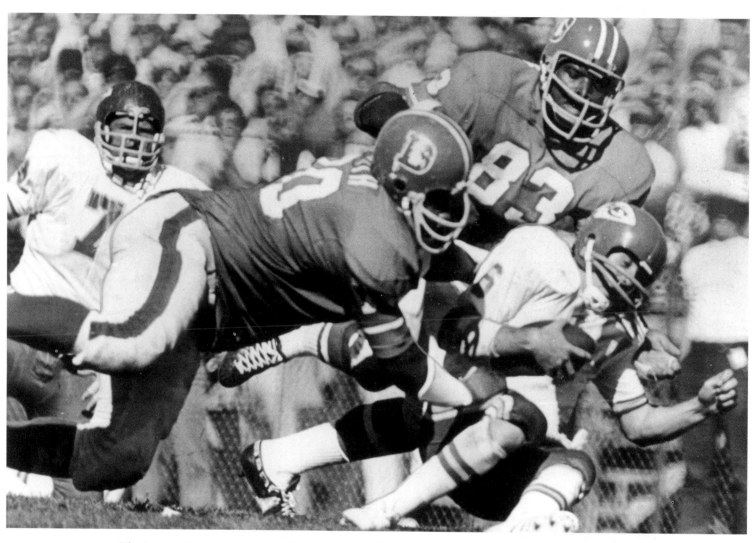

The Denver Broncos were a civic obsession even in the pro football team's early, bad years. Defensive lineman Paul Smith, here tackling Kansas City quarterback Len Dawson in a game October 2, 1972, was one of the most popular players.

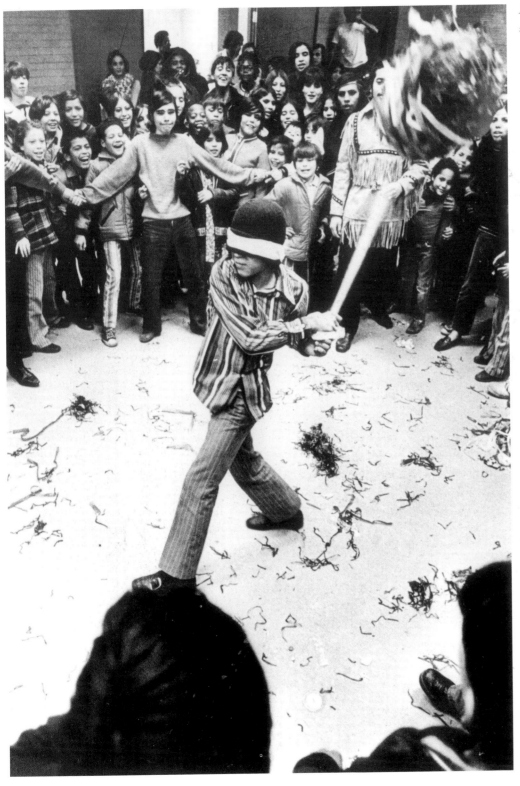

A blindfolded boy flails at a traditional piñata as children look on.

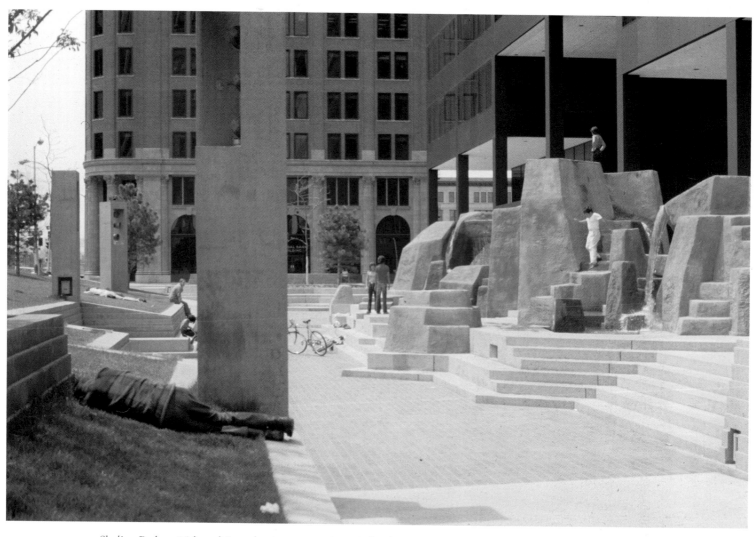

Skyline Park at 15th and Arapahoe streets was intended to be a cool, downtown oasis when it opened in 1973. Landscape architect Lawrence Halprin used reddish concrete blocks and water features to capture the feel of the Rockies within the city. Unfortunately, the park fell into disrepair, more and more became a haunt of the homeless, and the city demolished most of it in 2003.

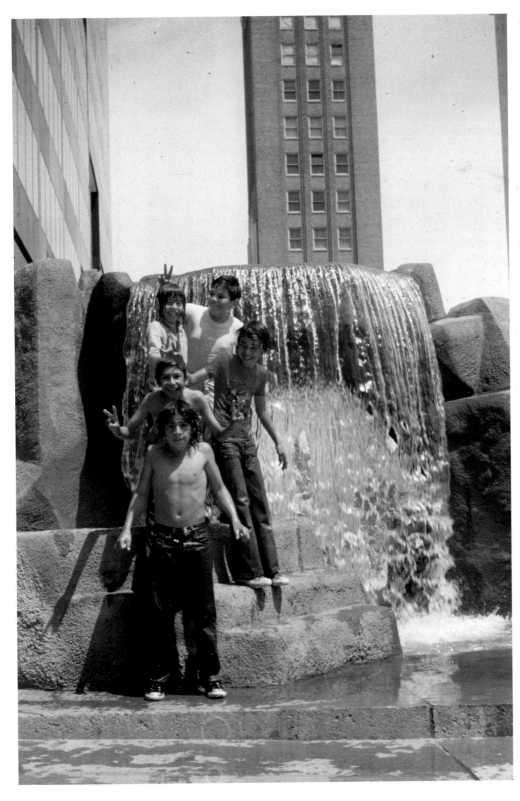

A group of kids shiver in fun in one of the waterfalls at Skyline Park.

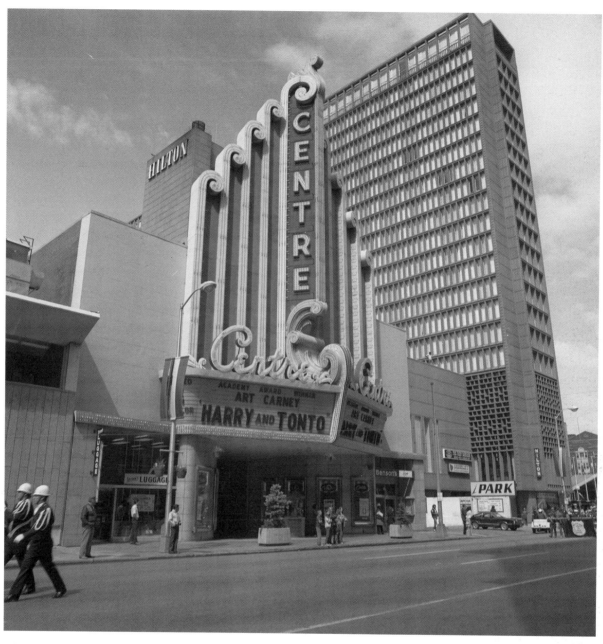

The Centre Theater on 16th Street between Court and Cleveland streets featured new movies like *Harry and Tonto* in 1974. The Hilton Hotel looms to the east. The theater opened April 29, 1954, with the Denver premiere of *River of No Return,* starring Marilyn Monroe. Like many of the city's old movie houses, it has since been demolished.

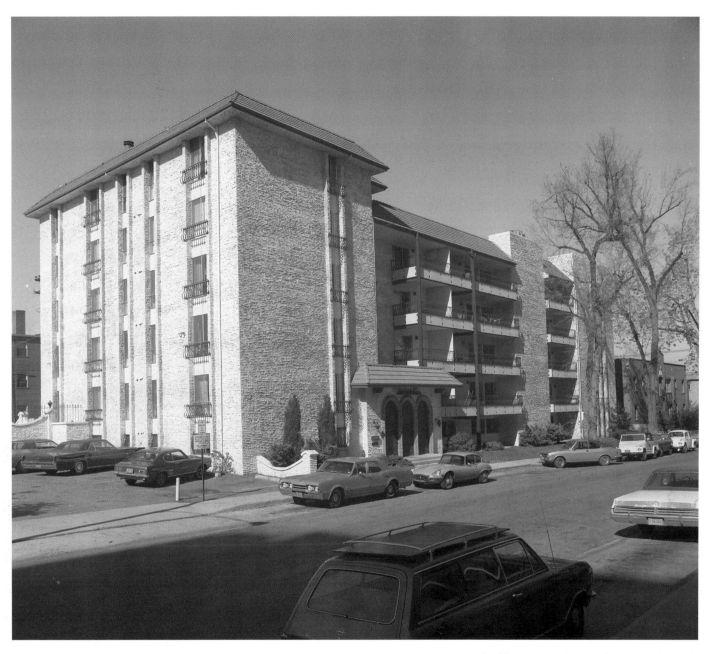

An apartment building at 239 Detroit Street in July 1974.

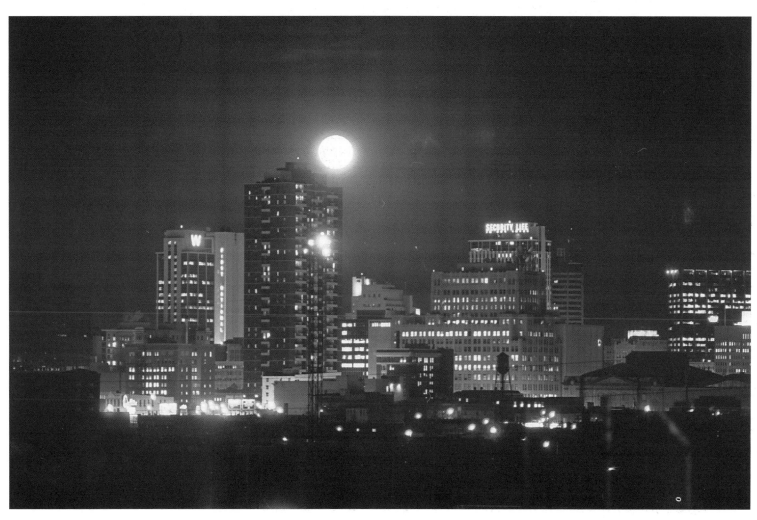

The brash lights of two downtown Denver skyscrapers—Western Savings & Loan and Security Life—can't compete with a moonrise over the city.

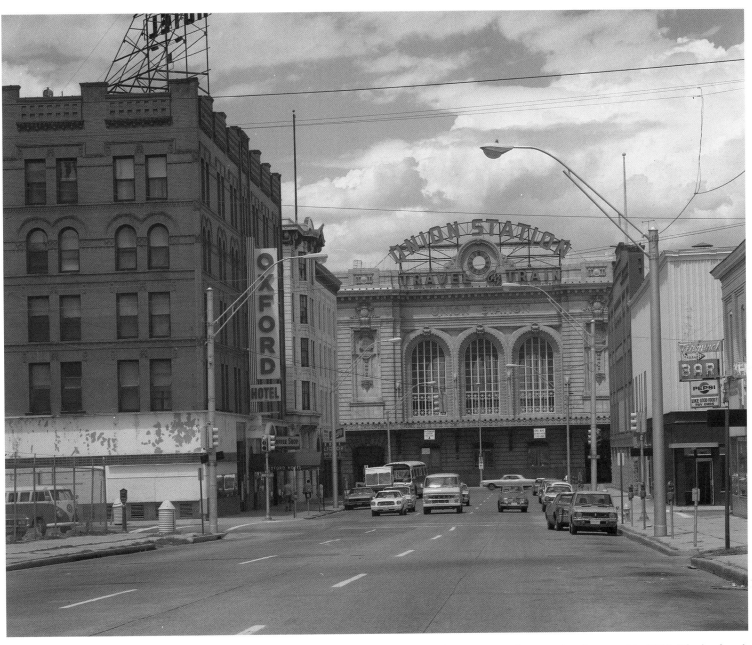

Union Station rail depot at the foot of one-way 17th Street was the gateway to Denver when it opened in 1915. The landmark was in some decline in the mid-1970s, when this photo was taken. The Oxford Hotel, which opened in 1891, also was showing its age, but in coming years it would be restored to once again reign as one of the city's finest. Union Station would survive into the early twenty-first century, when a redevelopment plan was executed that promised to return the historic depot to the limelight of downtown attractions.

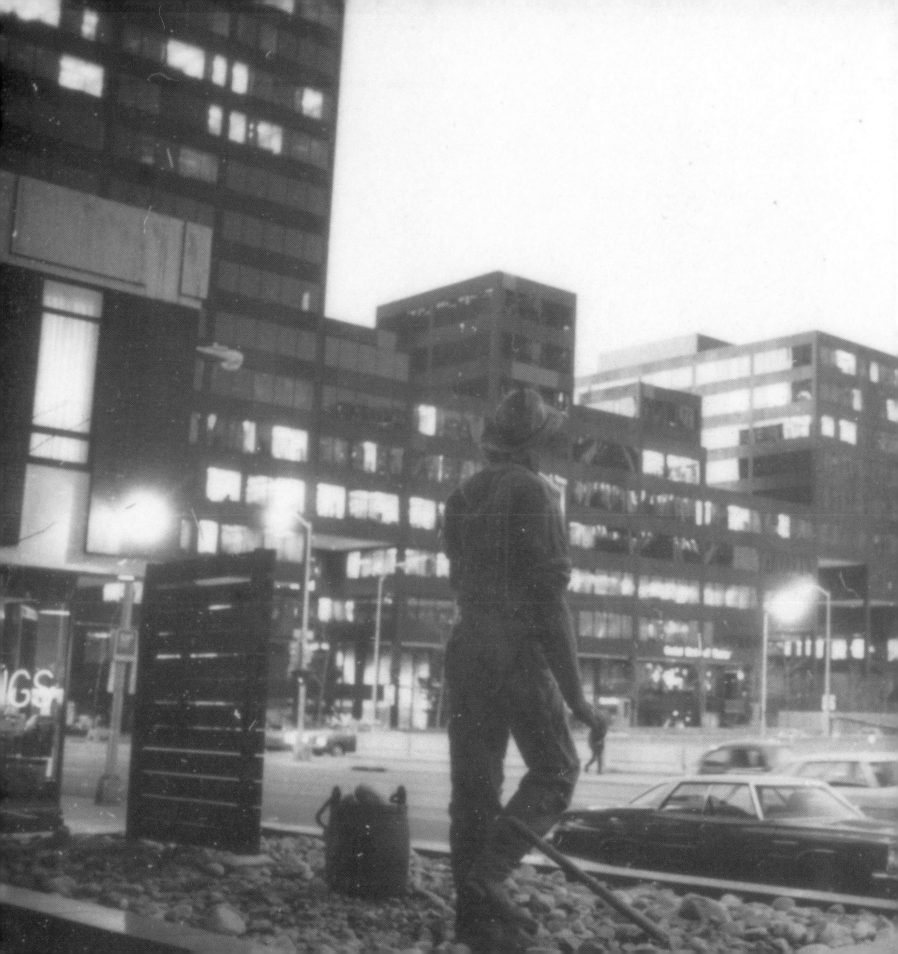

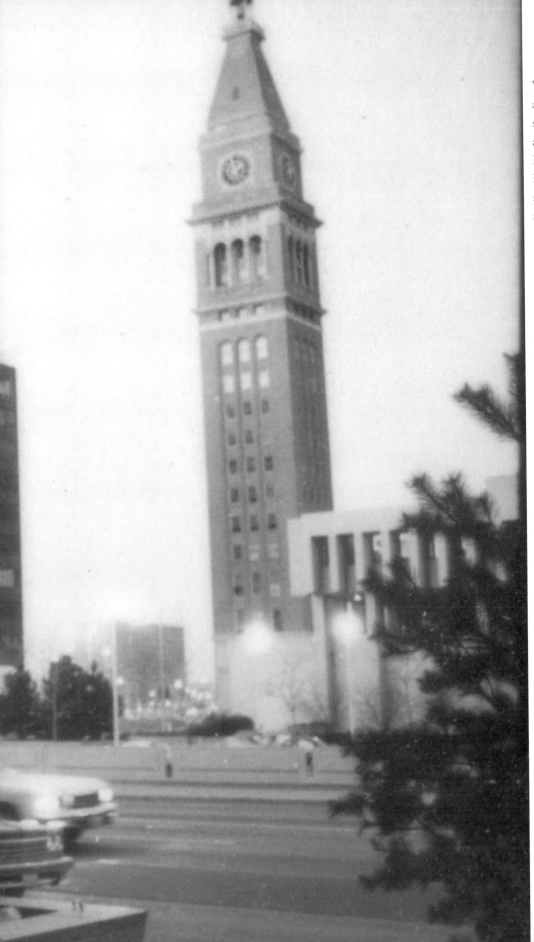

What appears to be a man staring across 15th Street at the Daniels & Fisher Tower is a 12-foot-tall copper sculpture named *The Ol' Prospector*. It originally perched atop the seven-story Colorado Gold Mining Stock Exchange when Alphonse Petzer sculptured the piece in 1891. Today it stands in front of the Brooks Towers, still a memorial in Petzer's words to "industry, patience and enterprise."

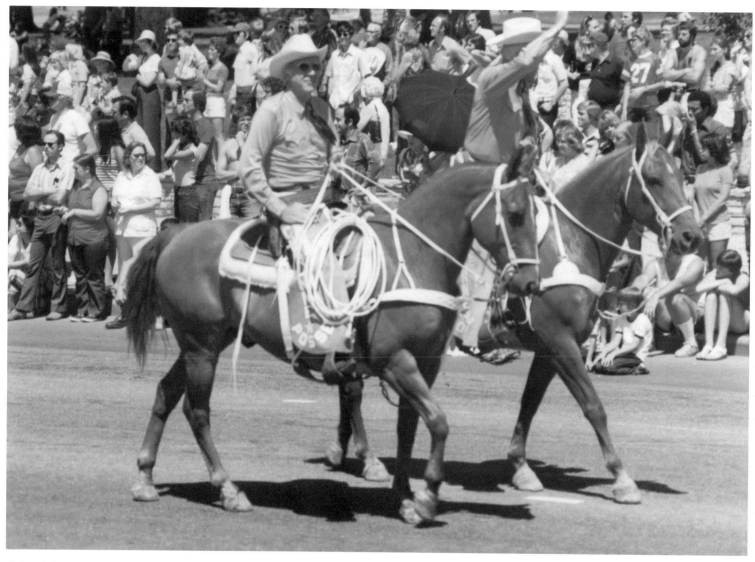

Colorado's western heritage is always represented in any Denver parade. During the nation's Bicentennial celebration, this pair of horsemen ride past the natural stepped lawns in front of the capitol.

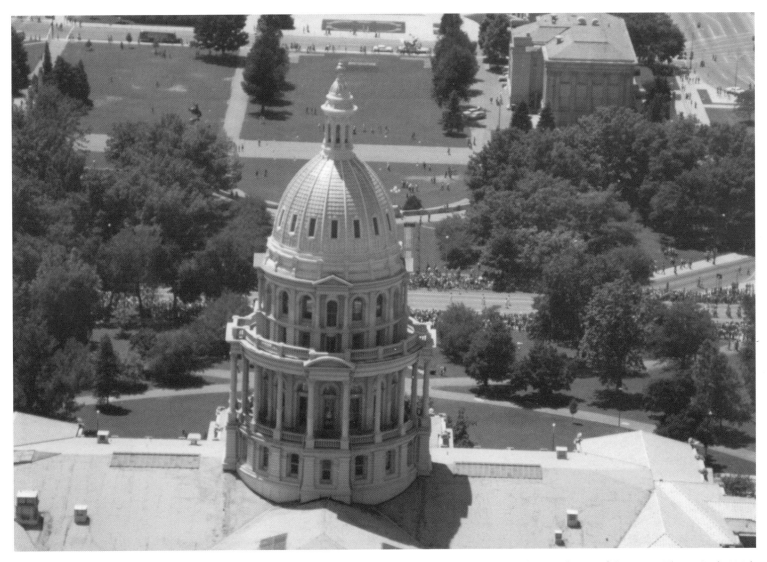

The Bicentennial parade proceeds along Broadway across from the capitol in this aerial view of the event. The nation's 200th birthday was celebrated in Denver and across the nation with numerous ceremonies and public events.

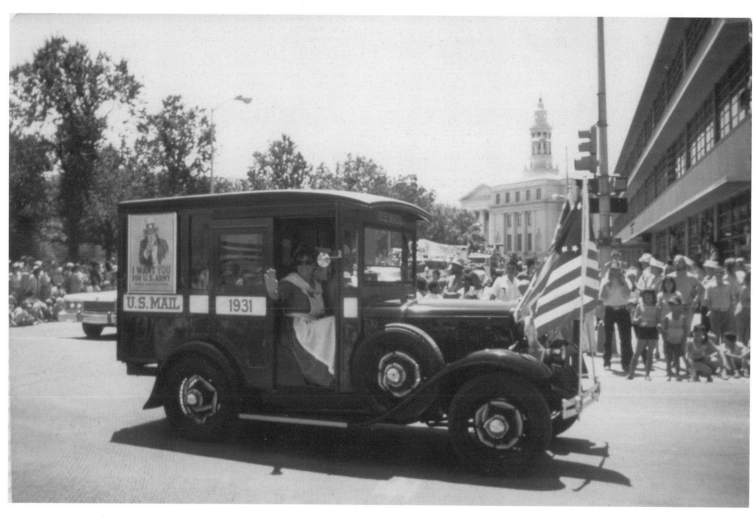

A vintage U.S. mail truck makes the turn onto 15th Street as the Bicentennial parade winds around Civic Center Park.

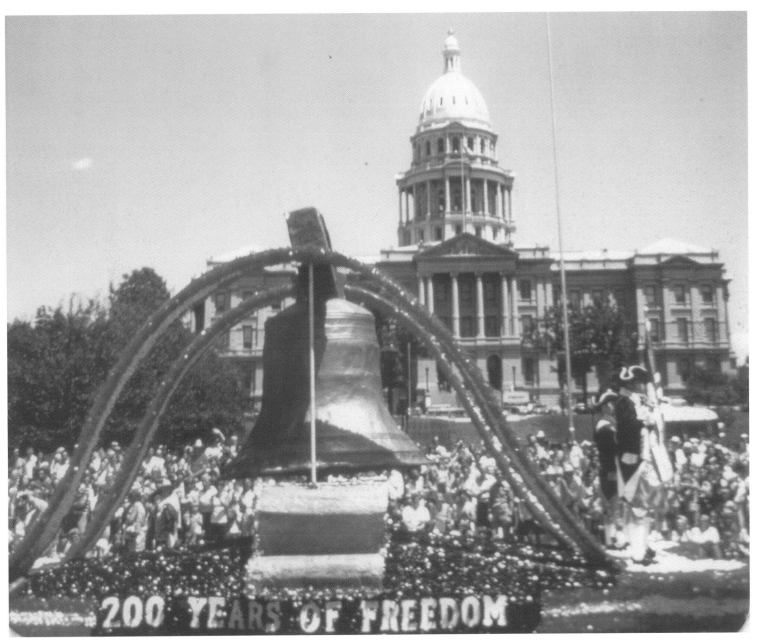

A parade float, part of Denver's celebration of America's Bicentennial, passes the State Capitol on July 3, 1976.

In the 1970s, the Globeville Community House at 4496 Grant Street was a gathering place for the largely immigrant community. Globeville was a residential neighborhood with broad ethnic diversity.

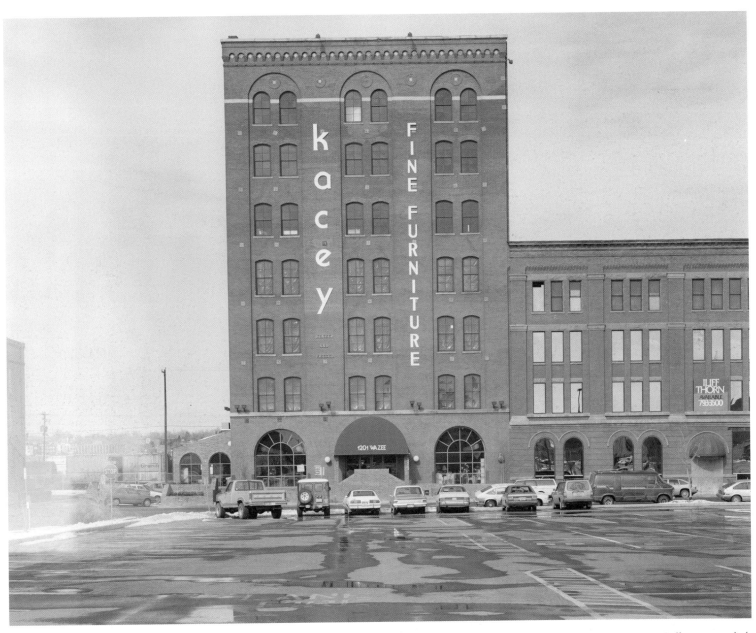

Kacey Fine Furniture's address was 1201 W. Wazee Street in the early 1970s. As nearby Metropolitan State College expanded, the address became 1201 Auraria Parkway. Now open for 41 years, Kacey still offers home decor to customers in Denver and the surrounding Rocky Mountain region.

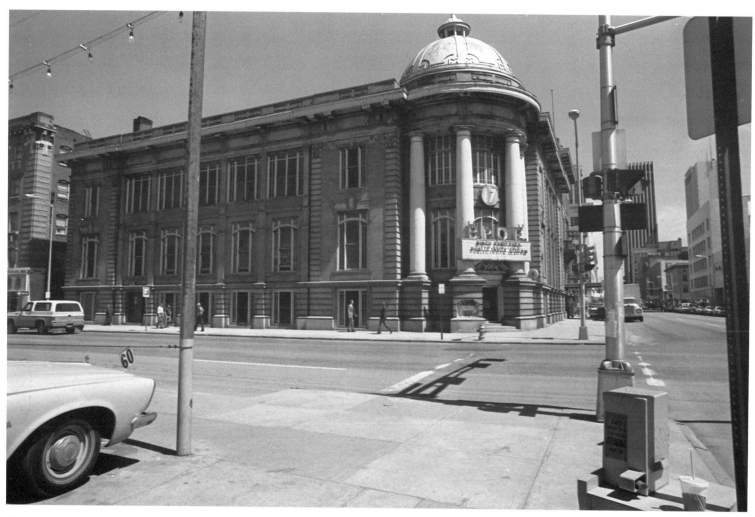

The Benevolent and Protective Order of Elks Lodge no. 17 had already earned the honorary title "Mother Lodge of the Rockies" by the mid-1970s when it moved into its new home at 2475 W. 26th Avenue. The original Lodge no. 17 hosted the funeral of William Frederick "Buffalo Bill" Cody, an Elks member, when the legendary showman and hero of the Old West died in 1917.

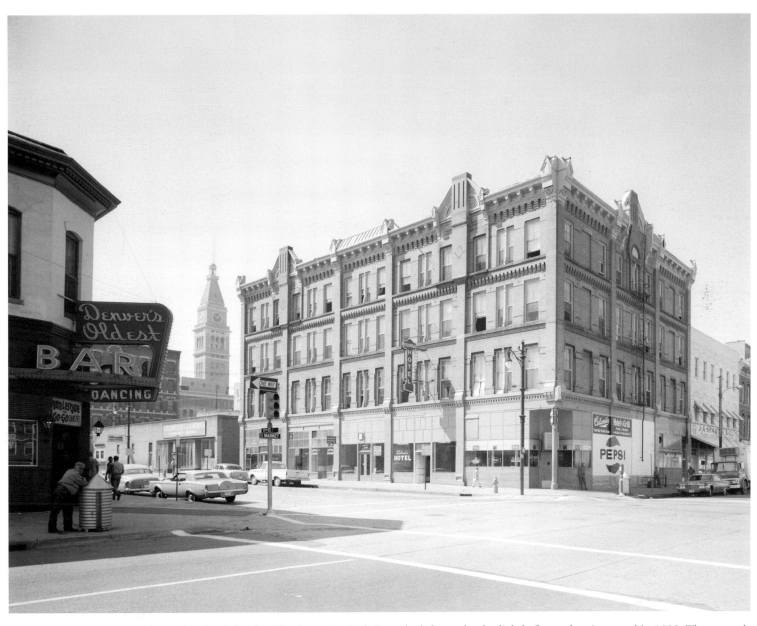

By the 1970s, the Columbia Hotel at 1330 17th Street had changed only slightly from when it opened in 1890. The upward-thrusting, triangular stoneworks visible on the ramparts were once part of taller fireplace chimneys. Across the street, a bar that claimed then to be "Denver's Oldest" is long gone.

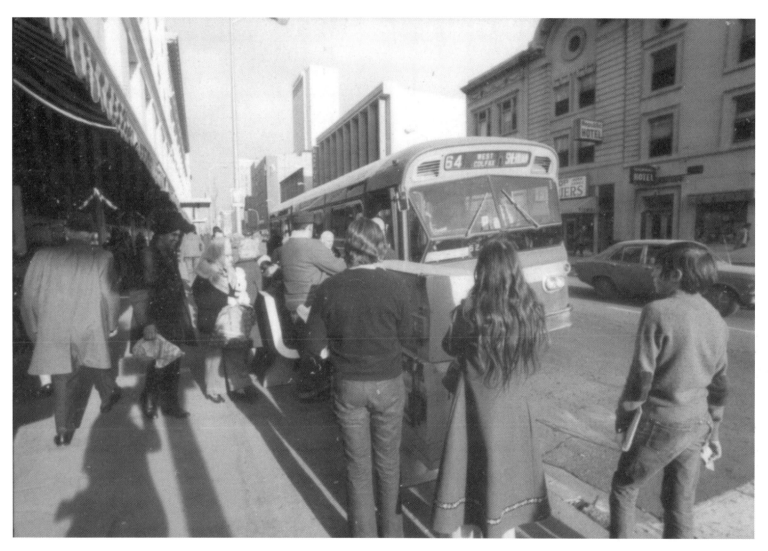

Bus riders wait their turn to board the "64" route bus downtown.

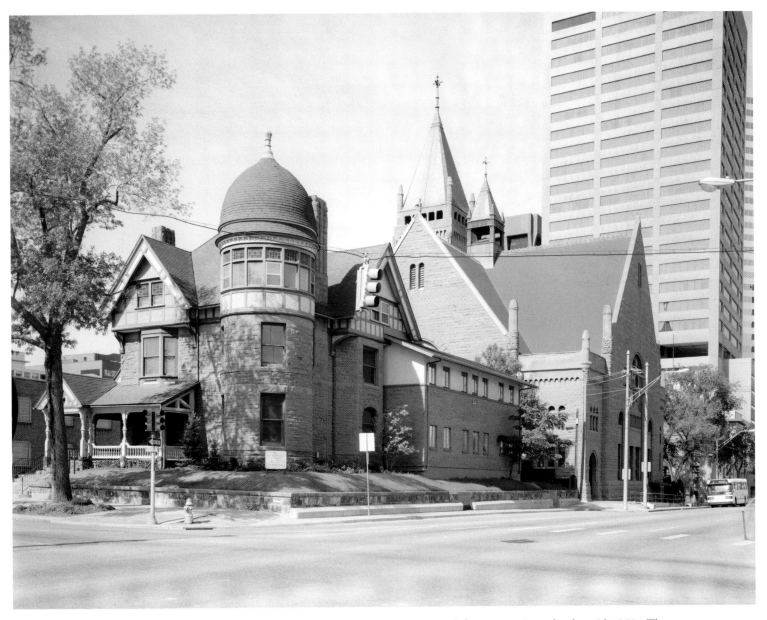

The George Schleier Mansion at 1665 Grant Street was one of the last "great mansions" left on Grant Street by the mid-1970s. The house, made of red sandstone in the Queen Anne style, was built for the businessman in the 1880s. It featured an onion-domed tower at its northeast corner and eight ornate fireplaces. Schleier died in 1910 as one of Denver's wealthiest and most prominent citizens, known for his gifts to those in need and contributions to the church.

Following Spread: Downtown Denver is silhouetted against the snowy Rocky Mountains in this view to the southwest from the Thornton suburb on a hazy January 12, 1976.

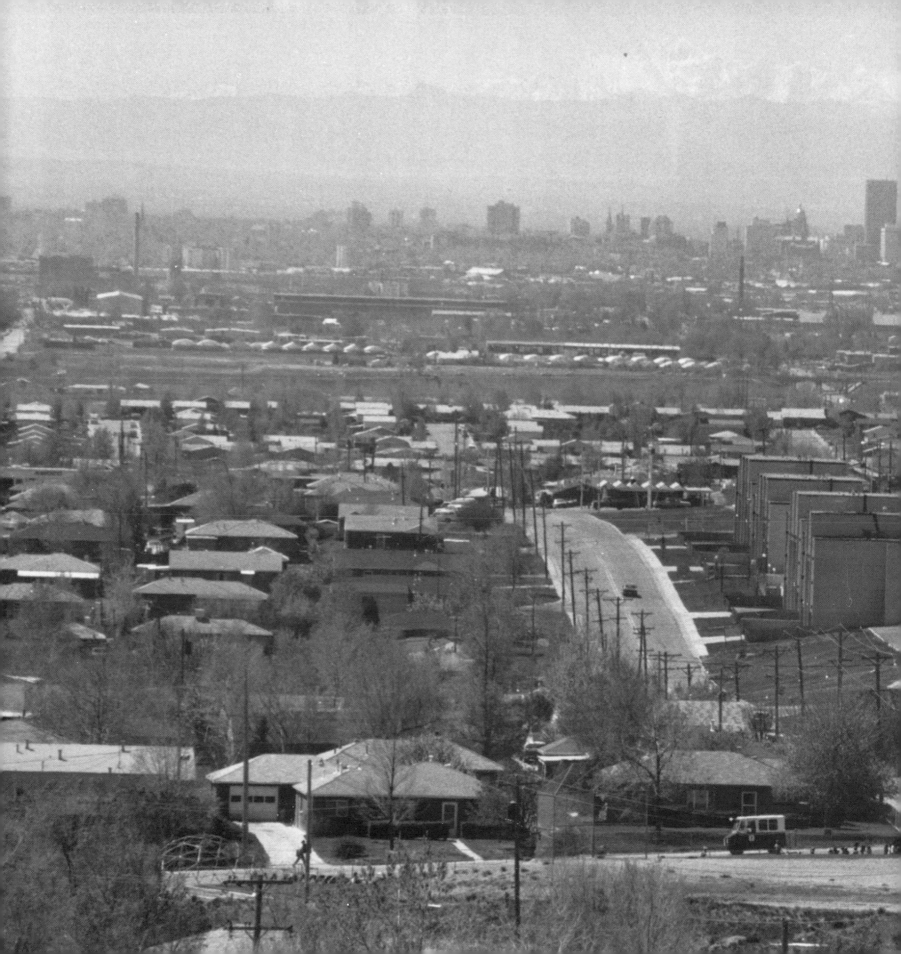

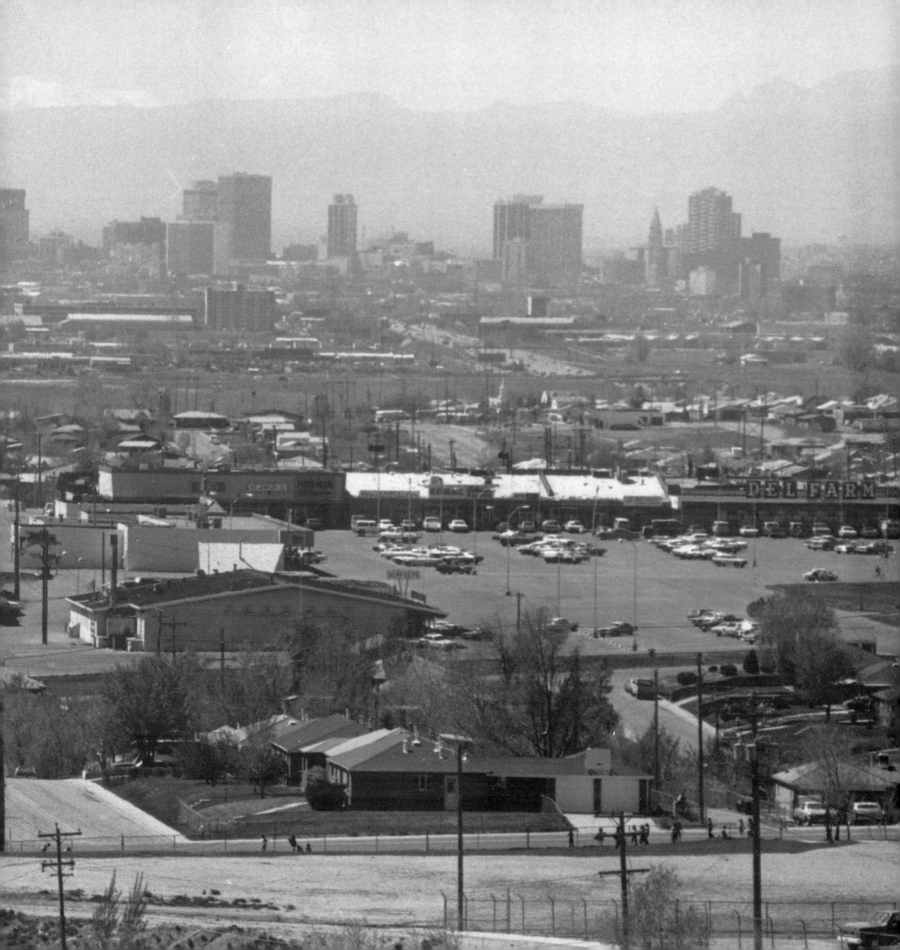

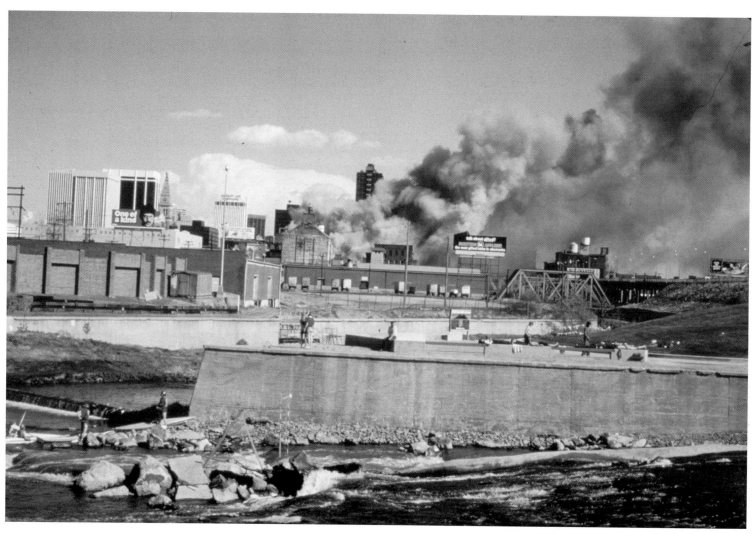

Downtown Denver is partly obscured by a fire at Constitution Hall, 1501 Blake Street, in 1977. The view is from Confluence Park. The concrete wall divides two rivers—Cherry Creek flowing behind it, and the South Platte in the foreground. Confluence Park has long been a popular playground for kayakers, some of them visible at lower-left. In later years the park and neighborhood would get a dramatic facelift.

Downtown traffic rushes past the Paramount Theater's old entrance on 16th Street at Christmastime. The original entrance at 519 16th Street was a lobby that cut through an office building behind it and then led into the theater and secondary entrance on Glenarm Street around the corner. The Paramount declined as a movie house, but in later years became a popular stage for national concerts and comics.

This smartly detailed building is identified only by the words "AnnRose" over its entrance.

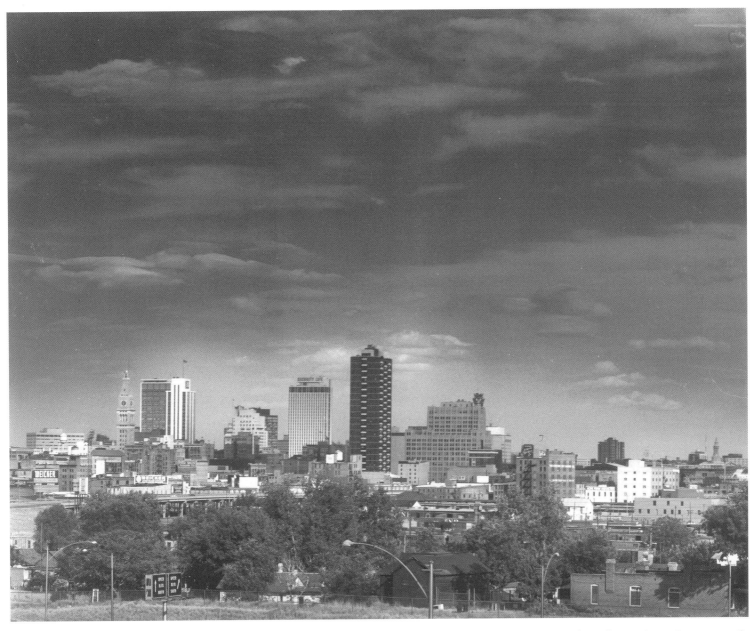

A view of the Speer viaduct as it enters downtown, looking east across the Valley Highway (Interstate 25).

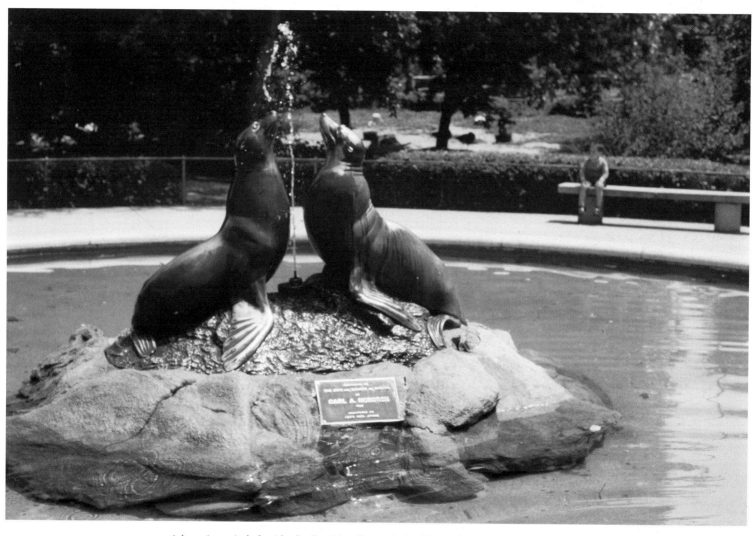

A boy sits quietly beside the Sea Lion Fountain in City Park in 1977. The bronze sea lions were one of many wildlife sculptures by Louis Paul Jonas.

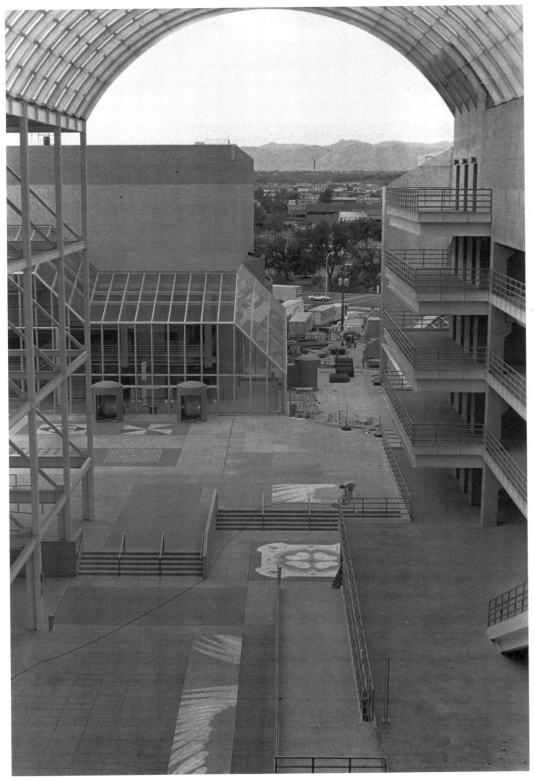

The final pieces of the atrium and main entrance of the Denver Center for Performing Arts come together in October 1977. Speer Boulevard and the foothills can be seen through the arch. Four months later, when the new complex of symphony hall and stages opened, the venue immediately became the city's cultural sun.

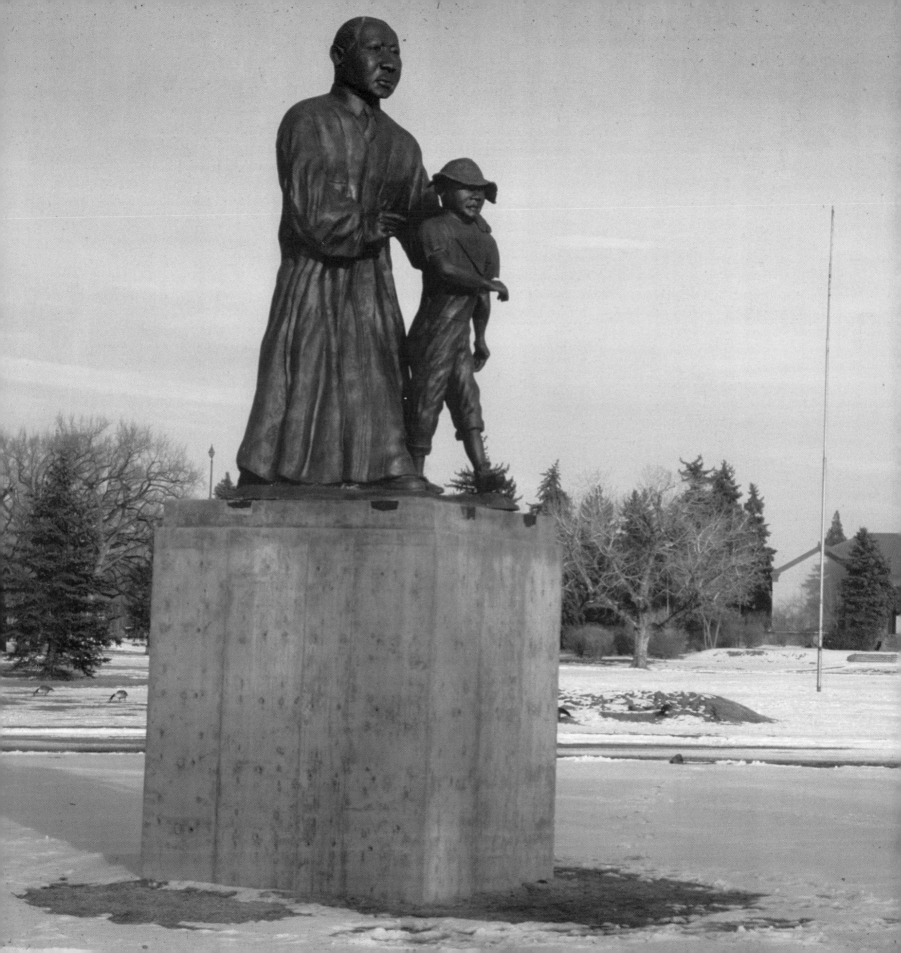

A bronze sculpture of civil rights leader Dr. Martin Luther King, Jr., a protective arm on the shoulder of Emmett Till, stood in front of the City Park Pavilion in 1978. Till was a 14-year-old boy from Chicago when he was murdered by segregationists in 1955 in Mississippi.

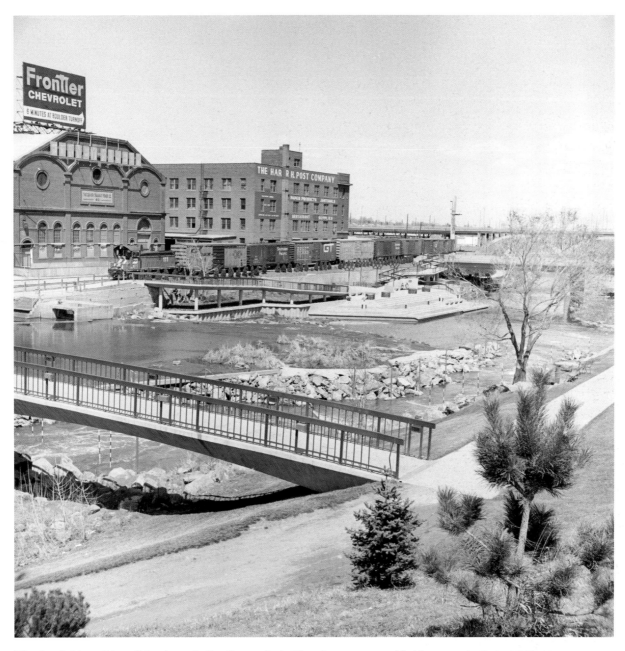

The South Platte River slides through Confluence Park. The plazas, steps, and bridges were built in 1975 as part of a renovation of the area. The former Denver Tramway Company powerhouse, at left, would later become a train museum and then an REI outdoor clothing store.

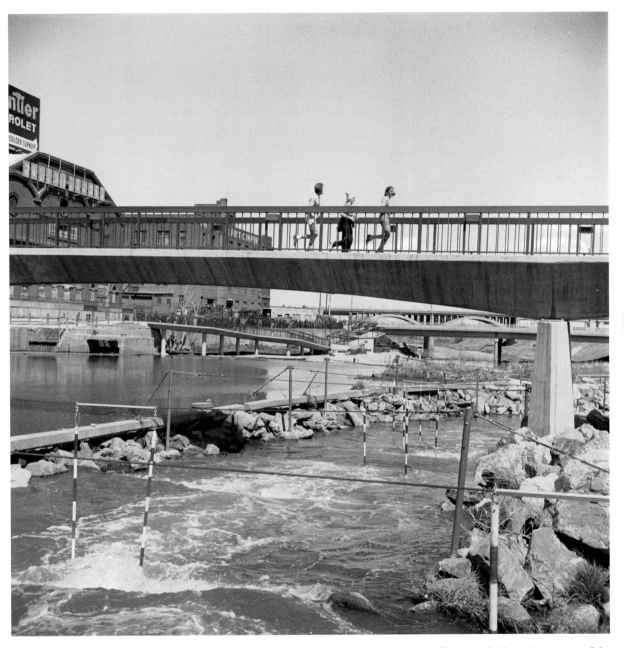

Dangling pole "gates" mark a kayak slalom course through a section of the South Platte River, one of the attractions of Confluence Park downtown.

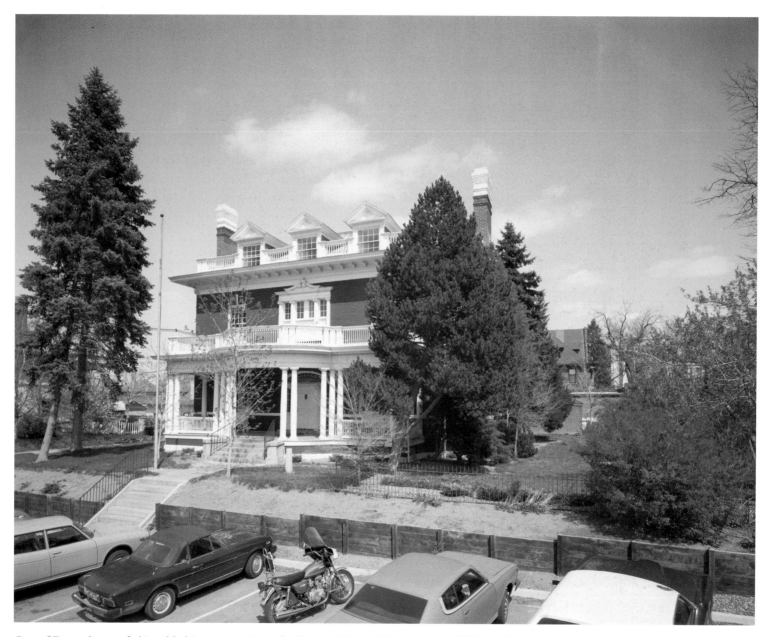

One of Denver's most fashionable historic mansions, the Tears-McFarlane House at 1200 Williams Street served as the Capitol Hill Community Center after it was purchased by the city in 1977. The house was built in 1899 for Daniel Tears, a lawyer, and his family. Frederick McFarlane, a Denver socialite, acquired the structure in 1937.

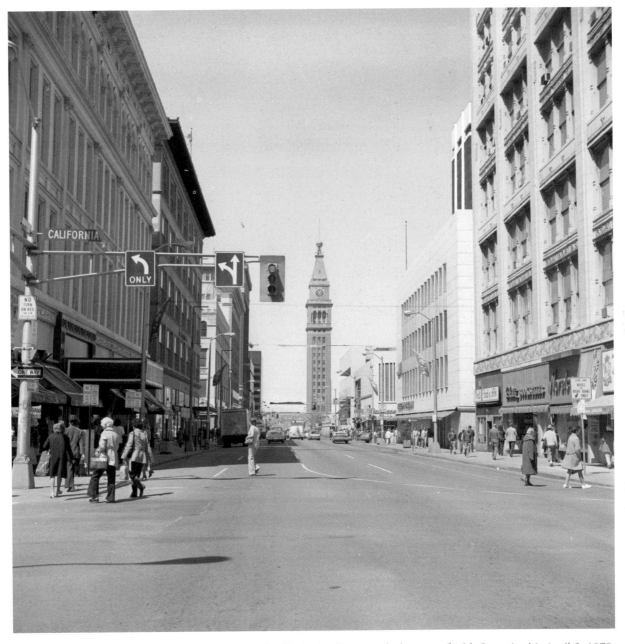

The Daniels & Fisher Tower dramatically fills the landscape at the bottom of 16th Street in this April 5, 1979, photo. Shoppers on the street could visit Walgreens, B. Dalton Booksellers, and other prominent merchants and retailers doing business in the area during the decade.

The west entrance of the Central Presbyterian Church at 1660 Sherman Street. Designed in Romanesque Revival style in 1892, the church survives into the twenty-first century.

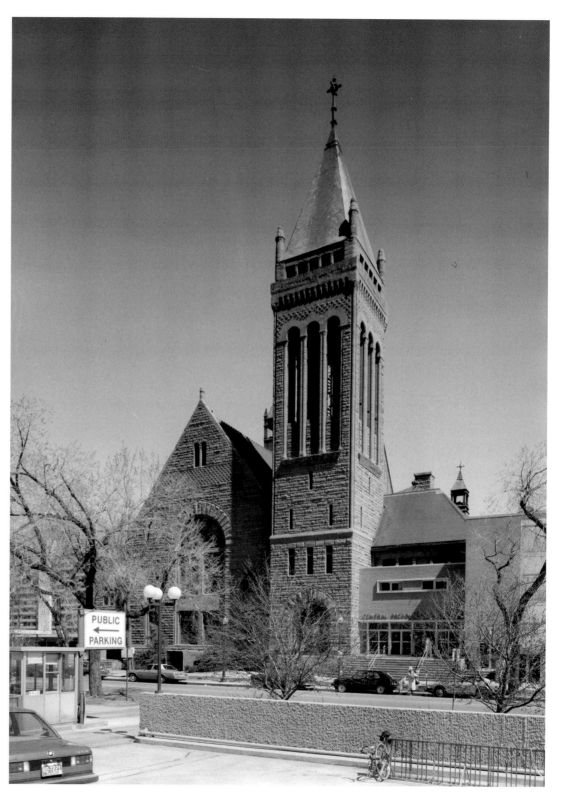

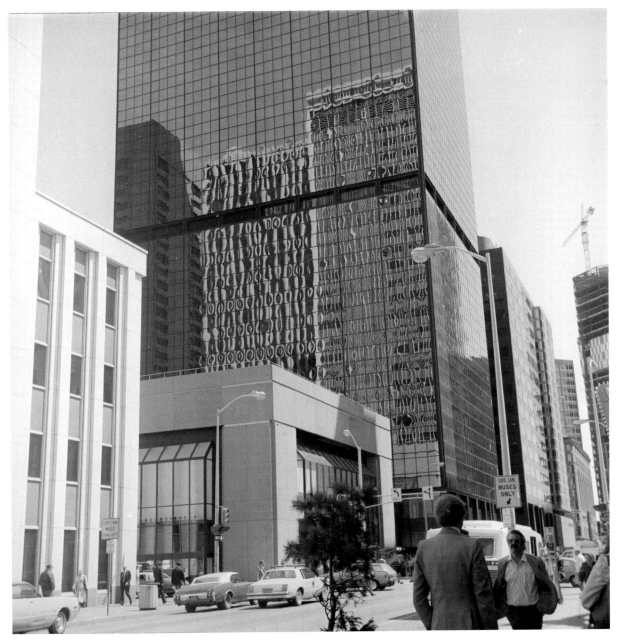

With its rippled, black reflective skin, the Anaconda Tower at 555 17th Street had a striking presence on the "Wall Street of the Rockies." Its design is a striking example of how 1970s architects sometimes attempted to build with a twenty-first-century vision.

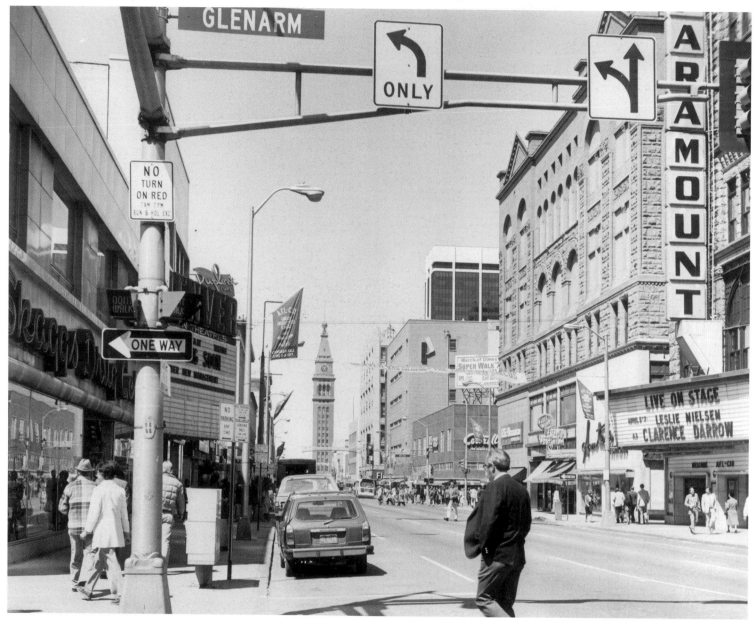

Business at 16th and Glenarm streets on April 5, 1979, offered an array of choices: on the one side Paramount Theater, Amster's Fashions, Richman Brothers, Cottrell's men's store, Florsheim Shoes, and Walgreens; and across the street, Skaggs Drugs and the Denver Theatre.

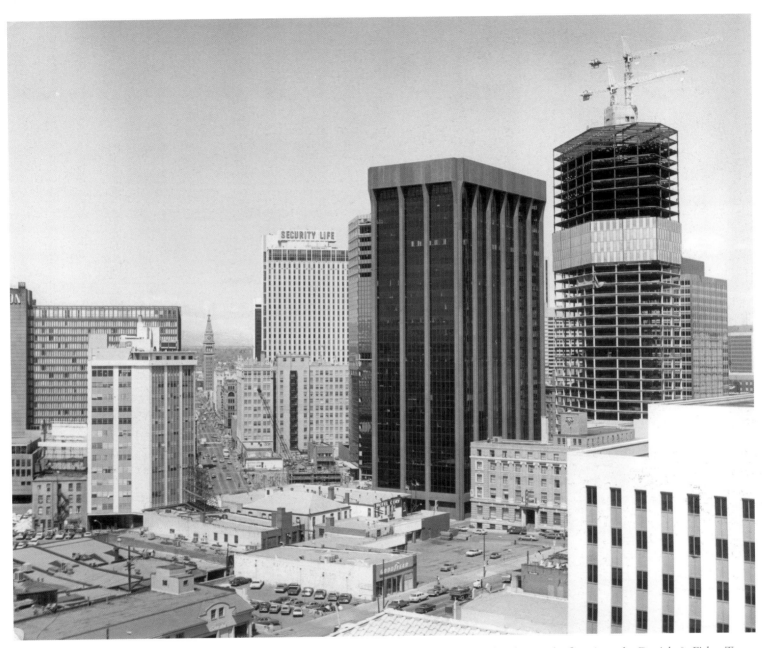

The height of Denver's skyline would rise dramatically during the decade. For the first time, the Daniels & Fisher Tower became dwarfed by the Hilton Hotel, at far-left, Security Life Building, Anaconda Tower (under construction), Colorado National Bank, and the World Trade Center (under construction).

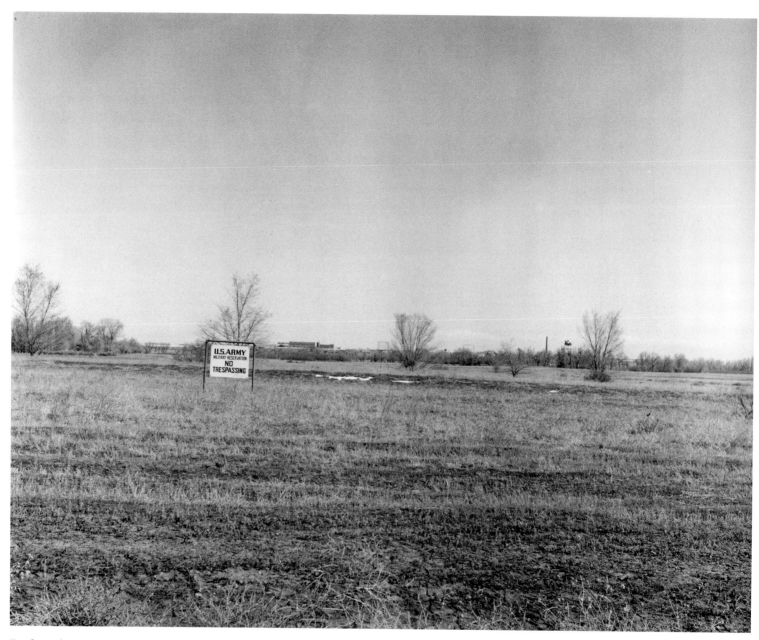

Far from downtown, in the northeast outskirts of Denver, Rocky Mountain Arsenal remained an inhospitable and guarded place in April 1979. The Army facility began manufacturing munitions in 1942 and eventually chemical weapons. When it was closed in the 1990s, 10 years and $2 billion were needed to clean up.

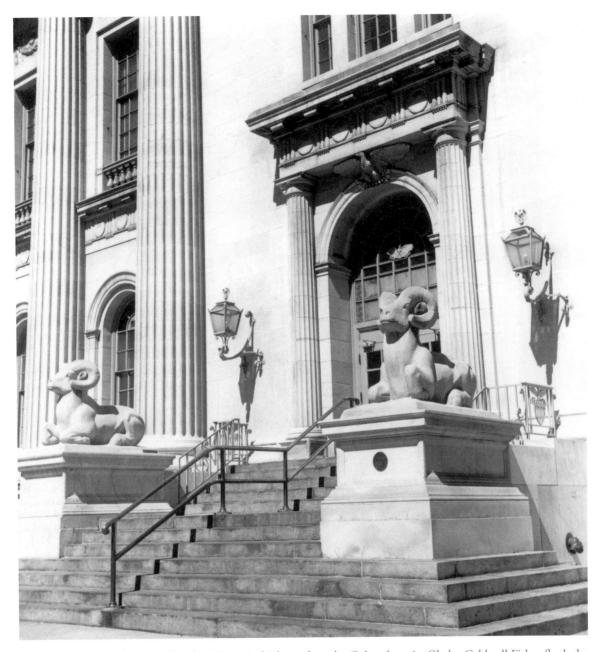

Sculptures of Rocky Mountain bighorn sheep by Colorado artist Gladys Caldwell Fisher flank the entrance to the U.S. Post Office and Federal Building at 1823 Stout Street. The home of the Tenth Circuit court was renamed the Byron White U.S. Courthouse in 1994 for the Colorado native and University of Colorado football star who served as Supreme Court justice for 31 years.

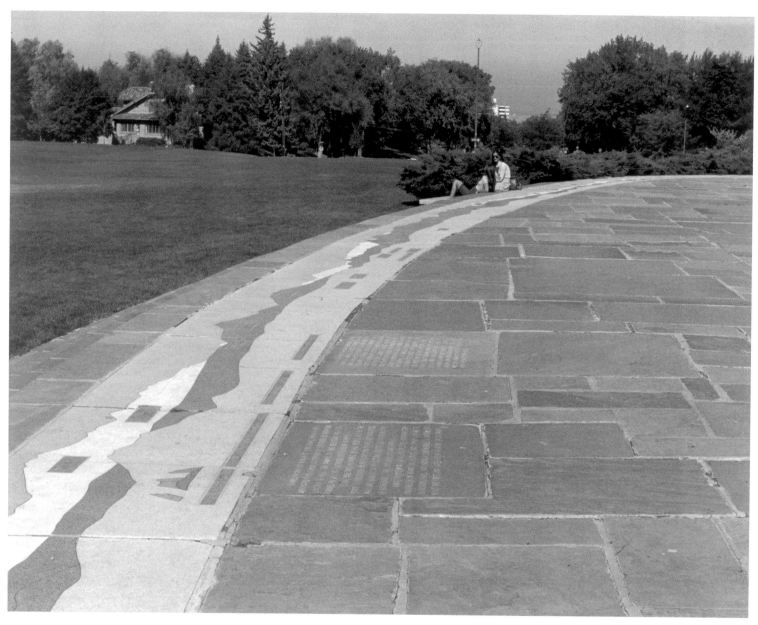

Cranmer Park in the Hilltop Neighborhood offers visitors on October 10, 1979, two views of the Rocky Mountains: looking up at the majestic peaks to the west, and down at their feet, where the Front Range is rendered in varying colors of flagstone as a panoramic mountain index listing the names and elevations of each mountain.

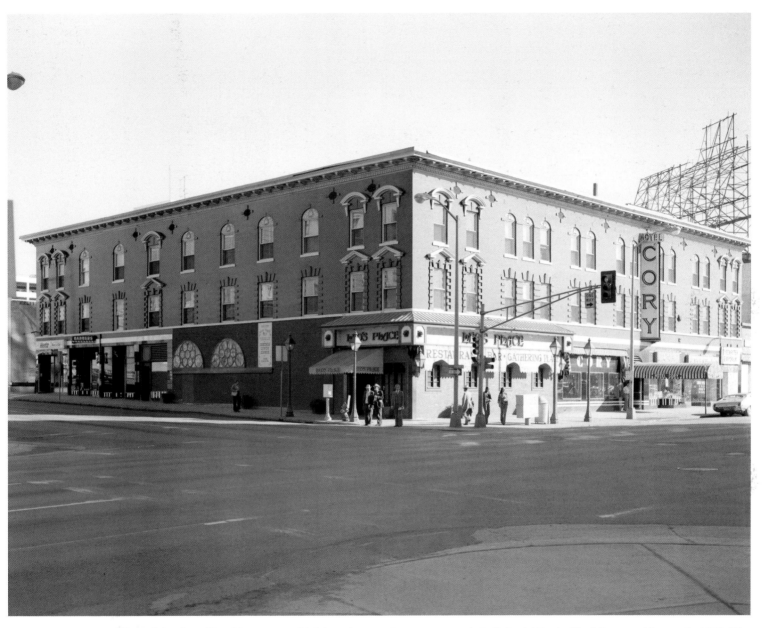

Builders of the Cory Hotel in 1898 couldn't have known the controversy their Colonial Revival building would cause in 1979. The building at the three-way intersection of Broadway, 16th Street, and 16th Avenue eventually blocked the vista up 16th Street, a main business thoroughfare, to the State Capitol. The building was demolished.

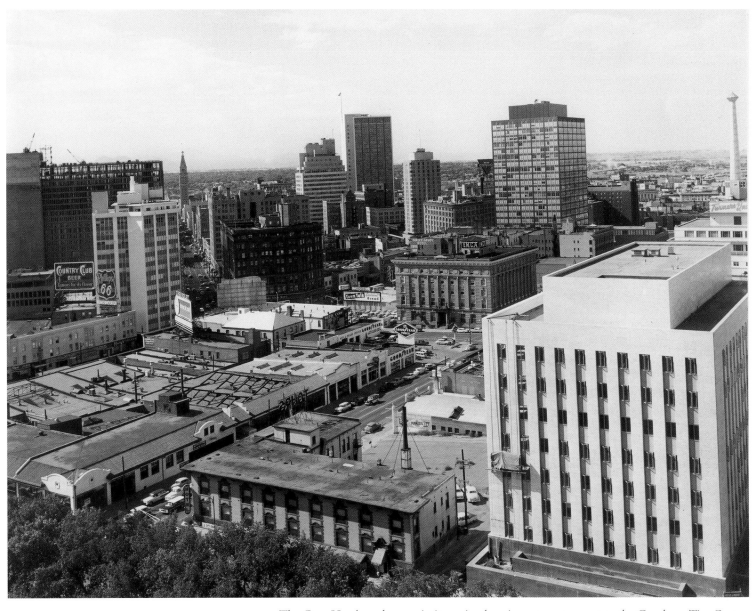

The Cory Hotel can be seen in its vexing location, at center, next to the Goodyear Tire Center.

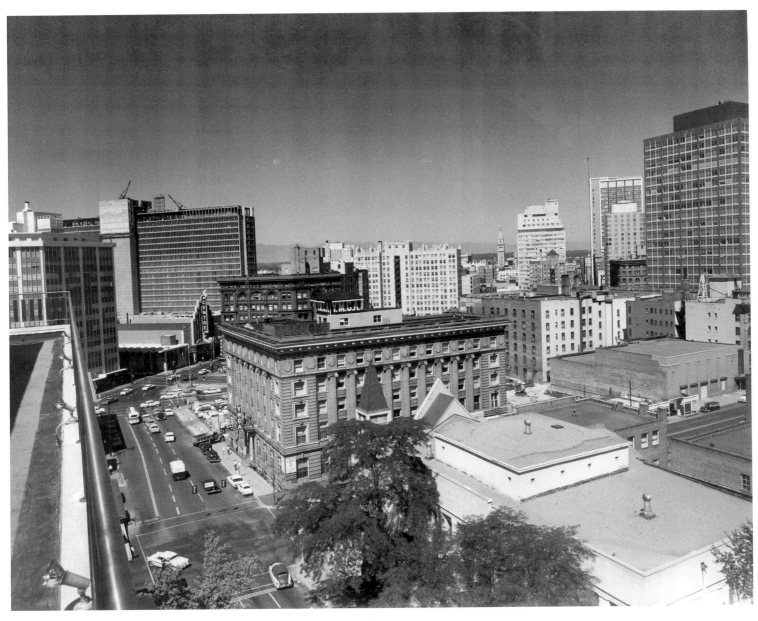

The Y.M.C.A., at center, stood across 16th Avenue from the Cory Hotel.

Following Spread: Downtown traffic on Broadway, at center, and Lincoln streets traveled in both directions in this mid-1970s photograph. Eventually, both would become one-way streets.

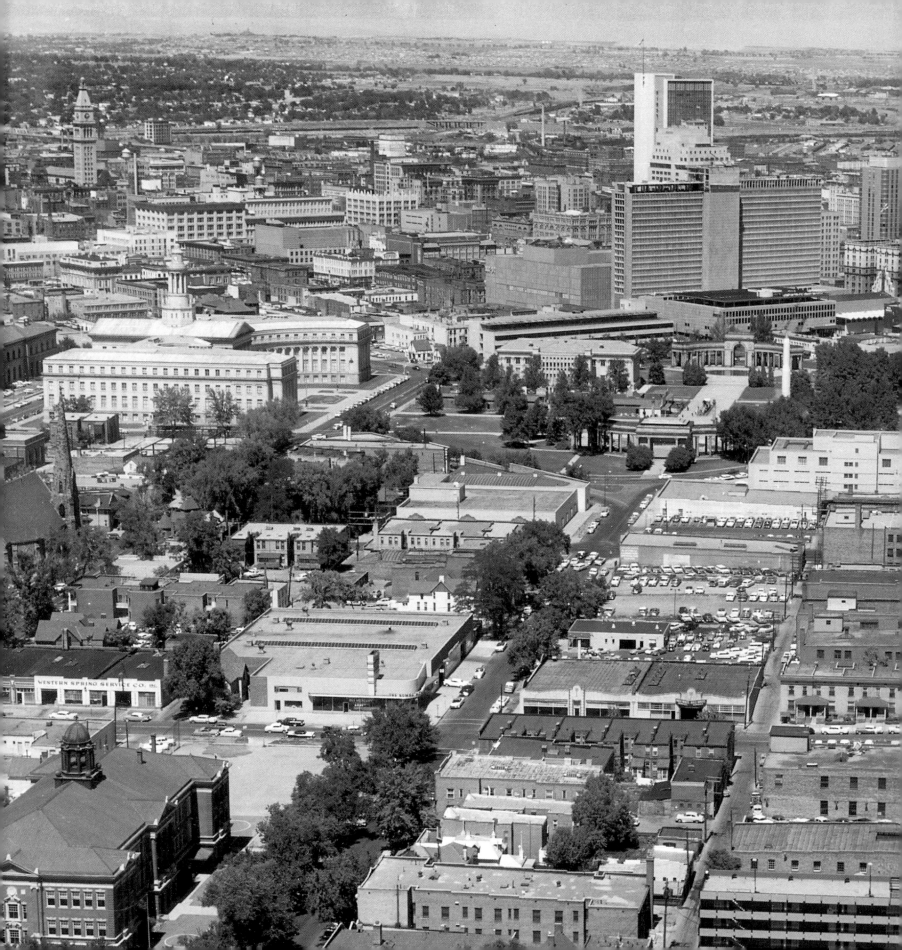

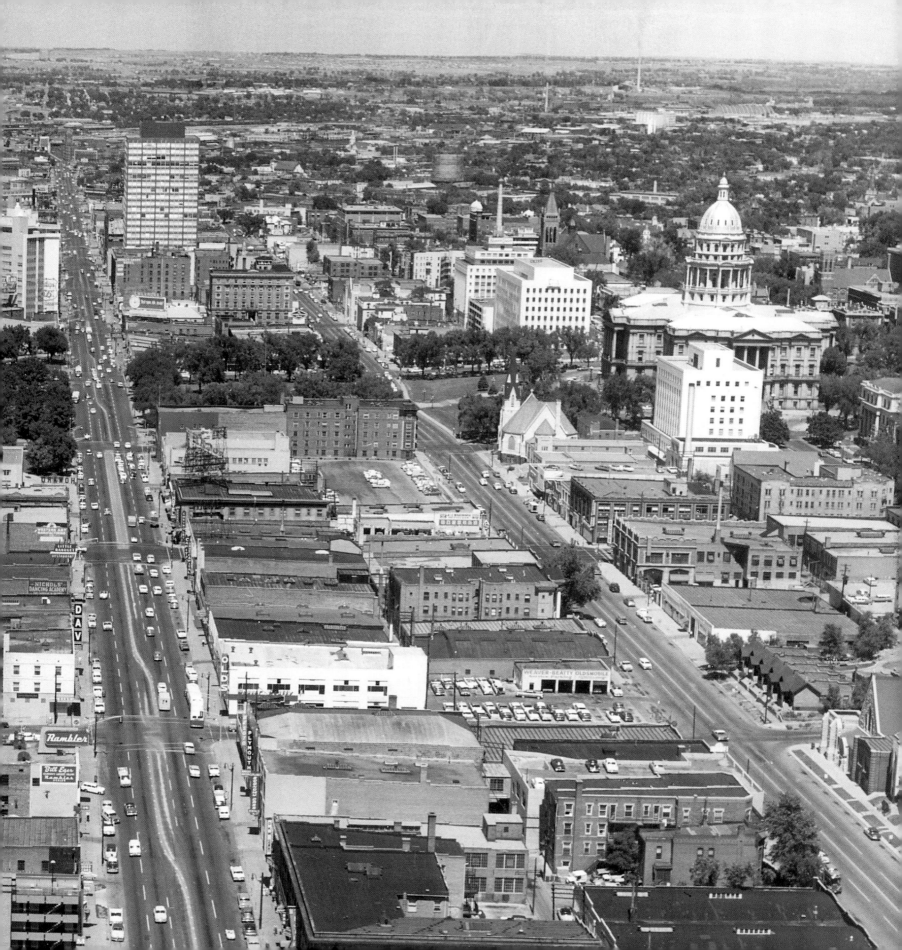

Patrons view the exhibits at the new Denver Art Museum, only eight years old here in March 1979.

Notes on the Photographs

These notes, listed by page number, attempt to include all aspects known of the photographs. Each of the photographs is identified by the page number, photograph's title or description, photographer and collection, archive, and call or box number when applicable. Although every attempt was made to collect all data, in some cases complete data may have been unavailable due to the age and condition of some of the photographs and records.